Cultural Heritage Manage
Indigenous People in the N

CW01431583

Cultural Heritage Management and Indigenous People in the North of Colombia explores indigenous people's struggle for territorial autonomy in an aggressive political environment and the tensions between heritage tourism and Indigenous rights.

South American cases where local communities, especially Indigenous groups, are opposed to infrastructure projects, are little known. This book lays out the results of more than a decade of research in which the resettlement of a pre-Columbian village has been documented. It highlights the difficulty of establishing the link between archaeological sites and objects, and Indigenous people due to legal restrictions. From a decolonial framework, the archaeology of Pueblito Chairama (Teykú) is explored, and the village stands as a model to understand the broader picture of the relationship between Indigenous people and political and economic forces in South America.

The book will be of interest to researchers in Archaeology, Anthropology, Heritage and Indigenous Studies who wish to understand the particularities of South American repatriation cases and Indigenous archaeology in the region.

Wilhelm Londoño Díaz is Professor of Archaeology in the Department of Anthropology, University of Magdalena, Colombia.

Archaeology and Indigenous Peoples

Series editors: H Martin Wobst, Sonya Atalay, T. J. Ferguson, Claire Smith, Joe Watkins, Larry Zimmerman

Maritime Heritage in Crisis
Indigenous Landscapes and Global Ecological Breakdown
Richard M. Hutchings

Memory and Cultural Landscape at the Khami World Heritage Site, Zimbabwe
Ashton Sinamai

Aboriginal Maritime Landscapes in South Australia
The Balance Ground
Madeline E. Fowler

Incorporating Nonbinary Gender into Inuit Archaeology
Oral Testimony and Material Inroads
Meghan Walley

Cultural Heritage Management and Indigenous People in the North of Colombia
Back to the Ancestors' Landscape
Wilhelm Londoño Díaz

For more information about this series, please visit: https://www.routledge.com/Archaeology–Indigenous-Peoples/book-series/AIP

Cultural Heritage Management and Indigenous People in the North of Colombia

Back to the Ancestors' Landscape

Wilhelm Londoño Díaz

Routledge
Taylor & Francis Group

LONDON AND NEW YORK

First published 2021
by Routledge
2 Park Square, Milton Park, Abingdon, Oxon OX14 4RN

and by Routledge
52 Vanderbilt Avenue, New York, NY 10017

Routledge is an imprint of the Taylor & Francis Group, an informa business

British Library Cataloguing in Publication Data
A catalogue record for this book is available from the British Library

Library of Congress Cataloging-in-Publication Data
Names: Londoño, Wilhelm, author.
Title: Cultural heritage management and indigenous people in the north of
Colombia : back to the ancestor's landscape / Wilhelm Londoño Díaz.
Other titles: Back to the ancestor's landscape
Description: Abingdon, Oxon ; New York, NY : Routledge, 2020. |
Series: Archaeology and indigenous peoples |
Includes bibliographical references and index.
Identifiers: LCCN 2020029484 (print) | LCCN 2020029485 (ebook) | ISBN
9780367422189 (hb) | ISBN 9780367822774 (eb)
Subjects: LCSH: Kagaba Indians–Colombia–Santa Marta
Range–Antiquities. | Kagaba Indians–Colombia–Santa Marta
Range–Government relations. | Cultural property–Protection–
Colombia–Santa Marta Range. | Archaeology–Government
policy–Colombia–Santa Marta Range. | Historic
preservation–Colombia–Santa Marta Range. | Sacred space–Conservation
and restoration–Colombia–Santa Marta Range. | Santa Marta Range
(Colombia)–Antiquities.
Classification: LCC F2270.2.K3 L66 2020 (print) | LCC F2270.2.K3
(ebook) | DDC 986.1–dc23 LC record available at
https://lccn.loc.gov/2020029484 LC ebook record available at
https://lccn.loc.gov/2020029485

ISBN: 978-0-367-42218-9 (hbk)
ISBN: 978-0-367-82277-4 (ebk)

Typeset in Times New Roman
by Taylor & Francis Books

To Eloisa and Yebrail who gave me life; to all Indigenous people from Colombia who taught me how to resist

Contents

Figures

Acknowledgements

This book could not have been written without the support of the Universidad del Magdalena, my second home and my workplace; I must also acknowledge the unconditional support of my friend and professor Cristóbal Gnecco, who made the translation from Spanish to English; I must also acknowledge the support of Maira Mendoza Curvelo, who braced me to face the tedium of reviewing the bibliography and other details. Also, I want to exalt the support of Paris Ferrand with some of the fieldwork done for this book, mainly in the early years when I arrived at Santa Marta.

Also, I want to acknowledge Ramón Gil, Santos Sauna (RIP), Juan Nieves, Amado Villafaña, Francisco Gil, Ariel Daniels, and Ayrton David Cantillo for their unconditional disposition to listen and answer my questions for all these years.

I want to give special recognition to Anghie Mejía, who helped me to structure the book; without her I would not have had the self-confidence to write.

As well, I want to express my deep gratitude to the staff of Taylor & Francis, and Routledge for the warmth of their treatment and their incredible professionalism, mainly to Senior Editor Dra. Claire Smith who has been a source of inspiration for the practice of an archaeology committed to Indigenous People.

Finally, the main ideas of this book was made thanks to the FONCIENCIAS 2018 grant "Resettled Chairama: Indigenous resettlements in the Tayrona National Natural Park" awarded by the Universidad del Magdalena.

Of course, I want to acknowledge all the *ezuamas* that connect me with the world: because of them I'm still breathing, even in the middle of this pandemic. As they told me when I was walking to the streets of Taganga, the time of *anthropoceno* has come, and now we need to move forward to this society where the *ezuamas* rule.

List of abbreviations

CGSM	Ciénaga Grande de Santa Marta
CIA	Central Intelligence Agency
FARC – EP	*Fuerzas armadas revolucionarias de Colombia – Ejercito del pueblo* (Colombian Revolutionary Armed Forces – People's Army)
GHF	Global Heritage Fundation
GKM	*Gobernación Kogui Magdalena*
ICANH	*Instituto Colombiano de Antropología e Historia*
MET	Metropolitan Museum
NMAI	National Museum of American Indians
OGT	*Organización Gonawindua Tayrona*
PNN	*Parque Nacionales Naturales*
PNNT	*Parque Nacional Natural Tayrona*
SNSM	*Sierra Nevada de Santa Marta*
UFC	United Fruit Company

Introduction

This book is about the principles of life in the world of the Indigenous peoples of the Sierra Nevada de Santa Marta (SNSM thereafter). Those principles are in the immense cliffs that crown the highest parts of the SNSM, and they are also in the sea in the small islets that stand out on the coast, they are in small mounds that are in the low parts of the beach.

Many anthropologists and explorers went to sacred places like Makotama (see Figure 0.2) to understand this philosophy. For those of us who share this experience, the magnificent cliffs that face Makotama are the great examples of the beginning of the world. That is why the houses, which represent the mens' hat, are established to contemplate timeless creation. On the shoreline

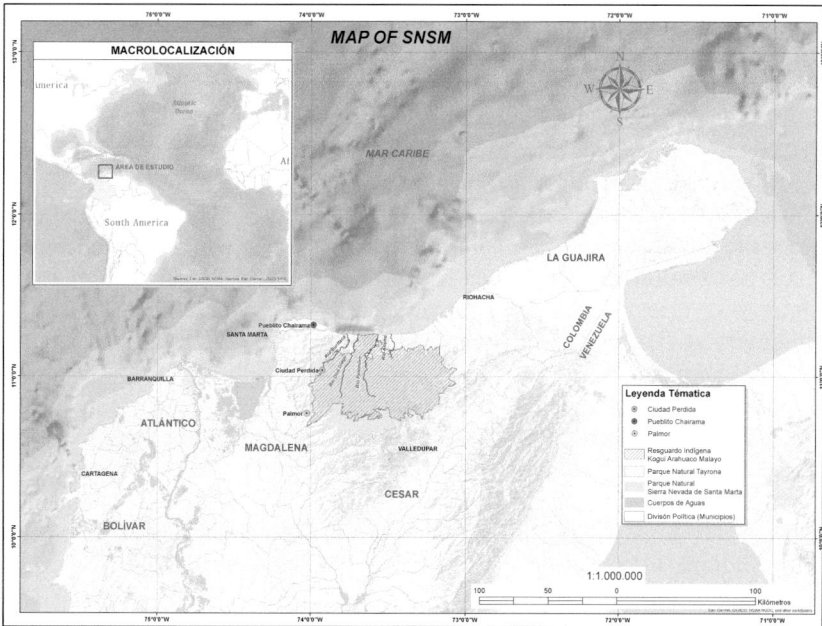

Figure 0.1 General map of northern Colombia with the areas mentioned in the book
Source: Map by the author, 2020.

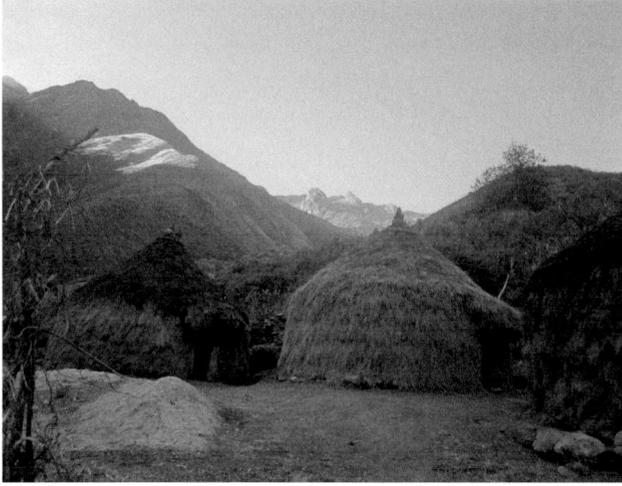

Figure 0.2 Makotama
Source: Photo by the author and Anghie Prado, 2017.

below, there are a few small slabs that resemble the great crags of Makotama. There, payments are made that are rituals where life is appreciated. As the *mamos*, culture connoisseurs, explain, upon the arrival of the conquerors these sacred places, called *ezuamas*, were destroyed. The few that remained were then looted. Until finally, the villas where the sacred rituals were performed became archaeological parks. So this book is an account of the process of recovering the sacred sites known as ezuamas. It is also an account of the role of archaeology in these processes of struggle of the Indigenous social movement. The ideas presented are based on the collaborative participation that I have had with the Indigenous social movement of the SNSM.

In particular, three organizations have allowed me to establish a dialogue. One is the Gonawindua Tayrona Organization (OGT thereafter), run by José de los Santos Sauna. The other organization is the Kogui community of Palmor with Francisco Gil's accompaniment. Finally, there is the Indigenous community of Taganga, with their highest dignitaries being David Cantillo and Ariel Daniels.

I present the regional case to the reader so that they can have an image of a complex internal process with various nuances, given that the examples cover a large area of South America. Since archaeology for almost a century has meant the destruction of sacred sites in the SNSM, the word archaeology does not accompany many of the efforts of the Indigenous partner movement to decolonize archaeology to produce a local history – Indigenous archaeology.

In much of Latin America, Indigenous people have been excluded from their territories and their memories. For much of the 19th century, the Colombian state invested resources to educate Indigenous people, which in

practice meant taking away their autonomy. As the Colombian state was configured as a Catholic state, various rulers thought it was better to leave Indigenous education to the church. This process was entirely an internal process of colonization; it means an endocolonialism. For this reason, when the first ethnological institutes were founded in Colombia in the 1940s, the students and professors of those institutes had to deal with a negative image of Indigenous cultures. Doing anthropological research involved a double task: helping Indigenous social movements in their mission of fighting the forces that advocated their disappearance, and doing research to understand local cultures, their worldviews, and their life expectations. In this case, this book is a summary of the organizational processes of the Kogui nation that inhabits various places in northern Colombia, and that has different historical backgrounds. Here we explore the recovery process of the sacred Teykú site that is traditionally known as Pueblito Chairama archaeological park.

In this process, I had participated at different levels and moments. This process involved various activities concerned with how to bring the voice of Indigenous communities to the academic settings of archaeology; and also to generate content, audiovisual and written, to spread the thinking of Indigenous communities. Likewise, to legally support claims for political recognition. Thus, this book is the narrative of that process that is related to others such as the political recognition of some clans, and the fight for the land in general.

In many of the political agendas of Indigenous social movements, archaeology is one of the fronts to attack, so in much of South America and Latin America the expression "decolonial archaeology" is used for practices where archaeologists support these political agendas. In many cases, this means fighting against the bureaucracies and archaeologists that do not want to forefront the Indigenous peoples' rights. In particular, the Indigenous people of northern Colombia are reluctant to accept positive evaluations of archaeology. In this context, the term "Indigenous archaeology" is used more for projects where Indigenous people are called to help interpret data. But these methodologies are questioned because they are not explicitly aimed at generating results for the agenda of the Indigenous social movement. As we will see, the main topic of the agenda is the recovery of some sacred sites used by the state as archaeological parks. In some cases, like this one, archaeology is more the obstacle and not the objective.

In this sense, this book is not a kind of attempt to use the philosophy of Indigenous people to interpret data or to make it more accessible to the public; on the contrary, it describes the agenda of the Indigenous social movement in northern Colombia that has had critical political achievements, as in the recovery of sacred sites, and legal and political recognition of some clans. In this agenda, fighting against archaeology and archaeologists has been a constant.

As the Kogui nation is so large, here in the book we mention only the main fieldwork scenarios: the first one is Teykú, the second Taganga Bay, and the third is the town of Palmor. Those are specific sites where it is possible to

appreciate different aspects of the relationship between political concerns and archaeological sites.

I was motivated to write this book by various Indigenous authorities (as we will see in the course of the book) mainly because it is necessary to know the problems that archaeology has been causing. For decades archaeologists have claimed that the sacred sites are pre-Hispanic garbage dumps. For decades archaeologists have said that today's Indigenous people have nothing to do with pre-Hispanic societies. With this background, it is possible to understand how problematic it is for the Indigenous social movement in northern Colombia to use the word archaeology in naming any of the items on their political agenda. Despite that, there is the borderland archaeology where Indigenous leaders and decolonial archaeologists find each other. This archaeology wants to rewrite history to show the deployment of colonialism for the domination of Indigenous people.

This book was originally planned in the early 2010s. On that occasion, a meeting was held at the Universidad del Magdalena, where several leaders of the Indigenous peoples of Northern Colombia attended. It was a clandestine meeting that allowed the spiritual leaders (mamos) to see what happened to their objects stored on the shelves of an archaeology deposit. There the mama told me that it was necessary to free some spirits that were in the prison of archaeology (Londoño 2012a).

Since this was a kind of commitment with some mamos, I dedicated myself to understanding what archaeologists called an archaeological site looked like from the Indigenous point of view. Only when I had understood this did I feel fit to write about it. To understand what it means to transform the history that has been woven about the Indigenous peoples of northern Colombia, it is necessary to know how they have been constructed as an object of study. Then we could hear some local voices and what they have to say about their sites. When Indigenous people talk about their sacred sites, this could be considered Indigenous archaeology, but in any case in northern Colombia, the concept is problematic. This requires an extensive discussion that I cannot exhaust in this book, and I am only interested in leaving some ideas that can be taken up.

The modern images of Kogui people were constructed mainly by American anthropologists and archaeologists; they were the first to generate reports on the Koguis and the archaeological sites in their territories. For me and some Indigenous leaders, it was even necessary to understand how anthropology had built northern Colombia as a research space. So, when I decided to get involved in the struggle of the Indigenous people of Sierra Nevada de Santa Marta, I localized myself as an archaeologist that could help to understand why and how archaeology had helped to destroy sacred places. As we could see during the book's planning, in northern Colombia, Indigenous archaeology could be more connected to the history of colonization by Europeans, so in that case, the main activity of that archaeology would be to understand the European way of thinking and its destructive ontology.

In 2014 I traveled from Santa Marta, Colombia, to Boston, in the United States, to visit the Baker Library at Harvard University. The idea of that trip was to know how the Magdalena region was constructed as an area of interest by US companies and the government itself. This data would be fascinating to share with several people who wanted to dispute the images created of the north of Colombia by foreign academics. It was autumn, and the cold was unbearable for a man adapted to the Caribbean. I reviewed the historic files of the United Fruit Company (UFC, hereafter), primarily photographs taken in Santa Marta and Magdalena in the first half of the 20th century. The file contains almost 11,000 photographs, with no accompanying documents. No one knows the fate of the reports that must have come with the photos. In this particular case, the images have to speak for themselves. I had previously requested an appointment to visit the archive, so once I arrived, I introduced myself, and a friendly staff member took me to the reading room. Before entering that room, I was delighted by the vast and bright lobby, which had an exhibition on the history of entrepreneurship in Boston. In the exhibit, I noted a repeated pattern: men dressed in elegant suits with collar and lapel, wielding canes. They only lacked brandy and cigars to fit the stereotype of the early 20th century industrialist. Having a slightly different reading of the presence of the UFC in Latin America, the meaning of these examples was at least problematic. So in that lobby, the idea that the struggle of the social movements in Latin America must prioritize changing the way they have been constructed by American anthropology became more understandable to me. And the UFC had been an essential part of constructing a historical background to Latin America.

In his recent book, *Hard Times*, Mario Vargas Llosa (2019) tells the story of the coup d'état against Guatemala's president Jacobo Árbenz in 1954. Árbenz had become a headache for the UFC because he intended an agrarian reform that would equitably distribute the land, thus undermining the power of landowners. Árbenz simply sought to hand over the land to the peasants to create a class of small landowners who would help modernize the country. This was unacceptable to the UFC for it would lose much of its economic power in the region. The UFC, with CIA support, orchestrated the move against Árbenz. The CIA portrayed Árbenz as a threat to the stability of the region because his policies would open the door to Soviet communism. The CIA sponsored paramilitary groups that eventually overthrew Árbenz, who went into exile with his family. In the following decade he fell prey to a smear campaign staged by the landowners, the business partners of the UFC. The campaign was so intense that it was rumored to have caused the suicide of his daughter Arabella Árbenz in Bogotá in 1965. The UFC did the same with northern Colombia's past; they gave financial aid and support to present the region as uninhabited but for just a few decadent Indigenous people (Londoño 2020).

I could see nothing worthy of the entrepreneurial spirit in the Baker Library exhibition. When I revisited the boxes with photos of Santa Marta,

the old houses built by the UFC in the Department of Magdalena in the Colombian Caribbean began to appear. The UFC was a modern company, and its hierarchical structure is reflected in the industrial landscape it helped to build. That landscape bears the imprint of the ideologies of modernity: efficiency and hierarchy. In the architectural repertoire left by the UFC in Colombia, the houses of the agricultural engineers and the administrative staff stand out; they are rectangular, with high gabled roofs. The buildings for essential services—health, education, and recreation—are also notable. The continuity of the architectural design of these tall buildings is evident: the hot air of the tropics rose to the top of the roofs and left via the mansards. The workers' buildings were large rectangular enclosures with gable roofs and mansards. I tried to match the buildings in the photos with my memories of the visits that I had made. There, I could see the remains of the banana company that once dominated the region and brought the wonders of modernity—such as ice, industrial fruit production, and proletarianization. The old casino is now the headquarters of the workers' cooperative of the current banana production companies. The cinema is still intact in the casino where the UFC showed the films it produced to generate favorable opinion in Latin America. There are the Seville-Prado casinos photographed after a fire; I also see the offices of the UFC in Ciénaga and a report on the construction progress of the port of Santa Marta in 1953. For that port to be built, the people of the old neighborhood of El Ancón were evicted (Bernal and Almanza 2004).

Most of the photographs I found were parts of reports sent to Boston to describe situations needing quick decisions in order not to affect industrial operations. The photos of peasant families settled by the railway tracks reveal the pauperization that was already growing at that time. Other photos of men posing with machetes point out the need to think about better and more efficient designs of this tool. There are also pictures of parts of tractors and trucks, which make me think of the entire operating chain needed to get the banana plantations underway. For those who captured the images of the machetes, the engines, the endless rows of banana clusters, local people, and everything that was recorded, all this was part of a system that could not be stopped. For the UFC, those people barely existed. In the revolts of the 1920s, the company did not hesitate to press the government for the execution of union leaders who opposed the extension of the proletarianization model imposed by the UFC (Archila 2009). In that decade, many Indigenous people were displaced from territories that would be used for banana plantations. And at the same time this period saw the first arrival of the archaeological missions from the USA.

After my visit to the Harvard library, I took a tour to New York City that I had seen advertised on a billboard in my hostel. I had no interest in doing the tour they offered (wax museum, Rockefeller tower, etc.). I just wanted to take advantage of a visit to the Metropolitan Museum and see the pre-Hispanic gold figures of Santa Marta. For me, it was important to recognize those

objects because, in many meetings with Indigenous leaders from northern Colombian it was made clear that a primary task on their agenda was the recovery of those objects that are considered living entities. The virtual catalog of the Metropolitan Museum shows 85 pieces associated with the word Tairona. Most pieces are not exhibited, especially those incomplete or with little artistic value, such as stone axes. In the Met, and even on eBay, Tairona refers to gold objects from the Santa Marta region and northern Colombia in general. The visit to the Met was enjoyable because it unveiled a worldview built from the privileged positions left by the colonialism of the United States in the 20th century. However, the representation of the Americas as a mosaic of cultures is not in the Met but in the National Museum of the American Indian, which I did not visit but whose website is illustrative in that regard: the word Tairona is related to the Andean nations. The museum, eager to show a harmonious vision of the native cultures of the Americas, confuses archaeological cultures with ethnic groups, and it manages to fulfill the dream of multiculturalism: a mosaic of cultures defined by discrete features suspended in a space and absent from conflict. In that website, Tairona pottery is described under the heading of the Art and History collections. The right panel of the mosaic "Infinity of Nations" has twelve options with ten geographical categories, an introduction, and a miscellaneous one called "Contemporary Art." If you click on that mosaic, you will be able to appreciate the diversity of America's cultures, from northern Canada to Patagonia. The Andean collections of this museum were donated by Gustav Heye, about whom the "Andes" link says that his passion for pre-Columbian objects came well before professional archaeologists became interested in northern South America. Heye is represented as a pioneer, as a founding father of the collection system of this national museum. Yet, Heye was not passionate about "pre-Columbian art"; better put, his passion was not disinterested nor did it occur in a vacuum of interests as the museum wants us to believe. Heye's subordinates, such as archaeologist Marshall H. Saville of Columbia University (Heye was a Columbia graduate), were involved in espionage and were in charge of reporting German movements in Latin America before the First World War (cf. Londoño 2020).

The first professional archaeologist who visited Santa Marta, John Alden Mason, was a spy who moved about in a governmental network that operated out of the UFC headquarters, from Central America to the Colombian Caribbean. He was one of the first archaeologists to establish contact with Indigenous Koguis and steal sacred objects. Although the revelations about the political past of Marshal H. Saville and John Alden Mason have been taken as mere anecdotes, the evidence shows that spy-archaeologists worked for a broader network that sought to generate two situations: first, to ensure that Latin America became a new frontier of the colonial expansion of the United States; and second, by organizing the local population to put it in the service of the business and production efforts of American companies—which translated into proletarianization and demographic aggregation. Neocolonial

expansion could not have occurred without an explanation of what was happening; that is, the UFC would not have been able to achieve its grip on Latin America without an understanding of the region. This exercise took place in the United States from a historical and cultural perspective; explaining who the barbarians were was a task of the growing research system, especially of the Latin America studies programs started in several universities. That was when characters such as Gustav Heye played a predominant role. They were responsible for creating a historical vision of Central America and the Caribbean. Heye may not have had a plan to "falsify" Latin American history; yet, his "passion" for "pre-Columbian art" allowed him to generate a positive assessment of extinct Indigenous societies, while bracketing contemporary populations and their political problems.

Thomas Patterson wrote in 1986—when it was not yet known that Saville and J. A. Mason were spies (Harris & Sadler 2003)—that the early excavations by Columbia University aimed to present the ancient Central American civilizations as great societies of artists, to make a contrast with contemporary rural and Indigenous populations who were presented as backward and ignorant (Patterson 1986). The UFC, in partnership with the Colombian state, sought the same effect with the Koguis, separating them from their sacred sites. With this, the UFC liberated territories and the Colombian state constructed citizens. The archaeology of the early 20th century in Central America and the Colombian Caribbean was carried out by individuals who had experience in espionage and worked for magnates like Heye, who wanted to form collections to decorate the museums of Boston, New York, and Los Angeles.

US policies towards Latin America's native communities were two-pronged: praising past societies' achievements while condemning contemporary peasant communities accused of being prone to communism. The great repressions of Caribbean peasants at the beginning of the 20th century were associated with the population control imposed by the UFC and local governments (Archila & Pardo 2001). US interventionism in Latin America did not operate in a conceptual vacuum: the region was theorized and subsequently subjected to intervention. Europe built the East (Said 1999); the United States built Latin America (Mignolo 1995). Development became the master trope for organizing and intervening in the region (Escobar 1998). Underdevelopment was to be overcome through industrialization, which could reduce rural populations in favor of urban centralization. In this process, many Kogui clans lost their territories and were displaced from their ancestral lands. Since underdevelopment was a transitional stage, the interim subject was the peasant—something to deal with. Yet, if the Latin American peasantry was an anomaly, what to say of the Indigenous people? They were considered well behind the developmental stage, worthy only of evangelization (Lander 2000). No wonder that by the end of World War II studies of the peasantry proliferated (Ospina & Tocancipá 2000). By that time US policies had achieved two goals: the idea of Latin America as a region in need of intervention to overcome

underdevelopment; and a version of history that presented pre-Hispanic societies as archetypes of civilized values: art and culture. Contemporary societies were doomed to be represented as second-class and expendable, always in need of education and basic services.

The construction of the Latin American peasantry as an object of developmental interventions, plus the naturalization of the idea that those peasants were unrelated to the monumental works recorded by the archaeologists (especially on the UFC's plantations), laid the foundations for the institutionalization of social sciences in Colombia. In the 1940s, when anthropology was institutionalized, archaeological sites began to be nominated according to the categories coined by American spy-archaeologists such as John Alden Mason (Londoño 2019a). Since the beginning of professional archaeology in the United States, one fundamental professional goal was to create a map of pre-European cultures, at least the civilized ones. The work of Gregory Mason and Marshall H. Saville helped to fill the void existing between the Peruvian and Central American records. Saville created the Tairona archaeological culture (Londoño 2019a) by considering that the villages and other archaeological sites found in northern Colombia belonged to the tribes defeated by the Spaniards. With this argument, Koguis clans were sentenced to be apart from the places that archaeologists stated to call Tairona archaeological sites. Academics used the Spanish chroniclers for this purpose, especially those written in the 18th century (Londoño 2019b). As Juan Nieves, a Kogui leader, says, archaeological research was a kind of bad practice that came with modernity. Archaeology was a kind of blending tool that allowed its practitioners to make historical ruptures.

In the 18th century, Father Julián's book *La Perla de América* [The pearl of the Americas] was published, portraying the Tairona as an ancient tribe of giants (Londoño 2019a). In that representative book, past populations are depicted as glorious and refined, condemning today's societies to be represented as backward and ignorant. The historical landscape we know today was structured by neocolonial dynamics. After returning from Boston, I had a couple of opportunities to share my Harvard experiences. José de los Santos Sauna, the highest authority of one of the Kogui organizations, told me that he had experienced the same thing in Berlin when he saw sacred Kogui objects in a museum. He was talking about the city's ethnographic museum that houses objects extracted by explorers in the early 20th century.

In South America, Gustav Heye is not seen as a defender of native cultures but as an entrepreneur who sought to colonize territories deemed vacant. Heye's passion led him to finance explorations in northern Colombia, such as that of Gregory Mason at the beginning of the 20th century (Londoño 2020). The archaeological sites he visited in the Sierra Nevada of Santa Marta (SNSM hereafter) were adjacent to large villages of Indigenous communities, such as the Kogui, although his reports convey the feeling that they were lost in time and space. Yet, Mason was surprised to find that Kogui authorities recognized every item he unearthed in his excavations, but he noted that they

were not the Tairona but the remains of that civilization; they had no relationship with the societies of the past, but were mere strangers—only useful to understand the archaeological record. Mason's report showed how the natives with whom he spoke regularly asked him to return the polished stones that he seemed to possess in large quantities and that he had been collecting on his journey through the SNSM.

Mason's report remained unquestioned for over a century. In archaeological courses in Colombian universities, his report is compulsorily consulted for its typologies, which help to categorize artifacts. No one questions the political activities of Mason, neither those of his predecessor, John Alden Mason. Yet, even a cursory analysis of their work and the political context of the time shows that they duly engaged with US expansionism. Those explorers, spies and archaeologists were the presenters of the oddities (Fabian 2014) needed to generate a coherent plan for US intervention in Latin America. That is the ugly truth. There is a telling picture of what Gregory Mason was (Zúñiga 2017: 37): a collector of rarities. In 1933 he made explorations in Honduras and ran into a fossil, one of the first found in Central America. He also encountered another oddity that caught his attention: the old revolver of William Walker, the American mercenary who became president of Nicaragua in the mid-19th century, and was defeated by a coalition of Central American armies and executed in 1860 as a threat to Central American stability (Acuña 2016).

The review of classic works, such as those of Gregory Mason, only began when meetings were undertaken in border areas—not only geographical peripheries but also epistemological and political borders. In 2010, after a couple of years of living in Santa Marta, I was invited by some Koguis authorities to make payments (*pagamentos*), a kind of ritual of great importance for the peoples of the SNSM, as I will show throughout the book. During the payments, I was asked to remember my last dream, to take it in my hand, and to bury it on a beach near the mouth of a creek. The previous night I had dreamed of the archaeological items curated in the Laboratory of Archaeology at the University of Magdalena, where I was teaching. The university had to show excellent facilities for the audits carried out by the Ministry of Education, so we worked hard so the Ministry would find a well-organized collection.

I dedicated myself to carrying and counting pottery vessels with my colleagues at the time, Alfonso Orjuela and the late Enrique Campo (RIP). It was only appropriate I should dream of pottery. During the payment, I said that I had dreamed of archaeological objects; some of the indigenes there told me that those spirits wanted to talk to me because they had something to say. It took me ten years to understand what it was that those objects had to tell me. This book is a result of that understanding: the spirits not only wanted to tell me something, but they also wanted me to speak about it. In this case, this book is not the result of a systematic process of a traditional investigation of cultural heritage studies that involved the voices of Indigenous peoples, nor

is it a translation of what Indigenous people think about what archaeologists do. The book is a kind of journey through the struggle that the Kogui nation has carried out to keep their culture alive. In this fight, I have participated in many ways, such as directing the first symposium between Indigenous people and archaeologists in some versions of the National Congress of Archaeology. Besides that, in the anthropology department at the Universidad del Magdalena I had coordinated several seminars on Indigenous archaeology; in those seminars, there were many critical Indigenous leaders as Cayetano Torres, Ramón Gil, Ariel Daniels, and Francisco Gil. These seminars were held to review how two centuries of the republic had attempted to erase a long-standing tradition. Immediately it began to become clear that it was necessary to configure a process of recovery of the sacred sites that decades ago began to be considered as archaeological parks. For at least a decade, I served as a resident archaeologist at the Universidad del Magdalena as a mediator with the state so that the claims of Indigenous communities regarding the return of sacred areas were taken into consideration. That happened at a moment when some in Colombia clearly felt that Indigenous social movements could have their own political agendas regarding their archaeological sites.

For this reason, I had the opportunity to support the recovery processes of sacred sites, especially in the SNSM. Since the return of a sacred area is a legal matter, the legal and technical aspects are not discussed in detail, mainly because it was a process developed by an NGO. However, this it is not a crucial aspect of the process since the Colombian legal system allows Indigenous people to handle national land because they are considered as ecological by nature.

The SNSM is a bastion of those spaces where the modern *cogito* has not managed to order the territory and the people. In these peripheries, the Cartesian dictum *Cogito ergo sum* fails because the Being is not associated with thought but with the territory. To be in the SNSM, you have to make payments, and to make payments, you have to live in the territory. Here *Cogito ergo sum* gives way to *Sedere ergo sum* (I am sitting; therefore, I am).

My trip into the SNSM was the continuation of several others. In 2007, when I arrived in Santa Marta, I had come from Argentina after working with Alejandro Haber in the Puna de Atacama. Alejandro's archaeology team was mainly composed of Ph.D. students who accompanied the organizational processes of the Coya community of Antofalla: Carolina Lema, Marcos Quesada and Enrique Moreno. Given that the struggle of Indigenous communities in Latin America is mainly based on repelling the dynamics of community disintegration imposed by the state, the dynamics in Argentina were similar to those I had witnessed years ago in the southwest of Colombia (Londoño 2002). In 1998 I started working with the Nasa on the recommendation of my archaeology professor, Cristóbal Gnecco. In the years before, Gnecco had begun to discuss the need to rethink archaeology, especially in a scenario of great cultural diversity such as the Department of Cauca (Gnecco 1994).

With this background—training in Latin American universities with the archaeologists who were decentering scientific agendas—I began my working life in Santa Marta in a territory characterized by its unique cultural and ecological diversity and its bloody and systematic conflict. In Santa Marta, I was able to think of an archaeology that was distanced from scientific purposes, still dominant in Colombia in the 1990s when young archaeologists were returning with Ph.D.'s from US universities.

In Santa Marta, my presence soon began to be contested by various Indigenous actors. This confrontation quickly led me to understand that we had imprisoned spirits (Londoño 2012a) and that the most sensible task was repatriation. Yet, there were problems in our way. Besides being a complicated legal process, repatriation implied a deconstruction of regional history that could only be done with decolonial theories. Consequently, the book narrates the dialogues that I have had with various people over a decade about the Indigenous agenda. The backbone of the Kogui nation's struggle is the total recovery of its territory to guarantee the preservation of life.

The book describes the tensions woven around so-called "cultural heritage" and points out how it is a part of the agendas of contemporary Indigenous movements—albeit with a different name and from a different ontology. Currently, for the Colombian case, at least, there are two options for doing archaeology. In the first, archaeology is done with traditional questions (when did the first humans arrive in the region, how did they become sedentary, and how did they generate hierarchical structures). The second option involves doing archaeology on the side of Indigenous social movements, and this book is a sample of that option and agenda.

The book was written sequentially, so reading the chapters separately is not a good idea for it risks missing the meaning of the reclaiming of Teykú by the Kogui (in some circumstances Kogui people accept the colonial nomination "Pueblito Chairama" for legal purposes, so I use the designation Teykú to highlight some aspects of the political agenda). Since in Colombia archaeological sites are supposed to be state-owned, the reclaiming of Pueblito Chairama is a paradigmatic landmark of what is happening concerning archaeological sites and Indigenous peoples in northern Colombia. As we can see in this case, there is an almost irreconcilable tension between the eagerness of the tourism market for pre-Hispanic villages and the efforts of the Indigenous social movements to link these villages to their identity projects.

After the Colombian government's recognition of the sacred character of Pueblito Chairama (in 2018), the controversy has not ceased. I have structured the chapters so that the reader gets an idea of how the sacred sites of the Indigenous SNSM were constructed as archaeological sites. In this way, the reader can understand how the agenda of the Indigenous peoples of northern Colombia involves contesting and controversializing these constructions. As several Indigenous leaders say, it is necessary to de-archaeologize the sacred sites. And what we now believe, with some other leaders, is that it

is necesary to reclaim their history through decolonial archaeology or from Indigenous archaeology.

The book is divided into five chapters. Chapter 1 gives the reader a general idea of the Kogui nation, their location, and their main cultural elements. All the information presented in the chapter has been validated by the Kogui political organization. The chapter seeks to emphasize what it means to think from the perspective of the ontology of the Koguis.

Even linguistic elements are used to familiarize us with the ways of being and living of the Koguis. Chapter 2 shows how the Kogis were formed as a tribe of newcomers who arrived in the territory in the 18th century. This image was added to the idea that the Tairona tribe had built several sites that were on Kogui lands. Understanding how that breakup was generated is critical to understanding the logic of the Kogui nation's agenda. This agenda declares that the Koguis, and not an ancient and mysterious tribe, are responsible for the construction of those several pre-Columbian villages. Chapter 3 describes how the recovery process of Pueblito Chairama took place, and how the process of raising awareness among citizens that the area was not an archaeological park, but a sacred site, began. Chapter 4 provides elements that help explain the function of sacred places within the Kogui culture. Many of these places are known as ezuamas and are places where libations and other rituals take place. These sites are decisive for the reproduction of society and territory. Finally, Chapter 5 describes the contemporary situation. After some Kogui clans have been accepted to control certain areas, criticism of these empowerment projects has begun to mount. The chapter reviews this situation.

References

Acuña, V. (2016). *Centroamérica: filibusteros, estados, imperios y memorias*. Vol. 1. Costa Rica. Editorial Costa Rica.

Archila, M. (2009). *Bananeras: huelga y masacre 80 años*. Bogotá, Colombia. Universidad Nacional de Colombia.

Archila, M. & Pardo, M. (2001). Movimientos sociales, estado y democracia en Colombia. *Pensamiento y Cultura*, vol. 4. Colombia, pp. 255–257.

Bernal, A. & Almanza, R. (2004). El Ancón: una identidad reterritorial en las fiestas de la Virgen del Carmen en la bahía de Santa Marta. *Jangwa Pana*, vol. 4, no. 1. Colombia, pp. 98–99. DOI: https://doi.org/10.21676/16574923.627

Escobar, A. (1998). *La invención del Tercer Mundo: construcción y deconstrucción del desarrollo*. Colombia. Norma.

Fabian, J. (2014). *Time and the other: how anthropology makes its object*. United States. Columbia University Press.

Gnecco, C. (1994). El mapa, el territorio: la arqueología colombiana al final del siglo XX. *Virola*, vol. 1. Colombia, pp. 65–70.

Harris, C. & Sadler, L. (2003). *The archaeologist was a spy: Sylvanus G. Morley and the office of naval intelligence*. United States. University of New Mexico Press.

Lander, E. (2000). *Ciencias sociales: saberes coloniales y eurocéntricos*. Buenos Aires, Argentina. Clacso.

Londoño, W. (2002). *Arqueología y política cultural en una comunidad nasa en el suroccidente de Colombia.* Bogotá, Colombia. Universidad de los Andes.

Londoño, W. (2012a). Espíritus en prisión: una etnografía del Museo Nacional de Colombia. *Chungura (Arica)*, vol. 44, no. 4. Chile, pp. 733–745. DOI: https://dx.doi.org/10.4067/S0717-73562012000400013

Londoño, W. (2012b). Fausto Ignorado: una etnografía sobre la construcción e ignorancia de la modernidad en la Puna de Atacama (Doctoral thesis). Universidad Nacional de Catamarca, Facultad de Humanidades.

Londoño, W. (2019a). El "nicho del salvaje" en las formas de alteridad de la Sierra Nevada de Santa Marta. *Jangwa Pana*, vol. 18, no. 3. Colombia, pp. 519–537. DOI: https://doi.org/10.21676/16574923.3270

Londoño, W. (2019b). Santa Marta la ciudad blanca: memoria y olvido en la configuración espacial de los hitos patrimoniales de la ciudad. *Confluenze: Rivista di Studi Iberoamericani*, vol. 11, no. 2. Italy, pp. 34–60. DOI: https://doi.org/10.6092/issn.2036-0967/10266

Londoño, W. (2020). Archaeologists, bananas, and spies. *Arqueología Iberoamericana*, vol. 45, pp. 11–21.

Mignolo, W. (1995). Occidentalización, imperialismo, globalización: herencias coloniales y teorías postcoloniales. *Revista Iberoamericana*, vol. 61, no. 170, pp. 27–40. DOI: https://doi.org/10.5195/reviberoamer.1995.6392

Ospina, G. & Tocancipá, J. (2000). Los estudios sobre la alta montaña ecuatorial en Colombia. *Revista Colombiana de Antropología*, vol. 36. Colombia, pp. 180–207.

Patterson, T. (1986). The last sixty years: toward a social history of Americanist archaeology in the United States. *American Anthropologist*, vol. 88, no. 1. United States, pp. 7–26.

Said, E. (1999). *Orientalismo.* Madrid, España. Siglo XXI.

Vargas Llosa, M. (2019). *Tiempos recios.* Bogotá. Editorial Alfaguara.

Zúñiga, L. (2017). Evidencia fósil de dinosaurios: un aporte a la historia de la paleontología en Centroamérica. *Revista Ciencia y Tecnología*, no. 20. Costa Rica, pp. 29–49. DOI: https://doi.org/10.5377/rct.v0i20.5494

1 The Kogui, an endless tradition

Some notes about the Kogui and their culture

The Kogui are one of the four nations of the SNSM. The other three are the Arhuaco, the Wiwa, and the Kankuamo. The languages of all four belong to the Macro-Chibcha, a group of languages that share a common ancestor, found from Honduras to Ecuador, including Venezuela and Colombia. Linguistic studies have shown that the Arhuaco and Kogui languages come from a common ancestor, and that from the Arhuaco originated the Damana of the current Arhuaco, and the Kankuamo, now extinct (Constenla 1991). Kankuamo and Arhuaco are located mainly in the east; the Wiwa in the north, and the Kogui in the north and southwest. The Kogui are endogamic, with matrimonial rules among two clans, Duxe and Take, the former being matrilineal and the latter patrilineal (Pérez 1995). A member of the Duxe clan must find a marriage partner from the Take clan; in most cases the couple's residence is patrilocal. This implies high mobility in the territory since the couple has relations with the clan of origin and the clan of residence. The Kogui have an expanded notion of the territory; touring the territory means strengthening family relationships. This high circulation has been interpreted as a lack of community cohesion. During the 19th and 20th centuries large clan movements were reported, from one territory to another, mainly due to factors associated with state violence; internal migrations were then added to normal mobility, which was read, by a particular classical anthropological literature, as a lack of consistency (Reichel-Dolmatoff 1953). The Kogui from the hydrographic basins of Ciénaga recognize that their settlements date from the end of the 19th century after police intrusions displaced them into their territories (Francisco Gil, personal communication). The archaeologists have interpreted 18th-century reports of displacements as discontinuity between the populations that inhabited the territory at the time of Spanish arrival at the beginning of the 16th century and current communities (Oyuela 1986). Some anthropologists maintain that Wiwa and Arhuaco communities, located in the lower parts of the SNSM, are mostly defensive, while the Kogui, located upon the mountain massif, preserve the laws of the universe (Gómez 2015). For Wiwa mamos such as Ramón Gil,

the four nations of the SNSM are like the four legs of a table; the Kankuamo is the weakest leg because it has suffered the most in defending its way of life. We should also mention the Tagangueros (from Taganga), which are fishermen clans associated with northern Kogui clans. They have recently gained state recognition as an ethnic community, yet are entirely invisible in the region's ethnographic literature. Despite this, the Indigenous council of Taganga managed to be included in the list of Indigenous authorities in Colombia.

This process has been led by Ariel Daniels, Mayor of the Cabildo, and the community leader David Cantillo. Taganga is an essential point within the Koguis ontology because it is recognized as the gateway to the territory.

Since the Kogui nation is large and extensive, political leaders do not recognize Tagangueros as Koguis, although the great mamos are aware of the blood ties that unite them. Let us talk about the Kogui ontology.

The worldview of the Kogui is based on a system of similarities or analogies (Gómez 2015). Despite being different from plants, animals, or things, human beings belong to the same group; this is expressed in language; for example the lexema *hu* has been translated as an idea of "home"; yet, it also means something "round" (*hu-ingaze*) or, as an adverb, "together" (*hu-ini*). The lexeme can also be a verb, *hu-luni*, "come into the house." House is *hu-i* and *hu-lene* is the gate of the house; then, many things belong to the group of things that count on this lexeme, including round things, the acts of joining a group and the action of entering the house. The Kogui language has several types of lexeme: nouns, qualifiers, adverbials, and verbals (Ortíz Ricaurte 2000:765); it also has nominal classifiers, prefixes that give meaning to words. For example, *kala* is "elongated", so that *kasa-kala* is ankle (*kasa* is foot and *kala* pulling, elongated). Rain is "elongated water": *ni-kala*. *Hu-kala* is a house roof. And so on. The episteme of similarities is also expressed in some word forms such as compound names. For example, a golden figure used for a payment is *niuba-kaggabe*, which means gold-people (*kaggabe* is used to refer to human beings). During many workshops led by Indigenous political organizations, it became clear that archaeologists had misunderstood everything. For example, since the arrival of J. A. Mason gold was believed to be a feature of the political distinction of past societies; however, it is now clear that gold is a material to pay fathers and mothers for human life. In a workshop where we discussed sums with Amado Villafaña, an Arhuaco filmmaker, it was understood that gold was of broad access since it was almost obligatory for people to pay with figures made from this metal.

The reader familiar with contemporary social science literature may note that the system of similarities in Amerindian communities is similar to what Michel Foucault (1999) called the system of the similarities of the 16th-century episteme in France. Although Foucault did not even consider the existence of this episteme outside Europe, the fact is that, in Amerindian communities and other parts of the world, this system exists, and coexists with the hegemony of modern thought. In these ontologies, to use the notion popularized by Descola

(2013), and as Foucault assumed, some marks of nature must be read by selected individuals. That is why Foucault spoke of *interpretatio naturae* as the art of deciphering the messages that nature had in store for human beings. The person entrusted to read these messages was the polymath, and from there emerged the "legends," the readings that the polymath can make of the world. In its original meaning, the legend is not something of a mythical order, but something that can be read by the polymath.

One morning in 2018, I was on the main square of the University of Magdalena. I was about to listen to a talk delivered by Ramón Gil, a Wiwa authority. Ramón has been a central figure for the SNSM communities, especially since Indigenous social movements begin to form there in the 1980s. He is one of the most respected authorities of the SNSM and represents one of the most prestigious Wiwa lineages because of his emblematic figure and assertive voice. Before the talk I greeted him, and he responded, as always, swiftly and told me that he had been trying to break down the word "baptism" to understand what made up the act of baptizing and how that composition was expressed in the language. I told him that, unfortunately, Spanish is not composed of lexemes, and that the closest thing were our syllables, but they alone say nothing. So, in a way, he concluded, "baptizing" meant nothing.

For the nations of the SNSM, the world is made up of interconnections between things and humans, which the mamos can read. The mamos are the polymaths of the SNSM. Such an interconnection must be maintained continuously and fed using payments. In their cosmology *jabas* and *jates* left places with markers showing where humans can make payments to them for the water, sun, animals, positive energies, and the like that they bestowed upon them. Payments are made with *tumas*, small polished quartz beads; each clan and each place has its particular type of tuma. The reproduction of society entails each person making payments with tumas and other paraphernalia for what they have received, such as the air or water, pottery vessels or mochilas, health and family. If payments are not made, the beings that feed on the lack of payments increase their power and gain ground, because what they want is to separate the clans and break the families. Colonial authorities since the 16th century prevented payments, so the clans were no longer able to feed the connections that keep the world in balance. The SNSM nations are currently striving to reverse this situation by reclaiming their territory and, to some extent, the tumas that were dispersed among countless museums worldwide, stolen by the archaeologists.

For decades, archaeologists have been destroying ezuamas. Since in ezuamas they used to have ceramic vessels in which polished stones were deposited, many payment sites were classified as mere dumps with the remains of polished stones. So, a significant part of the energy that the Indigenous social movements invest in their cause is oriented to preventing archaeological work.

Organization of the visible and non-visible worlds among the Kogui

The following description of Kogui philosophy is the result of several conversations over almost ten years that I have had with the Kogui, Wiwa and Arhuaco. Among these, I should highlight Francisco Gil, a Kogui academic; Amado Villafaña, the great Arhuaco documentary filmmaker; Ramón Gil, the great wiwa mamo; and José de los Santos Sauna, highest authority of OGT. However, I will use as a reference the book *Shikwakala: El Crujido de la Madre Tierra* (Mestre & Rawitscher 2018), published by OGT and the Kogui-Malayo-Arhuaco reservation; it has no single author, and it was produced using collaborative methodologies tethered to auto-ethnographies. This book is iconic because it was produced as a Kogui response to the representations that anthropologists have made of them for more than a century. Although it hides internal tensions, I stress the points of agreement. The research that led to the book involved tours of the territory and several interviews with Kogui mamos, especially those living in the northern basins of the SNSM. We must remember that access to the upper basins of the Kogi clans has been restricted since the H1N1 pandemic in 2009. Now with the Covid-19 pandemic, access really is impossible and also dangerous for communities.

Unlike other contexts and actors, few dialogic methodologies have been tried with the Kogui. The criticisms of the classic ethnographies on the Kogui did not denounce the abuses of unilateral descriptions but demonstrated the problems of ethnography as a form of literature (e.g. Orrantia 2002). That is, criticism was oriented to review the text's problems, not the political dimensions that produced the dynamics of subjection exercised upon the Kogui. Revisionist ethnographies of the early 2000s presented the Kogui as manufacturers of genealogies that operated within a concept of tradition as something "flexible that adapts to new situations" (Orrantia 2002:55); they presented the Kogui and their attempts at organization as multicultural opportunism, not as a struggle against colonialism. For now, it is evident, within the different sectors of the Indigenous peoples of the SNSM, that ethnographic representation must be controlled and operated from within the social movement.

As the Kogui authorities such as Governor José Santos Sauna point out, with books such as *Shikwakala*, the Kogui cease to be objects of study and become part of a conversation with the Western world. For the last two decades, through their various organizational processes, the Kogui have generated their own ethnographic characterizations and are beginning to make their own historical inquiries and documentaries. This has been done to prove how wrong anthropologists (and archaeologists) were, especially regarding their cultural depth.

The Kogui call themselves Kággaba (Mestre & Rawitscher 2018:27). In some Indigenous reservations, this Kogui notion is used to refer to this nation, distinguished not only by its language but by its kinship rules. For them, the

SNSM is Gwinendua, "everything that joins" (Mestre & Rawitscher 2018:27). The highest hill of the SNSM, Gonawindúa, is topped by Gwinendua. When the mamos, religious and political authorities, talk about this mythical relationship, the metaphor they use indicates that Gwinendua is like the hat they wear, the *namanto*. Gwinendua is the confluence of all the points that connect the world, so the Kogui believe that SNSM is the heart of the planet. There is an equivalence between the Kogui principle of unity of the points that make up the world, and the geometric idea that, in a sphere, all points are equidistant from center.

Using that simile, the SNSM is the center of the world, a point of confluence, because it is from that point that the whole is perceived. The Kogui are aware that not all human beings can see these relationships between different fields and between different beings, so their philosophy is projected with a moral tone. The practice of this philosophy has gone against the dynamics of capitalism, which seek maximization in production; on the contrary, the Kogui have demanded, concerning the tourist exploitation that occurs in the Colombian Caribbean, to consider the territory as a living being that must rest; this political agency has led to the temporarily closure of the PNNT and other spaces, such as "Ciudad Perdida" (the "Lost City"). These measures should be understood, not as whims of Indigenous people, but as practices of defuturing—which, in the terms of philosopher Anthony Fry (1999), are the conditions for transcending the Anthropocene era. For the Kogui agenda the challenge is to halt the vision of the earth as a resource, in order to heal the territory. Santos Sauna told me, in his OGT office, that their land management projects were intended to allow water to flow again in the creeks, so the birds can sing because they have water to drink. Santos Sauna was thus speaking of defuturing, because when one thinks of the future as being about the birds singing again, it ceases to be the projection of a radical transformation and becomes a space for reassembling anew. In this sense, the Kogui defuturing projects will be the realization of the communal (in the sense of Escobar 2016), a movement that re-establishes life in the territories, allowing the river basins to be reforested, and the forests everywhere to grow back. Those projects are not about making agriculture a monocrop production.

The Kogui territory is delimited by *jaba* Séshizha, the "Black Line." It is a line because *jaba* Séshizha is composed of points, the places for payments, defined by their function—since particular payments are made in each place. There are places to make payments for the elements, such as air and water; there are others to make payments for family and health. Before the end of his term, President Juan Manuel Santos (2010–2018) recognized such a territory as a place for the practice of Indigenous religions, without compromising the private ownership of specific areas. This is one of the oxymorons of contemporary capitalism. However, Santos' policy has had a positive impact on the political agenda of local communities for it has so far acceded to the demands of the Indigenous nations of the SNSM to be consulted regarding

all development projects along the "Black Line." This has not been a conflict-free issue, since these territories are in areas of high tourist demand. In any case, the struggle for the territory of *jaba* Séshizha continues.

The word Séshizha is made up of *sesun*, night, and *ñuizun*, day (Mestre & Rawitscher 2018:31). In the Kogui world, Sé is what provides the order of everything, and within this invisible order that is Séshizha there is a visible reflection called *mamo Sushí*, a sort of map of the order of the world, linked to the Séshizha universe. Sushí is like a person who, at the same time, is the universe "and contains information codes for the management of the land and the SNSM and that is engraved in stone and other sacred objects" (Mestre & Rawitscher 2018:31). Although petroglyphs in the SNSM are scant, the "Donama Stone" near Santa Marta is a Sushí (Mestre & Rawitscher 2018:31). Particular outcrops with large boulders are considered mamo Sushí, visible signs of Séshizha. Before Séshizha, there is Aluna, and then mamo Sushí. Then comes Pankatza, which expresses an order of things, plants, and animals; it indicates the ordered distribution of the territory between towns and clans. The mamos Kogui says that Pankatza was represented in pottery and gold items; for that reason they were destroyed by the Spaniards, by *guaqueros*, and by the archaeologists. Some rocks and tumas are Aluna; yet, they are not representations of Aluna but contain it and therefore are part of it. The payments to the *jates* and *jabas*, owners of things (such as animals, plants, or knowledge), are made with tumas. Each clan has it place assigned with Sushí, called ezuama, where it must make payments with the corresponding tuma, according to the function of the site. For example, in the case of the owners of water, whether rivers or underground channels, the Ñikwitti tuma (the tuma of water) is used. The essential *jates* are Siugkukwi, the father of birds; Sezhánkua, the father of order and land management; Sintana, the father of thought; Kulchabita, the father of wisdom and seeds; Aluamiko, the father of animals; Mulkweke, the father of authorities and governance; Dugunabi, the father of the arts and objects to rule; and Matuna, the father of songs and music. Likewise, the essential *jabas* are Seiatakan, the mother of stones; Kankeka, the mother of knowledge of land types and clay pots; Kunchaiuman, the mother of the eye and vision; Alueiuban, the mother of red and menstruation; Kasuma, the mother of water; Kwan, the mother of life; and Zaldsiuman, the mother of marine elements (Mestre & Rawitscher 2018:45–63).

At the beginning of the 2010s, a Kogui leader, then a medical student at the University of Magdalena, visited me in my office to talk about the concerns of several Wiwa, Kogui and Arhuaco mamos, who were to meet at the Indigenous House, the headquarters of OGT, in Santa Marta. At that time, I did not quite understand what it meant to have boxes and boxes full of tumas in a deposit within the university. We agreed that the mamos would come to the university to visit the collection. One day, I received a text message on my cell phone, saying, "they are here." I took a taxi to the Indigenous House, where the mamos had gathered. As it was not a meeting planned for me to

participate in, my hosts simply introduced themselves hastily and asked if they could see the collection. We called five taxis and left for the University of Magdalena, some 20 people. It was a Saturday afternoon, and the campus was starting to look empty. At the entrance gate, the guards asked me why I wanted to let in a group of not so neat people, with long hair and dirty clothes, with stained teeth and lost eyes. The only thing I said was that they were the owners of the SNSM. The guards let us in. We walked the long distance between the entrance gate and the ceramics collection, the mamos talking and laughing. We passed a three-meter-high statue that represents an Indigene from the SNSM; I noticed that they were looking at it and laughing. At the ceramics deposit (Figure 1.1) mamo Ramón Gil, the highest living authority of the Wiwa, questioned me about the tumas. He told me that they had to sow water because people had forgotten to make payments to the owners of water. He held some tumas in his hands, and then the mamos left, restless. With hindsight, I think that they saw, in those boxes full of tumas, the savagery of modernity that through archaeology had destroyed the sanctuaries of the SNSM. The archaeologists, showing no respect, plundered the tumas and stored them in deposits, imprisoning the spirits of the clans (Londoño 2012).

The Kogui call ezuamas the sacred places where connection with the principles of creation may occur; they are, consequently, the visible signs of Séshizha. Each ezuama must be handled with payments and visits regulated by the mamos. Since many ezuama have tumas as payments, they have always been a favorite destination of looters and archaeologists. In the ezuamas, there are clay pots with information related to mamo Sushí. The Kogui have identified in the Gold Museum in Bogotá pottery vessels with mamo Sushí

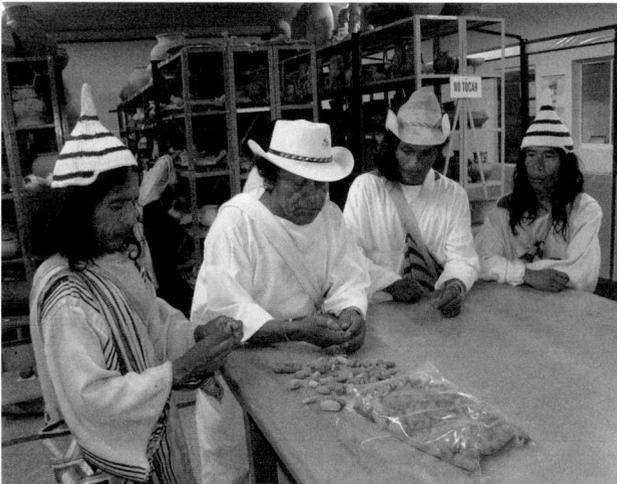

Figure 1.1 Ramón Gil and other mamos at the University of Magdalena
Source: Photo by the author, 2012.

codes. These concentric circles unfold from a center representing the ceremonial masks that allow connecting with different beings, making the necessary libations to maintain the order of the universe, including the social order. Some of those beings are Jisé Wake, father of the dead, who is paid for the negativity of nature; mamo Subaldsi, who is paid for everything that is inside the earth; Mezhajuí, father of food, insects and fruits; mamo Wake, the father of the sun, whose energy serves to breathe movement into nature; mamo Sugldsi, father of authority; Nabukáka, father of felines; Nansawi, father of snow, fog, and social behavior; Waju Wake, father of the birds; and Kagldulda Seshi, the earth. The Kogui see their territory as a sort of canvas alive with ezuamas.

According to the Kogui, their role in the world is to maintain order, which is achieved by the work done in the ezuamas. This task has been assigned to them by *jaba* Sé, the Mother of Origin (Mestre & Rawitscher 2018:27). They make the necessary arrangements so that the appropriate tumas rest in the corresponding ezuama. The alteration of the ezuamas is a severe fault because it breaks the commitments that humans have with the superior beings and with the clans themselves since each clan has been assigned a specific tuma. For many Indigenous authorities of the SNSM the drought that nowadays hits the region, plus the imminent death of coral reefs and the chaos generated by coal exploitation, drug trafficking and unchecked tourism, result from the alteration of the equilibria that are maintained through the payments made with tumas.

According to Descola (2013), Amerindian cultures practice analogic and animistic ontologies; for him, a typology of ontologies must take into account four attributes, divided into two large pairs of similarities and differences. In totemic ontologies, for example, a being belonging to a group must possess inner and physical similarities. In this ontology, culture and nature are separate. Animistic ontologies, on the other hand, assume that beings may have inner similarities and physical differences in order to belong to the same group. The counterpart of animism is naturalism, for which inner differences are prominent, although there are physical similarities; human beings, despite being similar to other animals, are different because of their symbolic capabilities. This is why Clifford Geertz (1973) pointed out that anthropology is the study of culture, the producer of differences, conceived as something external to human beings and encompassed by the idea of extrinsic symbols. In analogic ontologies, the beings belonging to the same group may be different, both inside and physically: a rock can belong to the same group as humans (Descola 1992, 2013). Kogui ontology is analogic: the world of humans is a pole of the real world, the world of the owners of things. When they look down at a mountain top, they see the top of a world that unfolds a world underneath. On the surface of the landscape lie some marks, signs, "legends" that announce the forces of creation that are concentrated and materialized in the territory. The large slabs scattered throughout the SNSM (Figure 1.2) are transition sites between the real world and this one that is its

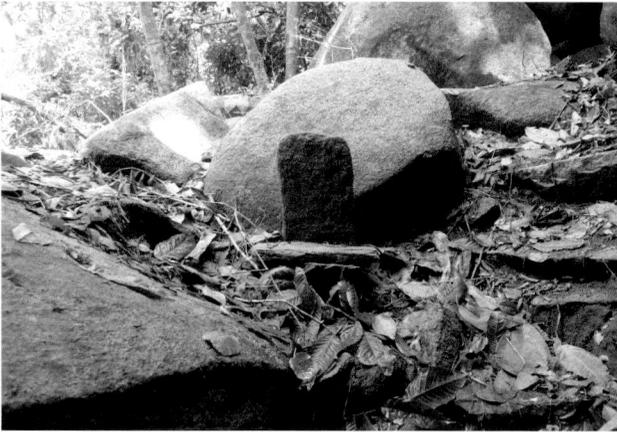

Figure 1.2 An ezuama in the PNNT
Source: Photo by the author, 2009.

projection. The Kogui are aware that there are territories, such as those located to the south of the SNSM, nowadays privately owned, that contain ancient villages with old ezuamas.

The knowledge of the Law of Origin, Sé, is Shibulama, which begins with Shi, "the conductive thread that weaves the infinite integrality of the Universe and connects with everything that exists in nature" (Mestre & Rawitscher 2018:41). In analogical ontologies, the fundamental task is the work of connection between the various beings that make up the universe. Among the Kogui, especially among men, knowledge is measured by the distances that have been traveled visiting ezuamas and mamos in a continuous process of knowledge. This has been a bit easier for the Kogui, who retreated to sacred sites far from the colonizers, such as Makotama, to the north of the SNSN and 2,000 meters above sea level. Makotama is not only the passage to the Guatapurí river valley, where the city of Valledupar now stands, but also where the sacred Kogui masks are produced and used, the very masks so desired by museums in Europe and the United States at the beginning of the 20th century.

The arrival of the Europeans in the 16th century started a wave of territorial control and plundering that has not yet ended, and that has sought to break the relations established under the principles of Sé. For the Kogui, the archaeological discourse positing that they, as an ethnic group, are an 18th-century construction (Oyuela 1986), is insulting. On the contrary, they are aware of a continuity that goes beyond the historical breakup produced by the Spanish conquest. They do not distinguish between 16th-century colonialism, 19th-century endocolonialism (at the origin of the Colombian state), and the new coloniality brought about by oil exploitation and mass tourism (Korstanje 2012). The Kogui assume that their governance and their autonomy are determined by their ability to perform the rituals necessary to

maintain the equilibrium of the world. For this reason, they demand the immediate return of the tumas, pottery vessels and gold objects plundered from the ezuamas by guaqueros and archaeologists

In short, what is desired is the repatriation of objects, and not a dialogue between archaeologists and Indigenous people to produce better interpretations. Nor is it a question of sites and objects being considered as heritage; it is about preserving political autonomy and giving it the place that sacred sites deserve

Regarding the origin of the whole, the Kogui believe that it was generated from Aluna Sé, from which Sé Jaba emerged, which can be thought of as a feminine essence from which the threads are born, the *shi* with which Séshizha is made, the design that sustains the world. Certain ezuamas are spaces to perceive the network that connects with the networks, producing an interconnected and related world. This is a theory of relationality, also extant in Andean animist societies (Haber 2009). From this network of networks, drawn by Séshizha, emerges *jaba* Sénenuglan, "the Universal Mother." In a drawing included in Mestre & Rawitscher (2018:42), *Jaba* Sénenglan is depicted as a seated woman, full of marks in the shape of rounded grooves, whose feet sink into the sea. *Jaba* Sénenglan is similar to a woman, with the grooves carved in the Donama stone, all over her body, sitting on the seashore; her legs fade in the transition from the shore to the sea, like the rocks that form the bays of the SNSM. Punta Betín (Figure 1.3), where the Spaniards established defense batteries with cannons, is where the first fathers and mothers established the difference between sea and land.

In Figure 1.3's photograph, taken from El Morro (another sacred site known as Shibaldigeka), *jaba* Sé can be seen in the background, corresponding to the bay of the city of Santa Marta. *Jaba* Sé is the spiritual origin of things, the mother of mothers, the place of origin of Zhátukwa, the

Figure 1.3 Utakwindua, where land and sea were set apart
Source: Photo by the author, 2016.

consultation of the oracle of the law of origin made by the mamos. Utakwindua can also be seen in Figure 1.3, the stony point that protrudes from the sea; in front of it is a small island, Sangramena, a character who left the knowledge on the sanctification of sacred sites and people. Although Sangramena is a small place, it has connections with the main mountains and it is recognized as the place from where the world, as we know it, was designed.

The photo in Figure 1.3 was taken from the Santa Marta lighthouse; the ruins of the fort of El Morro, built by the Spaniards in the 18th century on Shibaldigeka, are also visible. This is a spatial palimpsest of different times, where colonialism left its marks. One of the most significant transformations occurred on *jaba* Sé: in the 1950s, a platform was built to allow large ships to approach the port to load bananas. A 1953 photo I saw at Harvard shows construction in progress. That photo represents the strength of the Americans' commercial spirit, while for the Kogui it represents an indelible mark on *jaba* Sé.

Jaba Sénenuglan is the origin of many other mothers, who created the air, the earth, the rocks, the minerals, the water, the sun, the mountains, rivers, plants and animals. Everything was organized through these subsidiary mothers, so all things have Aluna, which connects the threads of the Shi creation with Sénenuglan (Mestre & Rawitscher 2018:42). The mamos say that these principles are found in the placenta, the ancestral territory, the *mochila*, the clay pot, the *nujué*, and the *zhátukua* (Mestre & Rawitscher 2018:42). The *nujué* is a construction with vines and fiber roofs where men meet o deliberate. The nujué, as a fabric, connects with Shi as the threads that weave the whole. *Zhátukua* is the art of the mamos for connecting with that network of networks using a small container with water, on which some tumas are thrown; it is merely the reading of the "legend." From there, a message that the mamo reads allows him to make decisions that affect his community. There is an intrinsic connection between ezuamas, nujué, and zhátukua. If ezuama did not exist, there would be no nujué, and without it, there would be no divination, and without divination, there would be no culture. The conquerors knew this well: their first task was to prohibit local cults. Later, in the republic, that process was intensified; besides being banned, sacred sites were converted into archaeological areas, or private property, or both. In the case of SNSM, the process involved the loss of the Kankuamo language and harsh interventions upon the Wiwa and Arhuaco. As the mamos remember, Catholic priests forbade them to speak the language, make payments or fulfill traditional obligations, making them convert to Catholicism as quickly as possible. But that did not mean the collapse of Macro-Chibcha relational worlds that survived in ezuamas beyond the reach of colonialism.

In the Kogui world, as well as in other relational worlds—even within Europe (González-Ruibal 2014)—analogic systems still exist, so it is a violent act label non-modern ontological systems as museum antiques or missing epistemes. They are the other worlds that make up the pluriverse, and that hope to connect in order to allow the collapse of the Anthropocene

(Escobar 2018) and the emergence of the Ecozoic (Berry 2013). The Kogui thus live in a Postanthropocene period characterized by energy transitions and the end of capitalism. This vision is somehow official within Kogui communities, and it is presented in the context of a utopian society. No one wants to examine their internal tensions, the unequal redistribution of resources, or the health problems—high rates of infant mortality, alcoholism and domestic violence. There are even severe corruption accusations that compromise high Kogui authorities. However, there is a concerted effort to confront the vast forces impacting them, such as tourism companies that simply want to exploit the entire coastline of the SNSM. Although internal discussions are not the focus of this book, they are paramount in Kogui life, more so because there is a growing number of women who are being educated and claiming prominence in the political agenda.

Kogui territory is a large nujué that was made from Takankukwi, from where a thread was woven that gave structure and shape to the space. Without that first point, tantamount to the first stitch that a woman makes when knitting a mochila, it would have been impossible to make the world with its dimensions, distances and differences, as marked as those between day and night, the earth and the sea. The Kogui do not consider the day in opposition to the night, the land to the sea; they consider them as parts of something in oscillation that holds together what is apparently disjointed. From this organization, which resembles the way a mochila is woven, the four cardinal points emerged: Jaba Ñuimatan (where the sun rises), Jaba Mamoskwa (where the sun sets), Mamoishkaka (south) and Siashkaka (north). The fabric that makes up these cardinal points is recognized as Shikwakala, similar to the loom with which they make their blankets and clothes. They think that the world of their material culture is a simile of how space is organized through the starting point proposed by the Takankukwi theory. In this way, the world in which we can talk to the Kogui is a scale model of the universe's order. The mountains, especially Gonawindúa (the highest peak in the SNSM), are the locations of Takankukwi points or sites (Mestre & Rawitscher 2018:43). So, if their houses and tools are a simile of the world's ordering, their physical world must also be regulated by principles that are equivalent in the main world. Their rules are in the ezuamas that *jaba* Sénenuglan left; they also are in *jaba* Sé. According to this normative scheme, all things have an owner, to which payment should be made for their use. If I were to use animals for carrying cargo, I should make payments to the father of animals, *jate* Aluamiko, with the appropriate tumas. The Kogui, and other SNSM nations, even make payments to the fathers or mothers responsible for modern technology, such as cell phones or camcorders. Nothing can be left out of the network of networks, even things that are external to their world. In 2014, while we were making a documentary about the sacred sites in Santa Marta, Juan Mojica, Zeikú, a young Wiwa filmmaker, made the corresponding payments so that the project could be duly completed. No activity can be disconnected, and everything must be united to maintain the world's integrity.

Despite the consistency of this theory of relationality, things are not going well in some Kogui clans. In 2014 I directed the research of anthropologist María Paula Rivero in the Seywiaka community located in the Kogui–Arhuaco–Malayo reservation near the Macotama basin (Rivero Agudelo 2014). María Paula used to sell handicrafts on the crowded beach of El Rodadero to pay for her anthropology studies and knew Seywiaka families who had gone down there to beg. María Paula became friends with them because she often defended them from the police telling them not to sleep on the street. When she decided to work with them to assess this situation, she witnessed the death of a child she had met months before when she made her first visit to the community. The child had died from a respiratory infection, for which he received no medical attention. The event was devastating for María Paula and highlighted the problems faced by Indigenous communities, surrounded by the armed conflict and losing access to their territories, not only for cultivation but also for traveling through and establishing relations. The young people of Seywiaka had lost faith in their religion and no longer paid attention to their mamos. Seywiaka was going through a deep crisis, and the youngsters were simply leaving. On this issue, Santos Sauna pointed out that the Kogui are certainly vulnerable in terms of medical services and medical training. They do not oppose modern medicine, yet, like other rural populations in Colombia, they lack essential services.

The ezuamas most affected by colonialism are the places where payments to jaba Seiatakan, the mother of stones and metals, were made. In ancient times ezuama offerings were made with gold, which was subsequently stolen by conquerors, guaqueros and archaeologists. The most visible ezuamas are those of *jaba* Seiatakan because they have Jaksínkana, elongated stones that resemble columns. Jaksínkana coexist with Jatoke, rounded stones; the former are masculine and the latter feminine. The importance of these sites is that they evoke government, command, power, and respect; they are also thresholds that connect with the true worlds, of which ours, the one we share with the Kogui, is a similacrum. These sites also contain Jagsizha, ancient roads that connect the territory (Figure 1.4). The archaeologists and the guaqueros followed these roads hoping to find ancient settlements and ezuamas with objects.

The Kogui are aware of damage caused by site intervention, either by the plundering that occurred in the 16th century, by archaeology in the early 20th century, or by *guaquería* at the end of the 20th century. One of the pillars of the Kogui political agenda has been the detection of these sacred sites and their reclaimation through payments to the appropriate tumas. This has implied not only regaining authority over the sites but a process of political formation, offering young Kogui the opportunity to reconnect with their religious system. This, as will be seen in Chapter 3, was precisely what happened in the reclaiming of Teykú.

Just as the ezuamas related to *jaba* Seiatakan were affected by the archaeologists, the ezuamas for making payments to *jate* Dugunabi were also

Figure 1.4 The main street in Teykú
Source: Photo by the author, 2016.

impacted, for the sun dances involving ceremonial masks, well known in the ethnographic literature (Preuss 1927), took place there. These masks were reported since the 17th century as evidence of native idolatry. Following the colonial "extirpation of idolatries" (Tobón 1996), many ezuamas were destroyed for the control and monitoring of the territory. Those masks not destroyed were sent to the Vatican. At the beginning of the 20th century Konrad Theodore Preuss, a German ethnologist, took some masks to the collections that were being assembled in Berlin, and in the 1930s, the explorer Gregory Mason took a mask to the United States (see Chapter 2).

The Kogui world, full of *jates* and *jabas*, has negative counterparts, such as Due Nuanase, the father of negativities. Mamo Shibulata Zarabata comments that Nuanase was a Kogui authority that transformed into a tiger at night and went out to hunt mamos because he saw them as his competitors and enemies. The mythical story tells that after Nuanase, in the form of a tiger, made the killings he was responsible for making people believe that the person responsible was a Kogui. Mamo Shibulata says that Nuanase talked to people about the Kogui, without anyone knowing who they were, because the word had never been spoken before. On one occasion, Nuanase went out to hunt mamos in the shape of a tiger. While on the lookout for a victim, he crashed over a cliff; although he was an enemy of the mamos, one of them found him injured and took the trouble to heal him, leaving him in human form. From that mythical story comes the idea that to cure an animal, you have to make payments to Nuanase (Mestre & Rawitscher 2018:71). In Kogui cosmology, Nuanase or Sangramena have murky pasts. We have already seen what happened with Nuanase. Sangramena, the small island in front of Punta Betín (Figure 1.3), tried to seize the sacred spaces and, despite not achieving this, learned about how to handle them, and that is why he is remembered.

Besides Nuanase there is also Due Dibunshizha, the father of worry; Due Kagshindukua, the father of lies and deceit; Due Uldabangwi, the father of materialism; Due Kasougui, the father of damage to trees; A Kashkuama, the mother of plant diseases; Due Sankuishbuchi, the father of diseases; Due Zóngala, the principle of destructive fires; Due Zhantana, the principle that destroys and dries water; Nabobá, the mother of lagoons and negative rains; Wakamaia, a mother who damages crops; and Nu Jaldami, a mother who destroys the order of the ezuamas. The phenomenon by which the Kogui describe the destruction of sites by the archaeologists is called Un Jaldami (Mestre & Rawitscher 2018:82). It is hard to accept that an archaeological excavation, despite its academic purposes, ends up in the realm of Un Jaldami, whose only concern is altering ezuamas. So, from the Kogui point of view doing archaeological research is an activity of destroying sacred places.

As Juan Nieves, the Kogui authority of Teykú (Pueblito Chairama), comments, in the 2000s, archaeological investigations were reactivated at two important sites, Pueblito Chairama and Ciudad Perdida. In the case of the former, where Juan lives, an archaeologist and his team began to extract pieces, affecting the connections that had been established long ago. This worries Juan. The pottery vessels, emptied of tumas, look for sustenance and feed on other principles—such as those that dry out ravines, damage food and make animals and people sick. A performance by a Un Jaldami is not only taking place; in the actions of the archaeologists, the histories of Nuanase resonate.

Ramón Gil, amidst the hundreds of pieces curated in the archaeological deposit of the University of Magdalena, asked me what the meaning of accumulating pieces of the Indigenous people was if those pieces had no soul for the archaeologists. Ramón is always asking awkward questions. I replied that when the archaeologists find pottery vessels, they have something to say in their archaeology reports; they give them prestige because people are eager to hear about the oldest find or the most recent discovery. The archaeologists are motivated by the recognition of others. Ramón asked me if the archaeologists could not get prestige by means other than destroying ezuamas.

The struggle for persistence

The Kogui know that they have been the object of studies and interventions since the beginning of modernity. Many leaders currently reject the representations made of them, especially in the works of the anthropologists Theodor Konrad Preuss and Gerardo Reichel-Dolmatoff, and the archaeologist Augusto Oyuela, who in 1986 said that the Kogui had resulted from the rearrangements of various chiefdoms during the 18th century (Oyuela 1986). In several meetings, I have learnt that those three fellows were not authorized to write and say what they did about the Kogui. In particular, one thing that the Kogui resent the most is that the anthropologists hold that there is a break between the pre-Hispanic past (archaeology's object of study,

that is, archaeological ruins) and the ethnic present, their world, narrated by 20th-century ethnographies of mountain tribes. This break is perceived by several leaders, who say that the archaeologists "consider that their god is Reichel-Dolmatoff, who for the sake of writing books thinks he's got the right to steal things." Their annoyance was related to research conducted for a doctoral thesis at the University of Chicago (Giraldo 2010).

The comments that I will present below, part of the Kogui perspective of colonial history, are the result of my conversations with various leaders. They have also been the result of conversations with Francisco Gil, a teacher at a school located in the old settlements of Pocigueica, the first region conquered by the Spaniards. I was also able to construct this history thanks to conversations with Juan Nieves, a resident of the environs of Pueblito Chairama. Amado Villafaña, a famous Arhuaco documentary filmmaker, also gave me a local perspective on colonialism. Amado explained to me the violence that occurs when objects are taken from sacred sites and put in museums. This narrative is formed in the interstices when an academic like me tries to understand how the natives see the work of the archaeologists; this intentionality joins the interest of some subjects located in other ontological paths, the natives that I have named, who wish to communicate, to an academic, how they see academic practices and discourses. This is a narrative in the borderland (Anzaldúa 1987; Mignolo 2012). Gloria Anzaldúa wrote about the complexities of Chicano identities that were neither Mexican nor American, and that allowed one to elucidate a world from the borders. Mignolo (2012) added the concept of border epistemologies. In this context, many conversations occurred in the borderland created when the Kogui talk about how they see archaeology, and when an archaeologist moves beyond his disciplinary boundaries.

The Kogui are busy confronting hegemonic history, which portrays them as a recent invention resulting from colonial chaos, as defined by Oyuela (1986:42), according to whom "The 18th century marks the beginning of a new culture originated from the regrouping of Indigenous peoples from various regions and chiefdoms." This statement (which granted its author the means to promote his academic career and has been considered a starting point for regional historical understanding) is locally read as a daring speculation that delegitimizes and ignores a political agenda that has allowed Kogui cultural persistence through the centuries. As Santos Sauna pointed out, statements such as Oyuela's ignore the oral traditions that remember the atrocities committed against the Kogui since the beginning of the 16th century.

The portrayal of the Kogui as an 18th-century mixture of peoples has been complemented by the Global Heritage Fund (GHF hereafter), an international NGO that promotes the research, management, and conservation of archaeological sites. Adding to the idea of the Kogui as newcomers, the GHF published in its website (2019) that its field of action is focused on the archaeological ruins of a civilization that "mysteriously disappeared in the 16th century." The Kogui know that this purported rupture with their past

translates as saying that the ruins of villages full of ezuamas are simply archaeological sites. In this regard, it is up to the ethnographers to investigate current ethnicities and to the archaeologists to investigate the societies of the past. The practice of this NGO clearly follows the paths of cultural heritage management. The organization even gave some help to Indigenous and peasant communities in the region, improving particularly useful infrastructure for archaeological tourism.

What was not on the organization's agenda was understanding the demands for control of the site that various Indigenous leaders had been making for decades.

The way the Kogui read history differs substantially from the inventions of academics. At the arrival of the Spaniards, they had settlements along the western flank of the SNSM, from the north (by the mouth of San Salvador river) to the south (at the limits of the SNSM with the Ciénaga Grande de Santa Marta, CGSM hereafter). In pre-Hispanic times each territory was in equilibrium due to the payments made to *jabas* and *jates*, in addition to the proper relations with the Fathers and Mothers of contrary principles. The territory was duly interconnected through stone-paved roads and villages, important centers with materials containing Aluna. The roads, with their directions and names, allowed exchanges between clans, divided by two large groups, Tuxe and Dake. The payments were made by weaving relations between *jabas* and *jates* in the form of objects of gold, wood, and pottery. Funeral ceremonies were carried out using the territories for the bodies to rest in, mainly on the shores of coastal bays. The mamos performed ceremonial dances with sun masks in the nujué. This all ended when Spanish ships appeared on the horizon. The first clans to be affected were those of the bays of Gaira and Santa Marta, where the Spaniards began building houses and from where they attacked Pueblo Grande or Pueblo of Pocigueica. According to mamo Bernardo Simungama, the town was called Bunkuanezhaka (Mestre & Rawitscher 2018:169), popularly known as Pueblo Viejo, nowadays a tourist destination designed to ease the pressure on more famous sites such as Ciudad Perdida. This is where some NGOs from Santa Marta operate, investing in the conservation of the site with the money collected by archaeological field schools offered in the summer and which further epistemic violence: the old villages are still excavated and interfered with without consulting the spiritual authorities of the Kogui.

The arrival of the Spaniards at Bunkuanezhaka perhaps occurred at the end of June. The mamos were making a celebration with ceremonial masks and gold garments, while men armed with guns and horses ascended the basins of the creeks that feed the Frío Río river. The invasion started in the ezuama of Mokuaka. There the Spaniards tore people apart, stripped them of their belongings, and enslaved young men and women. This also happened in several more ezuamas, as in Inzhishaka and Guamaka, as a result of which the ezuama of Zhaika and Matugaka helped bury the dead (Mestre & Rawitscher 2018:168–169). Colonial records document the looting and

burning of villages in September 1529, in the vicinity of Indigenous villages near the CGSM (Friede 1955:104–118). The archaeologists and historians who have worked in the region bypass the ability of Kogui memory to relate the conquest's facts. Quite simply, the Kogui vision of history has been neglected, and only recently have we come to learn that the mamos have precise knowledge of what happened, how it happened and where it happened.

After the Spaniards destroyed the villages, they planted seeds brought from Europe in Bunkuanezhaka, and then continued their advance through the territory, seizing women who were later killed. The mamos have in the vicinity of those places a site with a sword and a Spanish axe that were used those days (Mestre & Rawitscher 2018:168–169). These objects are the living memory of the first acts of a structural colonialism that has afflicted Kogui communities for more than five centuries. The Spaniards razed agricultural fields, burned houses, desecrated graves, and took the gold that served to connect the body to the territory. After they razed Pueblo Grande, they went north. According to colonial documents (Friede 1955), most groups were subjected by the *encomenderos* and the missionaries, while others retreated to the highlands. When the colonial period ended, the region was occupied by the newly formed state and by religious orders (such as the Capuchins), who crushed the Indigenous spiritual authorities. There was little difference between Spanish and republican colonialism. The payments were no longer made, the language could not be spoken, the land was captured, and the Kogui, Wiwa, Arhuaco and Kankuamo were subdued. Many of their ancient sites, such as Pocigueica, became privately owned, along with their nujué and ezuamas, which today cannot be seen and which they cannot access.

I once had the chance to talk to a medical doctor in Santa Marta who owns large tracts of land in what was once Pociguieica. He dreamed that his farm was the new Ciudad Perdida, full of tourists who would pay the entrance fee to an archaeological park. For the doctor, the Kogui are nowhere; after all, his is private property, and Kogui history would not fit in the histories to be sold to tourists.

State policies not only impacted the Kogui but all other rural communities. They intensified in the 20th century when the savannas adjacent to the CGSM were cultivated with bananas (Bucheli 2005). This also happened to the north of the SNSM coast. Although in the 1960s the Capuchin order was evicted from the area, the marijuana boom took a toll on the territory and the communities (Bocarejo Suescún 2018). The most affected were some Wayuu, whose participation in the drug trafficking business disintegrated entire clans. After marijuana, cocaine production came to the SNSM, bringing new pressures, such as the dreadful paramilitary groups recruited and armed to exercise the control necessary to produce and commercialize the drug—paramilitarism, by the way, has produced a low-intensity democracy in Colombia (Ardila 2015). Several Indigenous leaders from the four nations of the SNSM were killed;

their claims were at odds with the criminal groups that had even co-opted the state by financing the political campaigns of mayors and governors.

In 2015, statements from the chief commander of the army were released in local newspapers. The officer indicated that, for a few dollars, it was possible to visit the cocaine labs of the SNSM to see how the alkaloid was produced (Guilland 2012). The *baquianos*—experienced on roads, trails and short cuts, and acting as guides who take tourists to Ciudad Perdida—told me that all along the path that leads from the main road up into the mountains there are cocaine-producing facilities; visits are arranged with the guards that patrol the jungle. In August 2015, the presence of those facilities near Ciudad Perdida was confirmed (La W 2015); they are small, easily assembled, and are associated with the production of small amounts of marijuana and cocaine that are sold for local consumption.

Once the process began of demobilizing the paramilitaries, at the beginning of the 2000s, the conflict unfolded in other scenarios, and especially concerned the control of coca fields, cocaine production and its export routes along the Caribbean coast. It also allowed the consolidation of the coastline of the SNSM as a world-class tourist destination. Thus, the Kogui have to face the pressures exerted by tourism on their territories; in the case of the SNSM, it has been better to participate in the tourism boom than to oppose it, as this may imply severe reprisals by armed actors.

As the anthropologist, Anghie Prado (2018) has shown, the Kogui say that the conflict of the last three decades cannot be understood as separate from the colonialism that began in the 16th century. Since then, what has happened is a systematic attempt to exterminate the Kogui by prohibiting their ways of relating to the territory and by fragmenting it through systematic violence. Violence, thus, has not been alien to the region. At the end of the 1920s, an undetermined number of UFC workers were killed after several days of strike action. The army's order to shoot was a response to the company's demand to pacify the territory. This event made it to the books of Gabriel García Márquez, a member of the "Latin American Boom" in the arts of the second half of the 20th century and considered by many as a benchmark of Latin American critical and postcolonial theory. Since the 1950s, the colonialism imposed by the United States through the UFC has been criticized by Colombian writers (Posada-Carbó 1998).

The continuity of Kogui culture through education: the case of Namgexa

The panorama presented above summarizes a vision that is associated with the project of dialogue with the West started by OGT. Nevertheless, there are other Kogui who are furthering ways of resistance, such as the educational project carried out by Francisco Gil in Namgexa. Gil (2016) points out that the patronymic of his people is Kággaba Saja, "people of the highlands." For him, the story of Namgexa is related to Law 90 of 1888, which established police forces in rural territories. This meant that police officers were sent to

most villages in the countryside, including Indigenous peoples' territories. Their presence in the latter was a part of a state strategy to exert authority and control over the national Others (Gnecco & Londoño 2008). In Samigiezhi, in La Guajira, mamo Pildu Awigui and his wife, Saxa Manuilda, were tortured for disregarding police authorities. Indigenous languages were forbidden, as much as making payments in the ezuamas. For this reason, mamo Pildu left Samigiezhi and crossed the mountain range to settle in the upper parts of Ciénaga, in a place known as Sanandalde (Gil 2018:4), where he founded San Pedro de la Sierra, organized according to *janshi zhekualda*, the common good—*se kualda*, live healthy; and *namak shkualda*, authentic knowledge. After the death of mamo Pildu Awigui, the practice of these principles was followed by his son Jabilda Awigui, who, in turn, founded the town of Mamorongo. On the death of Jabilda Awigui, mamo Ignacio Awigui took over and founded San Antonio, where he built two schools, in 1977 and 1994. Before the beginning of the 1970s, mamo Ignacio Awigui allowed the missionaries of the Summer Institute of Linguistics to settle in the territory, with these words: "Mañki nani maldaldakna uniñkauwa kagi mige mite, guanaldikue nagisaldalda gualdiake; -¡due migisa gualdixa nakldá! akna uba zhikldeñsha guwa maldaxaldexaldixa nuxa nakldaldá" ("You are a younger brother; from the beginning, they located you on the other side of the sea. When you see that your older brother falls asleep, you come and say: big brother, get up before something bad happens in your land!") (Gil 2016:5). Mamo Ignacio gave this permission. After all, it was the time when the younger brother, that is, the people from outside, should tell the Kogui to be alert because something terrible could happen in their territory. When Francisco speaks of the missionaries of the SIL, he refers to Chad and Pat Stendal, famous in Protestant circles of the United States, not only for their evangelizing campaigns but for the kidnapping of a son at the hands of a Colombian guerrilla. The Stendals wrote several books describing Colombia as a pristine jungle in the hands of guerrillas who ruled in a lawless country-side. Their heroic work was to civilize the Kogui, who lived amidst wild beasts (Stendal & Stendal 1989).

Although this region had not been inhabited by the Kogui, who were displaced from Cesar by sheer force, it was known as a part of their traditional territory. In practice, this meant that the community knew which ezuamas were there and to which *jate* or *jaba* make payments. To date, the territory is controlled by a robust Kogui organization called Kutshabitaboya Kulsha Tuxe, in charge of the relationships with the authorities of Ciénaga, Santa Marta, and Magdalena. Its leaders do not always agree with OGT; the most considerable divergence occurs when the former gives a fundamental role to formal education, not so crucial for the latter. Kutshabitaboya Kulsha Tuxe leaders, unlike OGT, even want a grammar of the Kogui language to strengthen local processes. Yet, they are well known for directing OGT decisions, such as requests to the Instituto Colombiano de Antropología e Historia (Colombian Institute of Anthropology and History, ICANH hereafter)

for temporary closures of sites such as Ciudad Perdida. In the local media, the organization is known as the Council of Traditional Authorities, and on its website, it is called Gobernación Kogui del Magdalena (GKM hereafter). A hallmark of this organization is that it occupies the territory of the upper Tucurinca river, known in colonial literature as Pocigueica. The jurisdiction of GKM extends from the lagoon of Riofrío, atop the SNSM, called Jaba Uldu-mindia, to Jaba Nabaldijuwe, the lagoon of the Tucurinca river. These two points form a rectangle whose lower points connect with the "Black Line" at a site known as Papaldiwe. The other point is Nuaneshkaxa.

Within the framework of local autonomy, GKM is enacting its educational policies, as is the case of the Kogui Jukulduwe Rural Educational Center, which Francisco Gil himself directs. This school is part of the ancestral territory of Namgexa. As established by the schoo'sl programmatic document, the survival of the Kogui nation has been the result of maintaining its education processes, for which language strengthening is decisive. According to an elder from the community, Virgilio Sandingama, the pedagogical model is oriented by *kasa*-foot, the principle of the search for knowledge, the footprint that represents the travel that culminates with *kaukukui*-finger, that which seals with the fingerprint. The programmatic document that bears the signature and fingerprint of elder Virgilio Sandingama ends by tracing the genealogy of Namgexa, and by pointing out that the mamos who opened up to reflect on education and health were Ignacio Awigui (Kultsha clan of Mulkuexe), Dimata Dingula (Magutama clan of Sezhanñkua), Julián Gil (Zhalnexa clan of Alduwawiku), and Patricio Nolavita (Jukumezhi clan of Sintana). The pedagogical model is based on two fundamental premises: an education that teaches the genealogy of the territory under the principles defined by mamo Pildu Awigui and developed by their descendants; and an education that emerges in the borderland. The school imagined by Francisco Gil, based on community knowledge, has the official recognition of the Colombian state but does not aim to train Colombian citizens, but to regain Indigenous autonomy and to educate the young in their thinking while learning general skills. This duality leads to the construction of epistemological tools such as the notions of Virgilio Sandingama of *kasa*-foot and *kaukukui*-finger, which do not necessarily conform to a purely local philosophy, but it are not modern either; it is border thinking about how to make the social transitions needed to accelerate the collapse of the Anthropocene.

Border thinking informs not only the pedagogical principles of the school but also its organization. According to mamo José Awigui Dingula, the school is to operate in an educational center that gathers the teachings of mamo Pildu Awigui, while also recalling Kutshabitaboya, son of the spiritual mother, who aspired to be wise; this brought him into serious problems with his brothers, so he had to leave. Before the impending march, his older brother, Sintana, told him not to leave because he would need him sooner or later. To encourage him to stay, Sintana gave him the upper Curinca that is

Namgexa, where mamo Pildu Awigui decided to found his community. In Namgexa, Kutshabitaboya interceded before Guksaname, god of fire, for the liberation of the coca seed, which was the daughter of *jaba* Nuaneshkaxa. He also defended *uldu*-clay (clay mine), representation of women, before the forces that planned its disintegration. Following the history of Kutshabitaboya, the teachers, according to the school model designed by mamo José Awigui Dingula, are the potters of their students, so that they can be an example in the community. That is why the school is called Muñkuawitama, in honor of Kutshabitaboya and mamo Pildu Awigui—*muñ*, is to grow, sprout, dawn; *kua*, sanitize, be known; *wi*, life, continuous movement; *tama*, spirituality. Muñkuawitama used to be Shibaldama, the territory. Thus, the school must have a Muñkuawitama-director, who will guide the threads that will make up the Kogui of tomorrow, just as Muñkuawitama did with Shibaldama.

The Jukulduwe school considers teaching as a process that begins in the center of the individual; when expanding, it allows personal growth in four interconnected spheres: (a) government of the community (Sintana); (b) maker of thought (Mulkuexe); (c) good living (Sezhañkua); and (d) man–nature relationship (Alduawiku). In this interrelationship, Alduawiku allows the development of spiritual skills, which connect with Sintana, which allows the development of communication skills, which connect with Mulkuexe, which allows the development of personal skills. Sezhañkua connects with Alduawiku, and the individual develops community skills. It is a cycle, like the cycles that are immersed in the production of *mochilas* (*gama*) or in the heart of *muni* (*caña brava*), the reed with which human beings weave their houses, following the example of *nukuba* (the snail) or *malkua shizha* (the spiderweb).

When the Ministry of National Education asked the Kogui of Namgexa how the principles of thought were to materialize in academic courses, they answered that they would use the principle of Mulkuexe, Maker of Thought, for the preschool level in ethnomathematics and language (both in Kogui and Spanish); Sintana, the government of the community, will be developed in the courses on the social environment and civil competence; Alduawiku (man–nature relationship) in the courses Mother Nature and cultural art; finally, Good Living (Sezhañkua) will find its place in physical education and cultural rituals. The same would happen for the junior high and high school cycles.

The school has become an instrument of resistance and endurance and has served to halt the attempts of Colombian society to suppress cultural differences through violence. It also guarantees access to higher education, vital when the Indigenous nations of the SNSM recognize the need to have their own professionals—in medicine, anthropology, history, law, economics and accounting. The Namgexa school—actually a dozen schools spread across the territory, with no more than 400 students—is a strategy for cultural persistence; yet, there are significant risks. Internal risks are twofold: (a) the lure of

national society, causing migration as well as social disintegration; prominent Kogui, men and women, are sometimes urged to leave the territory and the community to have more access to everyday goods and services. Getting to be trained as a medical doctor, for instance, implies a vast effort and a considerable risk, for the young graduate may choose to leave the community to settle in the city; and (b) the lack of rigor in teaching the Kogui language. Since some parents believe it is unnecessary or an impediment to personal growth, its teaching is not sufficiently encouraged. Francisco Gil notes that there are not enough educational resources in the Kogui language to train teachers and teach the language. Concerning external risks, the Kogui live in territories where there has been a decades-long armed conflict linked to the production and export of illegal drugs. This has resulted in a tense calm: the Kogui must be careful not to become a target of militarized criminal gangs.

The Kogui have suffered all kinds of violence. Collective memory remembers the murder, in 2004, of José Antonio Nuevita at the hands of the guerrillas. That same year 11 Kogui families from Palmor, the hometown of Francisco Gil, were displaced. In 2005 Pedro Zarabata Pinto, a Kogui leader was disappeared. In 2006 two Kogui from Dibulla died from stepping on a mine, one of several apparently installed by the guerrillas at sacred sites, violating the right of the communities to make payments in their territories. On January 1, 2008, the displacement of dozens of families also occurred in Palmor due to the war between the guerrillas and criminal gangs (Observatorio del Programa Presidencial de Derechos Humanos y DIH 2010). Recently, Jacinto Sauna, son of OGT governor José Santos Sauna, was killed in his home by a hit man. Colombian authorities stated that there were no political motives behind the killing, that it was just a robbery (*La Guajira* 2015).

At present, the Kogui live in the SNSM; it is also disputed by irregular forces seeking to profit from its strategic location. The SNSM is ideal for illicit drug trafficking, since its mountains harbor cocaine production, while on its coast ships are loaded to export it to the United States and Europe. The Kogui struggle for territory and autonomy, as well as that of the other Indigenous nations of the SNSM, is thus a condition for their survival.

Francisco Gil's work depicts the new forms of Kogui resistance. If, in the 16th century, the struggle was armed and strategic, which meant moving from the ancient territories to higher areas, in the 21st century the strategy is not armed confrontation but identity strengthening through the intercultural school. This occurs in the interstices that multiculturalism has opened up: the recognition of ethnic difference, mostly as a commodity, enabled internal political appropriations that resulted in social movements that, as in the Kogui case, are slowly paying off. Such recognition did not necessarily imply territorial or legal autonomy, but it did permit discussing the ethnic issue, even allowing the consideration of worlds other than modernity. Francisco Gil's school and the reclaiming of Pueblito Chairama are instances of these

dynamics. As long as there are ezuamas, as long as reeds sprout from the hills, as long as the Kogui know how to weave the nujué, as long as the mamos make their divinations with tumas, the world above can reproduce, even knowing that we live in times of tremendous confusion. But despite all obstacles, the Kogui culture continues to persist.

In Palmor's case, the Kogui clans' process seeks to use education to empower local communities. In the case of Taganga, until 2019, the struggle was for political recognition. Since this recognition was obtained, the main task has been to regain territorial autonomy. In the Palmor process, we have been working with a group of anthropologists and linguists, and we have set ourselves the main task of supporting a process of organizing the teaching of the language. On the other hand, we have agreed on a review of the anthropological literature produced about them, to begin the task of a critical review. In the case of Taganga, the work has been oriented to the rescue of certain traditions such as the ways of fishing and building boats. This process has been led by anthropologist Eduardo Forero, who has accompanied the Taganga authorities in their political process. Together with the Taganga authorities, we have started a series of workshops that seek to use photogrammetry to preserve and teach the local nautical culture. In this case, the need to use archaeology to improve the understanding of the historical depth of the occupation of the bay has been demonstrated. This feels like an imperative since the pressure from the real estate sector to turn the bay into a purely tourist destination is enormous.

To close the chapter, I would like to mention Costa Rican linguist Adolfo Constenla (1991), an academic of Macro-Chibcha languages who used archaeological evidence to understand their diachrony. To him, we owe their understanding on a continental scale. He described in detail what made these languages belong to the same family and their most prominent differences. Constenla used the archaeological denomination of the Intermediate Area to refer to the cultures located between Mesoamerica and the Central Andes, as defined by Gordon Willey (Hoopes 2004). Constenla made it clear that those languages have an enormous temporal depth, and are no recent inventions as claimed by the archaeologists and heritage managers who have worked in the area. The four nations of the SNSM have a linguistic knowledge of cultural families that we know little about. This allowed Cabildo Mayor Ariel Daniels, of the Indigenous community of Taganga, to speculate that in times past, before the Spaniards, they communicated with much of the Caribbean using a sophisticated navigation system. In the Taganga heritage house, they have an anchor that appears to be pre-Hispanic, and which would be the only evidence of navigation technologies before the arrival of the Spaniards. Constenla's arguments allow us to understand the Intermediate Area as an area of circulation of ideas, peoples, and objects, among populations with analogic ontologies, of which we know little but that, despite all troubles, we still recognize as extant and vital.

Conclusions

The chapter showed that the Indigenous nations of the SNSM have forms of thinking whose ontological basis is easily traceable over time as it is connected to the development of Macro-Chibcha languages. Despite this transcendence, those communities are currently fighting against the way they were represented throughout the 20th century, especially by anthropologists and archaeologists. Current local dynamics seek the decolonization of history and education, highlighting significant tensions between local and state conceptions. In many institutional settings, Indigenous peoples are expected to exalt the country's multiculturalism while also denying their legitimate claims for land and autonomy. However, in the current circumstances, the Indigenous communities of the SNSM seek a decolonization of history and of the representation that was made of them; this to facilitate the development of their cultures from their ontologies.

References

Anzaldúa, G. (1987). *Borderlands/la frontera. The new mestiza*. San Francisco, United States. Third Woman Press.

Ardila, M. (2015). Colombia y México: hacia ¿diplomacias democráticas de baja intensidad? *Desafíos*, vol. 27, no. 2. Colombia, pp. 221–252. DOI: https://doi.org/10.12804/desafios27.2.2015.07

Berry, T. (2013). The determining features of the Ecozoic era. *The Ecozoic*, vol. 3. United States, pp. 4–6.

Bocarejo Suescún, D. (2018). Lo público de la historia pública en Colombia: reflexiones desde el Río de la Patria y sus pobladores ribereños. *Historia Crítica*, no. 68. Colombia, pp. 67–91. DOI: https://doi.org/10.7440/histcrit68.2018.04

Bucheli, M. (2005). *Bananas and business: the United Fruit Company in Colombia, 1899–2000*. New York, United States. New York University Press. DOI: https://doi.org/10.5860/choice.42-6592

Constenla, A. (1991). *Las lenguas del área intermedia*. San José, Costa Rica. Universidad de Costa Rica.

Descola, P. (1992). El determinismo raquítico. *Etnológica*, vol. 1, no. 1. México, pp. 75–87.

Descola, P. (2013). *Beyond nature and culture*. Chicago, United States. University of Chicago Press.

Escobar, A. (2016). Sentipensar con la tierra: las luchas territoriales y la dimensión ontológica de las epistemologías del sur. *Revista de Antropología Iberoamericana*, vol. 11, no. 1, pp. 11–32. DOI: https://doi.org/10.11156/aibr.110102

Escobar, A. (2018). *Designs for the pluriverse: radical interdependence, autonomy, and the making of worlds*. United States. Duke University Press. DOI: https://doi.org/10.1215/9780822371816

Foucault, M. (1999). *Las palabras y las cosas. Una arqueología de las ciencias humanas*. Madrid, Spain. Siglo XXI.

Friede, J. (1955). *Documentos inéditos para la historia de Colombia: coleccionados en el Archivo General de Indias de Sevilla*. Bogotá, Colombia. Academia Colombiana de Historia.

Fry, T. (1999). *A new design philosophy: an introduction to defuturing*. Sydney, Australia. University of New South Wales Press.

Geertz, C. (1973). *The interpretation of culture*. New York. Basic Books.

Gil, F. (2018). Propuesta para proyecto educativo propio bilingüe desde la interculturalidad de la comunidad Kogui de Mamarongo (Master's thesis). Universidad Santo Tomás. Maestría en Educación.

Giraldo, S. (2010). Lords of the snowy ranges: politics, place, and landscape transformation in two Tairona towns in the Sierra Nevada de Santa Marta, Colombia (Doctoral dissertation). University of Chicago, Division of the Social Sciences, Department of Anthropology.

Gnecco, C. & Londoño, W. (2008). Representaciones de la alteridad indígena en el discurso jurídico colombiano. Gómez, H. & Gnecco, C. (eds.). *Representaciones jurídicas de la alteridad indígena* (pp. 25–94). Cauca, Colombia. Universidad del Cauca.

Gómez, H. (2015). *Justicias indígenas en Colombia: reflexiones para un debate cultural, jurídico y político. Pueblos Kogui, Arhuaco, Wiwa, Kankuamo, Nasa, Misak, Yanacona y Camëntšá*. Bogotá, Colombia. Consejo Superior de la Judicatura.

González-Ruibal, A. (2014). Malos nativos. Una crítica de las arqueologías indígenas y poscoloniales. *Revista de Arqueología*, vol. 27, no. 2. Spain, pp. 47–63. DOI: https://doi.org/10.24885/sab.v27i2.403

Guilland, M. (2012). Colombia, el único riesgo es que te quieras quedar allí. De la promoción turística nacional al viaje a Sierra Nevada: usos y disuasión del riesgo. *Revista Internacional Interdisciplinar de Turismo*, France, pp. 2–12. DOI: https://doi.org/10.4000/viatourism.1252

Haber, A. F. (2009). Animism, relatedness, life: post-Western perspectives. *Cambridge Archaeological Journal*, vol. 19, no. 3. United Kingdom, pp. 418–430. DOI: https://doi.org/10.1017/S0959774309000602

Hoopes, J. W. (2004). Atravesando fronteras y explorando la iconografía sagrada de los antiguos Chibchas en Centroamérica Meridional y Colombia Septentrional. *Arqueología del Área Intermedia*, vol. 6. Bogotá, Colombia, pp. 129–166.

Korstanje, M. (2012). ¿Se puede ponderar la seguridad turística? Un ensayo conceptual. *Turismo e Sociedade*, vol. 5, no. 2. Brazil, pp. 368–390. DOI: https://doi.org/10.5380/tes.v5i2.26332

La Guajira. (2015). Cayó "Chorlis", presunto asesino de indígena Kogui. No. 28. Riohacha, Colombia.

La W. (2015). Destruyen laboratorios de coca en Ciudad Perdida. August 26. Bogotá, Colombia.

Londoño, W. (2012). Espíritus en prisión: una etnografía del Museo Nacional de Colombia. *Chungará (Arica)*, vol. 44, no. 4. Chile, pp. 733–745. DOI: https://doi.org/10.4067/S0717-73562012000400013

Mestre, Y. & Rawitscher, P. (2018). *Shikwakala. El Crujido de la madre tierra*. Barranquilla, Colombia. Organización Indígena Gonawindua Tayrona.

Mignolo, W. (2012). *Local histories/global designs: coloniality, subaltern knowledges, and border thinking*. United States. Princeton University Press.

Observatorio del Programa Presidencial de Derechos Humanos y DIH. (2010). *DIH: indicadores sobre derechos humanos y DIH Colombia, año 2008*.

Orrantia, J. (2002). Matices kogui. Representaciones y negociación en la marginalidad. *Revista Colombiana de Antropología*, vol. 38. Colombia, pp. 45–75.

Ortiz Ricaurte, C. (2000). Fonología y morfosintaxis nominal del Kogui. González, M. & Rodríguez, M. (eds.). *Lenguas indígenas de Colombia: una visión descriptiva.* Colombia, pp. 757–780.

Oyuela, A. (1986). De los Taironas a los Kogi: una interpretación del cambio cultural. *Boletín Museo del Oro*, no. 17. Colombia, pp. 32–43.

Pérez, M. (1995). Parentesco y familia en algunas comunidades indígenas colombianas: persistencia y cambio. *Avances en Enfermería*, vol. 13, no. 1. Colombia, pp. 93–100.

Posada-Carbó, E. (1998). Fiction as history: the bananeras and Gabriel García Márquez's *One Hundred Years of Solitude. Journal of Latin American Studies*, vol. 30, no. 2, pp. 395–414.

Prado, A. (2018). Aproximaciones al proceso de reparación de los kággaba. *Oraloteca*, no. 9. Colombia, pp. 96–111.

Preuss, K. T. (1927). Forschungsreise zu den Kágaba-Indianern der Sierra Nevada de Santa Marta in Kolumbien. Beobachtungen, Textaufnahmen und linguistische Studien. *Anthropos*, no. 3, pp. 357–386.

Reichel-Dolmatoff, G. (1953). Contactos y cambios culturales en la Sierra Nevada de Santa Marta. *Revista Colombiana de Antropología*, vol. 1, no. 1. Bogotá, Colombia, pp. 15–122.

Rivero Agudelo, M. P. (2014). Aproximación etnográfica a los Koguis de la parte baja de la Cuenca del Rio Palomino en la Sierra Nevada de Santa Marta (Seywiaka) y contextos urbanos (Rodadero) a partir de sus conceptos y perspectivas de "naturaleza" y "espacio" (Pregrad thesis). Universidad del Magdalena. Programa de Antropología.

Stendal, C. & Stendal, P. (1989). *The guerrillas have taken our son.* Colombia. Ransom Press International.

Tobón, C. (1996). Destrucción de templos indígenas en la Sierra Nevada de Santa Marta: siglo XVII. *Boletín Museo del Oro*, no. 40. Colombia, pp. 17–35.

Umaña, A. (1991). *Las lenguas del área intermedia: introducción a su estudio areal.* San José, Costa Rica. Universidad de Costa Rica.

2 The making of an archaeological culture
The Tairona

The first archaeological missions in the Sierra Nevada de Santa Marta

By the end of the civil wars in Colombia, at the end of the 19th century, the United States' grip on the trade in tropical fruits led them to the territorial and political control of large areas in Central America and the Caribbean (Bucheli 2005). At the onset of the Colombian Republic, whose territory covered most of northern South America, Simón Bolívar already expressed concern about the imminent expansion of the United States and the consequent instrumentalization of the liberated nations as economic enclaves (Bohórquez 2006). Bolívar was right, and at the beginning of the 20th century, large tracts of land were in the hands of American companies that planted banana for the growing domestic and European markets (Wiley 2008). The United States was also preparing to control the areas with oil deposits south of their borders—this was the time of the Monroe Doctrine (Livingstone 2013), which implied the colonization of territories in Central America and the Caribbean, and was parallel to an internal policy of consolidation of plantations in rural areas (Patterson 1986). This process saw the creation of several museum and thematic sites, some expressing the colonial reach of the United States (such as pre-Hispanic collections, especially of Maya objects, taken after invasions of Mexico), and some others expressing the plantation culture.

After the invasion of Veracruz, in Mexico, in 1914 (Ojeda 2014), the excavations of Chichén Itzá (Jones 1997) began to be negotiated with the Mexican government. The excavations were carried out by Sylvanus Morley, a spy for the United States (Harris & Sadler 2003). Morley led a double life. On the one hand, he was a renowned researcher of the Maya culture, highly valued in academic circles; on the other, he ran secret military missions that involved the rendering of reports to the US military, which detailed the movements of German citizens in Central America and the Caribbean. American archaeology in those decades had a double intention: (a) to compete with Western European countries in terms of archaeological collections and museums, themselves symbols of colonialism (Barringer & Flynn 2012); and (b) to create museums and collections for celebrating the pre-Hispanic marvels of

the nations they were colonizing; by doing so, the claims of local populations against the growth of large estates were undermined. By the end of First World War, the stereotyped image of contemporary Indigenous peoples made by the archaeologists, in which the former appeared as decadent societies with no relation to a glorious past, ran parallel to policies for regulating migration and improving the population through eugenics (Patterson 1986:11–12).

Since its inception, the UFC had it clear that it was not enough to secure lands for agribusiness; it was also necessary to teach consumers about the importance of banana consumption. UFC's advertisement department linked the nuclear family of the growing industrial society with modern forms of food, such as cornflakes with banana and milk. There are two everyday things that we owe to the UFC: the standard American breakfast of cornflakes, milk and banana, and the tropical fruit salad (Chapman 2014). That department also launched campaigns to discredit the Central American governments that were promoting agrarian reforms that undermined the power of UFC. They were not just campaigns, though; as we said before, Guatemala's President Jacobo Árbenz was overthrown in 1954 by a CIA-backed coup that portrayed him as an ardent communist who endangered the stability of the region (Vicente 2014). The US controllers of those countries, favoring the UFC, mocked them as "banana republics" (Moberg 1996).

We owe homogenizing behaviors to the UFC: not only how mothers feed their children but also how the past should be understood—through archaeological collections housed in the museums that were to be visited during leisure time. The United States was shown as the last link of Western civilization (Patterson 1986). This vision reached its peaks with the emergence of neo-evolutionism as a dominant anthropological theory after World War II (Trigger 1989). This ideology naturalized the world hegemony of the United States, especially because it was the nation most capable of harnessing energy (this time atomic). The definition of culture that founded processualist archaeology was popularized by Leslie White (1949), who pointed out that the evolution of culture was the result of the efficient harnessing of energy through technology. The naturalization of the United States' hegemony began to take shape at the end of the 19th century with the notion of the "Western Hemisphere" (Mignolo 1995). "Occidentalism" emerged parallel to "Orientalism," yet the former did not mean that the United States was the object of study as if it were the East, but that it defined Latin America as its object of study and intervention. "Area studies" naturalized the idea that specialized departments should study Latin America, Asia, and Africa in US universities. The University of Pittsburgh, for instance, through its departments interested in Latin America, produced a large amount of archaeological information about Colombia, which impacted disciplinary epistemology and politics in that country since most Colombian archaeologists since the 1980s were trained at that university.

It was in the midst of the growing world hegemony of the United States at the beginning of the 20th century that the first collections of pre-Hispanic

objects were formed in the United States, such as that of George Gustav Heye (Lothrop 1957), who had inherited a fortune from his family. Heye graduated in electrical engineering from Columbia University, so he must have known the role of his university in the development of anthropology. Heye assembled his collection by geographical areas with archaeological cultures, including South America. Heye was friends with Columbia University archaeologist Marshall H. Saville (Browman & Williams 2013), who was also a spy (Bonomo & Farro 2014) and possessed an extensive knowledge of ancient goldwork in northern South America. That is why a young explorer named Gregory Mason asked him to be his advisor in his attempt to get a Ph.D. from the University of Southern California with a thesis on the Tairona archaeological culture (Mason 1938). Gregory Mason was a renowned explorer who published press releases about his findings in Central America in New York City newspapers (Mason 1923), in which he proposed that the museums in New York, Boston and Chicago should stop thinking about Egyptian or Greek antiquities to better focus on the marvels to be found in their back garden. He stated that Chichén Itzá was "our own Egypt" (Mason 1923). After explorations in Central America, especially visiting UFC farms (Joyce 2017:23), he turned his attention to the SNSM because Saville had told him that it was possible to find traces there of an ancient warrior tribe, called "Tairona" by the Spaniards (Mason 1938: VIII). Saville must have read 18th-century works, such as that of Father Julián (1787); Julián's work reported on the wars of conquest of the 16th century. Those works stated that the Spaniards had faced a people, near-giants called Tairona, who, once defeated, allowed the province's progress. This is Julián's (1787:105) description of the Tairona: "The Tairona were once like the giants of the province of Santa Marta: *potentes a sæculo viri famosi.*" In the Western imagination, "the very famous giants of yore," mentioned in chapter 6 of the book of Genesis, were the result of the intercourse between a woman and an angel, and displayed evil behaviors. Those giants, long-standing literary figures, were used, at different times and places, to give content and characters to epic stories (Delumeau 2012). In colonial literature, Native Americans were seen as members of the lost tribes of Israel (Mignolo 2009), so biblical metaphors were used to talk about them. Historical descriptions created powerful and famous Indigenous figures from the past and decadent and ignored indigenes in the present.

Once Mason obtained Saville's approval for his research plans, he went to Santa Marta (in 1931 for six months and 1936 for two months) to search for the Tairona archaeological remains. His observations complemented those of another Mason, John Alden, who also sought traces of the Tairona tribes, but not with Gregory Mason's intensity (Mason 1938: VI–VIII). J. A. Mason actively participated as a spy in Mexico along with Morley (Price 2008:9). For his trip to Colombia, G. Mason used the UFC's routes, which operated steamboats forming "The Great White Fleet" (Lawton 1987). Those routes connected the northern United States with New Orleans, from where ships

sailed to Panama, and then to Barranquilla. To reach Santa Marta there was a train; the route was Puerto Colombia–Aracataca–Santa Marta. From Aracataca, there was a train to Santa Marta, the port through which bananas were shipped to the United States (Mason 1931).

G. Mason followed the footsteps of John Alden. Once in Santa Marta, he went to talk to UFC officers, as most foreigners did upon arriving in the city. As a result, he decided to travel north to the region of La Guajira. On that tour, he excavated archaeological materials in areas indicated by his guides. Besides this, he searched for the Kogui masks reported by Preuss (1993). American collectors, such as Heye, were aware of European collections being formed and were unwilling to trail behind. If the Germans had Kogui masks, Heye wanted to have them too, so he entrusted Mason with finding them. Yet, G. Mason's main intention was to document the ruins of the tribes that had resisted the conquest. Having in mind Saville's remark that something could be found of the ancient Tairona (Mason 1938:171), he looked for those Indigenous people in the province of Magdalena with greater stature and musculature to test whether that bioanthropological feature would support a past–present continuity. He also needed a cultural test, namely Indigenous stories capable of explaining the objects he found in his excavations, where they were located, and with what other archaeological materials they were associated. He regularly showed objects to Indigenous individuals, looking for ethnographic information to give content to the hundreds of mute objects he plundered around Santa Marta, now housed in the United States (Mason 1938:120).

From Santa Marta he went north by canoe in search of archaeological sites, apparently reaching what now is the PNNT; yet, since the park is full of archaeological sites it is not possible to specify exactly where Mason arrived, but it is possible that it was in San Juan de Guía, from where muddy trails lead to what would later be called Pueblito Chairama. Mason made some excavations there and found objects in quartz, gold, and pottery, which he brought along afterwards on his way north, to the mouth of Palomino river, where he learnt that he could go up to Kogui villages near Makotama creek to find the desired masks Heye had commissioned him to secure. It didn't take him long to find a mamo Kogui with a mask. Mason asked for it, but he was turned down. Instead, he was offered a ceremonial dance in which the dancers wore the masks, on condition that he return the objects he had plundered on his journey from Santa Marta. The Kogui, above all, wanted back the tumas he had taken without permission. There was no agreement, and Mason rejected the ceremonial dance. The Kogui indicated that they did not want to hand over the mask for a fundamental reason: nobody knew how to make it. As mamo Damian from Kasikiale told him: "There is no one alive today who knows how to make such a mask" (Mason 1938:122). Mason did not care and gave unequivocal signs of wanting the coveted object; likewise, he preserved the tumas he had excavated, showing disdain for the natives' insistence on preserving them in their own appropriate locations.

After his encounter with the Kogui in Makotama he went down to the village of Palomino, where a party was taking place. There, a mestizo offered Mason a mask he had stolen, the very kind of mask Mason was longing for; he accepted it and returned to the United States with the spoils he had been commissioned to get (Mason 1938:173).

The Kogui's wish to retain and reclaim their sacred objects and locations is also demonstrated by their desire that archaeological parks become ezuamas conservation sites again. This is expressed in the agenda of characters like José de los Santos Saunas, who wants the Kogui masks in Berlin to be returned. All this investigation of the history of the archaeology of Santa Marta has been disturbing for the mamos. However, they are aware that the first task of the archaeologists, once they arrived in Santa Marta, was to discredit them and deny them their historical knowledge. For Mama Ramón Gil, the fundamental task he continually reiterates is for the West to understand Indigenous people's culture. Nevertheless, that will be impossible if the dialogue starts from the premise that only Western thought can be the starting point. For this reason, in the critique of Indigenous archaeology, the main task is to de-archaeologize the territory.

Since the 17th century, the time of the extirpation of idolatries (Langebaek 2015), sacred sites where masks were used were seized. Some of those masks eventually made it to Europe (Reyes 2017); the Vatican Museum holds two, and two more are held by Berlin's ethnographic museum. Information available about the latter indicates that they are pre-Conquest, so the continuity of the Kogui religious system between pre-Hispanic times and modernity is evident. This does not mean that there were no ruptures due to the conquest or that the Kogui are as they were in the 16th century; it means that pre-Hispanic artifacts were still used in ritual contexts in the 20th century, even though the Kogui do not use excavated objects. As noted by the highest authority of the SNSM, José Santos Sauna, "the masks that were taken to Europe united us with our past" (personal communication, August 2017). This statement is not metaphorical; it signals a different conception of time that we have not understood, or that we have refused to understand. As Amado Villafaña, the Arhuaco filmmaker, explained: "the Kogui masks are like the ancient statues of the cathedrals of Europe, some of which have been there for over a thousand years" (personal communication, January 2009).

A few years after his first trip, Gregory Mason returned to Santa Marta and wanted to return the mask that he had taken without permission with the complicity of the mestizo who had stolen it. To his surprise, the Kogui did not want it because it was "bad, very bad ... devil, very devil" (Mason 1938:175). The natives of the SNSM were disciplined, well into the 1960s, by religious orders, especially by the Capuchins, who forbade them to speak their languages and perform their rituals (Friede 1963). This was part of the state policy called "reduction of savages" (Londoño 2003), which was implemented in Colombia from the end of the 19th century. This policy was to educate and incorporate the Indigenous people into the national society instead of

exterminating them, contrary to what had happened in the United States and the Southern Cone. Given this context, the people to whom Mason offered the mask were cautious because they could have been accused of sorcery, or heresy, and could have been subjected to punishment by the Capuchins (Bonilla 2006).

The mask episode allowed Mason, who did not know the Kogui language, to understand that they knew those objects that he had been collecting during his journey from Santa Marta to Palomino. He concluded that the Kogui knew the religion associated with Tairona sites well enough that, in their case, cultural continuity was granted. Bioanthropological continuity, however, was unlikely, given their small size. Mason thought that the real descendants of the Tairona were the "goajiros," who were taller and heavier (Mason 1938:1–10). However, the "goajiros," known as Wayuu—who inhabit the Guajira peninsula—denied any relationship with the people who had built the villages and burials he was investigating (Mason 1938:2). The only people interested in the tumas and other archaeological objects of the SNSM coast were the Kogui. As Juan Nieves suggests, "the archaeologists invented us in a way on paper that served to dominate us in reality."

The creation of the Tairona–Kogui rupture

The first archaeological missions in northern Colombia were carried out by spy-archaeologists, such as John Alden Mason, or by explorers like Gregory Mason, who looked for the very material cultures described in Spanish chronicles. They were meant to provide material content to the accepted narratives about the history of the region. They set out to define historical tribes, their territorial limits, and their objects. These elements were a clue in museum arrangements and told the story of powerful nations defeated by the Spaniards; their useless colonial successors had to give way to the thriving entrepreneurial spirit of the United States.

Those first archaeologists, busy stockpiling archaeological objects to swell American museums that were the apotheosis of colonialism, were not interested in historical processes, but in providing the material means to fill out the narrative about the conquest. Although difficult to accept, such disciplinary constructions were the spearhead that justified the UFC invasions in Central America and the Caribbean. First, the hegemonic representations of the Indigenous others served to justify the continuing conquest of the 18th century in works such as that of Father Julián and, second, to legitimize the looting of the region now in the hands of the UFC. Doing archaeology in northern Colombia meant assuming that the natives defeated by the Spaniards had disappeared, while contemporary natives were destitute remains of great civilizations; characterized by precariousness and pauperization, they were far from having cultural relations with the builders of the "Lost Cities" discovered. This concatenation (invading territories, doing archaeology, eulogizing the indigenes of the past to discredit those of the present) was

inaugurated with the investigations in Chichén Itzá (Patterson 1986). Johannes Fabian (1983) called allochronism the denial of coevalness to the Other, an artifice used by most Latin American democracies (Gnecco 1999). During times of liberal governments, at the end of the 19th century and in the 1940s, nation-building in Colombia appealed to pre-Hispanic objects and the names of Indigenous leaders (Pineda Camacho 1984). Such an association, at state level, was merely symbolic and entirely related to the past; contemporary Indigenous people were brutally dispossessed and subjected to ethnic extermination.

Gregory Mason was the archaeologist who inaugurated the rupture between the Kogui and the Tairona. He was the first to consider that living groups could provide information about extinct cultures, without necessarily having any real connection. The separation between past and present was the condition of the possibility of archaeological practice. In this way, Mason asked: what can we learn from the Kogui religion in order to understand that of the Tairona, without arguing that the former and the latter are the same culture? It would have been different from asking how it was that the Kogui survived the onslaught of 16th-century colonialism and republican endocolonialism in the early 20th century, but a question of that sort was prohibited by the need to build historical dichotomies.

The first archaeological missions to the region did not consider a past–present continuity. Instead, they provided the rationale to demonstrate that the UFC operated in territories of peasants prone to communism; the order they imposed contributed to maintaining peace in the Western Hemisphere. The idea of a past–present rupture won the day, and it became a canvas for the first strokes of archaeological studies in northern Colombia. G. Mason's ethnoarchaeology was based in the study of Kogui religion; however, the relationship between the Kogui and the archaeological cultures was purely academic, a way to give meaning to the hundreds of mute artifacts accumulated on the shelves of US museums. Any discussion on the impact of colonialism on local communities was conspicuously absent. As was evident in the visit that the mamos made to the Universidad del Magdalena, "it is necessary to take a step back with archaeology." At Universidad del Magdalena, an institution of the Colombian state, what we have been doing in the company of the Indigenous social movement of the SNSM, is to generate an archaeology that begins by recognizing the colonialism of traditional archaeology, and that starts from the understanding of the Indigenous ontologies.

In the early 1940s, with the institutionalization of anthropology in Colombia, the disciplinary agenda was built on the basis of the work of G. Mason. If I use the metaphor of the "savage slot" (Trouillot 2011), even before anthropology was institutionalized, it was already evident what was to be asked and how it was to be answered. Since Saville established that archaeological remains with some degree of monumentality were Tairona— the very premise that informed G. Mason's doctoral training—the first archaeologists in Colombia contributed to the niche of the Tairona by

documenting the materiality in northern Colombia attributed to that significant. Even though this construction was denounced in the late 1960s as an archaeological fallacy (Bischof 1983), that imaginary was not questioned.

The first scholar to arrive in the SNSM with some anthropological training was Austrian-born Gerardo Reichel-Dolmatoff. While in Austria, he was a member of the Nazi party, even participating in paramilitary actions. His father, close to the Nazi elite, was an average painter who gave his children a life full of absences, economic and emotional. Young Reichel had to flee Austria in fear of being murdered by his party (Oyuela 2012). He moved to France, where he met Paul Rivet and became his student. The German occupation of France forced Rivet into exile, first to Mexico and then to Colombia. Reichel followed Rivet to Bogotá. When the Colombian government banned the immigration of Jews, only allowing non-Semitic peoples (Galvis & Donadío 1986), Reichel quickly entered Colombia with his Austrian passport.

Reichel began his work as an anthropologist, without a degree, making descriptions of archaeological sites, toponymy inventories, and drawings on demand (Laurière 2010). Later, when he toured the country with his wife, he began publishing and positioning himself as a renowned expert. In the mid-1940s, he founded the Magdalena Ethnological Institute and moved to Santa Marta (Pineda 2012). During his stay in Magdalena, he did ethnographic research among the Kogui and documented archaeological sites, such as Pueblito Chairama, that were uninhabited by the 1950s.

In the first issue of the *Revista Colombiana de Antropología*, Reichel published a paper on cultural change in the SNSM (Reichel-Dolmatoff 1953). This is telling because later on, he would no longer address the issue of cultural change, dividing his work between archaeology and ethnography, with the Tairona taking the stage in the former, and the Kogui in the latter. Disciplinary separation would thus appear later in Reichel's work, as this rupture was necessary to treat contemporary Indigenous peoples as infants, as G. Mason did. In his 1953 paper, Reichel pointed out that many archaeological sites could not be called Tairona. Yet, he noted that Tairona "derives from the Tairo tribe" (Reichel-Dolmatoff 1953:19), thereby merging an archaeological culture with an ethnic group. To support his claims, he credited the chronicles of the conquest, such as those of Antonio de Herrera, who, according to Reichel, had been the first to use Tairona as a "tribal designation" (Reichel-Dolmatoff 1953:18). Reichel was dead wrong: Antonio de Herrera only used secondary sources, such as the famous "Anonymous Report" that recounts the conquest of Santa Marta. Herrera never left Spain and made syntheses that were entrusted to him, given his role as a scholar at the Spanish court (Malavialle 2008).

The General Archive of the Indies in Seville houses an anonymous report called "Report on the discovery and population of the province of Santa Marta," the oldest document about the region (Friede 1955), "written towards 1532" (Tovar 1994:125), which recounts Spanish military campaigns

in search of gold and other riches, beginning in 1525. It mentions the "Tairona valley that is 6 or 7 leagues from Buritaca, which is a great valley and very rich" (Tovar 1994:139). The Spaniards became interested in that valley after they pillaged the villages south of Santa Marta, currently recognized as ancestral Kogui territories—although, in private hands, they are places of pilgrimage for Kogui families. The most important village in that territory was Pocigueica (Tovar 1994:125–144), reputed to be the Tairona capital. As the report noted, Governor García de Lerma was angry at the people of "Pueblo Grande" or Pocigueica; not only did he snatch their gold but burned their fields and villages. After a few years of looting, there were no Indigenous peoples in the area. The gold that the Spaniards collected during the first half of the 16th century in the surroundings of Santa Marta was produced by those communities, perhaps in the previous two millennia; once the pieces that were in use were seized, plus those that were part of grave goods, nothing remained at the end of the 16th century, leaving the area virtually unoccupied. In the 17th century, no one talked about gold searching campaigns in the regions to the north of Santa Marta, such as La Ramada, or the south, as Pocigueica. Only in the 18th century was there a regained interest in these areas: after the exhaustion of the gold trade, a land market begun to form; the wealthiest families in Santa Marta created large "haciendas" (Herrera Ángel 2002), in some of which the old villages of La Ramada and Pocigueica were located—later to be researched by US archaeologists. The first collection of pre-Hispanic objects was formed in "Hacienda Cincinnati," a coffee farm owned by an American electrical engineer who arrived in Santa Marta at the end of the 19th century (Viloria 2019).

Returning to Reichel, after popularizing the idea of the existence of a tribe called Tairo in his 1953 article, he stated—following 17th-century documents he had read—that northern Colombia was composed of a mosaic of cultures that the Spanish managed to identify fully after the conquest. The construction of cultural maps was a 17th-century concern of an incipient modern organization, which continued in the 18th century with the Bourbon reforms of the Spanish crown (Rodríguez 2003), a landmark of which was the equivalence between territory and language, especially after the grammar standardizations of the Spanish language (Mignolo 1986). The Indigenous "cultures" defeated in the conquest and the territories they occupied were seen through that lens. The regional history of Santa Marta was thus constructed along its economic possibilities. Father Julián had said in the 18th century that Santa Marta "is the pearl of the Americas" because it has a river that communicates with the mines of the interior, it has pearls in its seas, and a port that connects Spain with regions fertile in resources. In this light, Reichel-Dolmatoff (1951) used 17th- and 18th-century documents to create historical-cultural maps in which he assigned ethnic groups to specific areas, thus completing the mosaic imagined by Father Julián. For Reichel, the province of the Tairona included the entire northwestern face of the SNSM, as well as the southern areas called "Pueblo Grande" and "Pocigueica" in an

anonymous chronicle. Using the same criteria as G. Mason, Reichel considered that the Kogui were the least acculturated group, so much so that he was able to establish continuities between them and the Tairona, but only for academic purposes. The Kogui were useful because they were the most authentic. Their territory, further, also coincided with that of the Tairona described in 17th- and 18th-century chronicles (Reichel-Dolmatoff 1953:27).

Reichel described the Kogui kinship system to indicate that the names of some bays of Santa Marta bear the name of the clans he had identified in the genealogies he made by interviewing more than 70 individuals at the end of the 1940s (Reichel-Dolmatoff 1953:32). He also noted that those bays hosted large amounts of archaeological materials, such as the polished quartz named with the prefixes of mythical tribes. Bahía Concha is the Kurcha bay associated with the Kurcha-Tuxe that are the ancient Matúna (Reichel-Dolmatoff 1953:33). The Kurcha-Tuxe were a version of the Tuxe, the complement of Dake, vital for establishing alliances and for the reproduction of society, as I noted in Chapter 1. The Matúna, Tairona, Tangui, Nuldaxága-kve, Nébbi-yaxa and Aldu-guíji had a cultural and linguistic affinity with the Kogui that strongly supports the continuity between them and the Tairona, as seen from their genealogies. Reichel stated that the Kogui, given ethnographic and historical evidence, are a mixture of various tribes, including the Tairona. Cultural continuity was evident in the settlement pattern and agricultural system, but also in the ceremonial use of pottery and polished quartz—which he found in his archaeological excavations (Reichel-Dolmatoff 1953:42). Yet, he was unaware that those archaeological sites were the ancient villages of the clans razed during the conquest, and that the objects he called "archaeological" are animated entities that need to return to their original places. This is weird, though, because he acknowledged that after a visit to the collections of the Ethnological Museum in Santa Marta, the Kogui "immediately identified the Tairona archaeological pieces" while rejecting those from the coast because they were made by "other people" (Reichel-Dolmatoff 1953:44). Reichel followed a chain of descriptions that gave weight to the idea of a cultural continuity that he will consider impossible in later publications. The words recorded in the chronicles of the 17th and 18th centuries, which he quoted, were understood by the Kogui at the time he did his ethnographic research among them. He pointed out how, for example, the word Pocigueic has a Kogui prefix, *busi*, which means sister, and a termination, *geka* or *geika*, which means hill or mountain range. Pocigueica, then, would mean "hill of the sisters" (Reichel-Dolmatoff 1953:48), showing that the territory was an extension of kinship relations. Pocigueica, the mythical city of the Anonymous Report of the 16th century, was possibly a matrilineal population associated with the Dake clans since the Tuxe are patrilineal; it was the place where the children of the older sisters resided. Now, with Francisco Gil we are searching information with the oldest mamos to know the history of Pocigueica.

For Reichel, positioned on the side of a cultural-historical archaeology, cultural continuities were essential for an in-depth understanding of the archaeological record, without considering that contemporary populations were being subdued by miscegenation policies that sought to replace Indigenous populations with mestizos. The white elite considered the Indigenous and Afro-descendant components of the nation as obstacles to the integration of Colombia into global markets. For instance, in the 1930s, Colombian politician Luis López de Mesa (1970) argued that the curse of Colombia was the Indigenous and black residue that remained in the Caribbean population.

Reichel closed his 1953 article reviewing the places, the diet, and the material culture described in historical documents since the 17th century, and noted that the Kogui had mixed and moved so much that it was impossible to establish historical continuities from the conquest to the present, even though the Kogui language had given him and G. Mason the keys to the understanding the archaeological record. Reichel noted that when he did ethnography, the mamos were losing ground, and the culture was disintegrating (Reichel-Dolmatoff 1953:100). Considering the struggle of the Kogui, this was a prejudice of Reichel, not a sociological fact. Reichel, trained to see cultural mosaics that mobilized an image of static cultures, considered Kogui mobility as an anomaly. But it was not an anomaly; it was the mobility of societies that responded to marriage rules that implied large displacements. Following the notion of the savage slot (Trouillot 2011) and that of purification (Latour 2007), I can say that Reichel was feeding archaeological collections with pre-Columbians because it was his mission to fill the savage slot, inaugurated by the work of G. Mason. He did so by purifying his data, separating what was archaeological from what was ethnographic, despite that both were interchangeable in the field. Purification was necessary, so as not to generate conflict with a government that sought the disappearance of the Indigenous component of the nation. This purification allowed the governmental policies, when the social movement of the Indigenous peoples of the SNSM emerged, which considered them as illegitimate. The Koguis and the other tribes were alleged to be of recent creation so they had no rights to the land.

In 1963 Reichel established the Department of Anthropology at the University of Los Andes, where he created a program for professional training. It was the 1960s, and he had abandoned his pretension to register archaeological sites in the SNSM, becoming more oriented to understanding the shamanic world (Langebaek 2005). He resigned from Los Andes in 1968, beset by a growing wave of criticism about his aseptic vision of the Indigenous condition at a time when landowners were acting against communal lands, and violence was mounting in rural settings (Friede 1976). Despite the resignation, he left on the national agenda the idea of cultural continuity in the SNSM but noted that anthropological dimensions should be treated independently of archaeological issues and that ethnographic data would only serve to illuminate archaeological data, without meaning anything else. In the 1960s and 1970s, when Reichel reached impressive peaks of popularity,

several anthropologists were persecuted and exiled for their militancy with Indigenous and peasant movements (Arocha 1984). At the beginning of 1940s, until the beginning of 1970s, the Indigenous past–present continuity was recognized, but only to serve as an archaeological heuristic. Practically, a past–present rupture helped positioned archaeology as a knowledge against Indigenous social movements.

With the advent of the 1970s, the end of the Vietnam War, and popularization of countercultural movements, which some authors see as the fundamental features of postmodernity (Jameson 1991), the SNSM was flooded with marijuana. Its production and commercialization generated large amounts of money for rural populations; given its profitability, river basins began to be deforested, some of them destroyed forever (Aide & Cavelier 1994). The disaster was not only ecological. The drug money unleashed unstoppable violence, which never ceased but merged with the paramilitary violence of the 1990s. With a large number of peasants from the interior of the country seeking an elusive fortune in the SNSM, the 1970s witnessed a conflict that has not yet ended and is recycled as the global economy keeps allocating a function to the region as an enclave: gold in the 16th century, Indigenous labor in the 17th, land in the 18th, agribusiness in the 19th, alkaloids in the 20th, and tourism in the 21st.

In the 1970s the conflict was fueled by the marijuana business and its consequences—scams, extortion, and theft triggered wars that compromised various groups, in some cases dominated by Wayuu clans. Another source of conflict was *guaquería*, the looting of archaeological sites, that even led to armed clashes between families. As the late Franky Rey, one of the first *baquianos* who began guiding tourists, told me, the war in Ciudad Perdida was prompted by the gold excavated on the site and later bought by the Colombian state and private collectors (Field 2012). Seeing that the peasant families were killing themselves for the gold of Ciudad Perdida, he went to Bogotá to ask for the military to impose order in the area. Small groups of soldiers were sent to the site located in the upper Buritaca River, about 24 kilometers from the last population with vehicular access. The archaeologists began to record the terraces along the Buritaca; on arriving at the archaeological complex, the first terrace that was found there had the consecutive number 200, so the site began to be known as Buritaca 200 (Groot 1980). The first archaeological missions were accompanied by young peasants, such as Franky Rey. Soon after, the restored site became an archaeological park controlled by the ICANH. Unofficial versions indicate that, in the 1970s, young people from Bogotá arrived in the Buritaca together with the soldiers to study the archaeological sites that were being looted. The peasants helped them take measurements, make trenches, fix the steps and terraces to leave the village tidy; they were the ones who adapted the site so that visitors could frequent it; they were the ones who created the stations currently used by tourists to walk the 24-kilometer trail leading to the site. Yet, their memories are invisible because they are the outcasts of the SNSM, represented as

predators (Serje 2008). Besides the state and NGOs, guerrilla groups were also present in the region, supporting peasant and Indigenous groups in their struggle against the growth of large estates. A wave of intervention followed, this time by area experts, who determined how the state should exercise control over a territory that had historically been exempt from government control.

In addition to the measurements made by archaeologists and the army bases on the site, the pressure to intervene in Ciudad Perdida led to the formation of NGOs such as the ProSierra Foundation, which sought to stop the deforestation resulting from marijuana cultivation; one of its founders, the anthropologist Margarita Serje (2008), said that it was a utopian project based on an understanding of the sustainable practices of the Tairona, supposedly still residing in the Kogui, and seeking to generate sound management strategies that could be taught to peasants. It was based on a supposed ethnographic legacy described by Reichel, and according to which, the Tairona had formed great chiefdoms without causing any environmental damage. Although for a time, Reichel conceived of historical relations between the Kogui and the Tairona, by the end of the 1960s, he speculated on the mechanisms of social complexity in northern Colombia only from an archaeological point of view (Reichel-Dolmatoff 1977). He investigated the ecological management strategies of Indigenous people through shamanic practices. His arguments were used to posit a purported environmentalism of Indigenous people, especially the Kogui. In his book on the Desana (Reichel-Dolmatoff 1968), this position was specified; there he argued that mythical prohibitions had a sustainable effect over the territory. These theses gave Reichel prestige at a time when countercultural movements promoted sustainable strategies and called for a certain primitivism that fueled the New Age (Lindquist 1997). Although in the 1970s, Reichel did not focus his attention on the SNSM, his thesis on shamanism and his theories of environmental sustainability were used to imagine an ecological and sustainable Indigenous movement in the SNSM.

In the late 1960s, Reichel-Dolmatoff became an icon for Californians interested in shamanic issues, in the sidereal journeys of Colombia's Indigenous people. The shamans became referents of a countercultural movement that required new languages to express its disagreements with modernity. The exploration of the psyche using hallucinogens, together with sustainable management of the territory, made shamans, especially from the Amazon, the target of anthropological studies that were thought to be useful in overcoming the probems of modernity. This issue was in high demand by the middle classes eager to consume stories of ecologically sustainable shamans, so Reichel spent much of the 1970s in Los Angeles.

The anthropologists who worked at the SNSM, most of whom had been educated by Reichel at the University of the Andes, presented the Kogui as millennia-old societies who practiced a sustainable management of the environment and whose villages should serve as models for the future cities of the

SNSM. The Kogui became the ideal good savage, a positively utopian image (Trouillot 2011), with the bonus of being politically inactive. They became "ecological natives" (Ulloa 2004), worthy heirs of the Tairona, an example of habitability without environmental collapse. The Tairona went from being antediluvian giants in the 18th century to become self-sustaining urbanists in the 20th century. Despite the positive role that the Kogui played in this literature of the 1970s, they were not conceived as the survivors of the centuries-old violence staged in their territory—beginning in the 16th century with the assaults on their villages, intensified in the 18th with the conformation of the land market, radicalized in the 19th century with the presence of Capuchin missions, and continued in the 20th with the arrival of the archaeologists.

The rupture between past and present was a disciplinary partition that was imposed like a mantra. The ethnographers searched for possible connections of the Kogui with pre-Hispanic peoples, but always retaining the temporal rupture. The archaeologists treated archaeological complexes as evidence of extinct societies that disappeared in the 16th century, as Reichel-Dolmatoff (1951) had explained. Since the disciplinary partition did not even consider the Kogui as survivors of centuries of expropriation, archaeology was entrusted with giving content to archaeological findings made since the beginning of the 20th century. A leading force behind these historical images was Reichel; that is why the analysis of his work helps to understand the anthropological construction of the Tairona nation. Furthermore, that is, as well, the reason why Indigenous people pretend to cut with his legacy.

In the 1960s, when Reichel had exhausted his experience in the SNSM, he was invited by Johannes Wilbert, then at the University of La Salle, in Caracas, to a seminar on plants among the Indigenous people of South America. In that seminar, he presented a thesis that would be decisive in the imagination of pre-Hispanic times by Colombian archaeology: corn, which arrived from Central America to the shores of the current Colombian territory, allowed nomadic societies of the coast to colonize the mountains. Corn became the main staple of chiefdoms (Reichel-Dolmatoff 1977). "Maize colonization," as he would later term it, allowed two societies in Colombia to reach the chiefdom level: the Tairona and the Muisca (Reichel-Dolmatoff 1982). Once "corn was discovered," native peoples could cultivate a plant that produced surpluses used to mobilize labor for the construction of roads and villages. This way, Reichel strengthened G. Mason's dream: contemporary indigenes were backward peoples that could not be compared to past societies. In a book commissioned by Thames and Hudson—a British publisher specializing in easy-to-read archaeological books for modern audiences—Reichel began to popularize these theses, generating a periodization accepted to date, which assumes that corn allowed the passage from nomadism to sedentarism. In this evolutionary classification, the period before agriculture was called "formative," as it was the transition to "classical" periods, themselves entirely agricultural (Reichel-Dolmatoff 1965).

In his archaeological syntheses of pre-Hispanic Colombia, Reichel presented the difference between the archaeological complexes of the SNSM and the coast of Santa Marta as temporal differences, no matter that he had previously presented them as geographical in his study of historical sources (Reichel-Dolmatoff 1951): the natives of the coast, according to his thesis of maize colonization, were more ancient than those of the SNSM—and less developed. His historical analyses were more overwhelming: Spanish chronicles report exchange systems between the Sierra and the coast, revealing the complementarity between societies that inhabit various ecosystems (Condarco & Murra 1987); it was a relationship of complementarity and not an expression of backwardness—in which, supposedly, agriculture was the feature of civilization. Coastal societies supplied dried fish to those on the Sierra, while the latter supplied gold and blankets. These exchanges were not only economic. They were kinship relations between various clans, including the Kogui (Reichel-Dolmatoff 1953), who recognized the family clans living on the coast, such as the Kurcha-Tuxe, who named Bahía Concha (Shell Bay). Not only were the northern Tairona complexes part of their clans, but also those in the south, in the region of Pueblo Grande or Pocigueica. At present, the Kogui from various basins recognize the vestiges from El Congo, to the south of Santa Marta, as part of the Pocigueica complex. Some Kogui with whom I have talked refer with sadness and nostalgia to Pocigueica, an open wound that expresses the power of the violence that spread over these communities with the arrival of Europeans. Even today, within the framework of reparations for victims of paramilitary violence, the Kogui ask the Colombian state that the reparations not be limited to the last three decades of the 20th century, but that they be applied from the onset of the Conquest (Prado 2018; Mejía-Cáceres 2018).

To appreciate how Reichel's paradigm on the historical development of northern Colombia became a rule to follow, I can recall just one case. In the 1980s, after security around Ciudad Perdida was achieved to some extent and visits by tourists were more frequent, a student of Reichel openly said that the current Kogui are a mix of groups, starting in the 18th century (Oyuela 1986). That premise, popularized by the archaeologists, was countered by OGT, which channeled the collective struggles of the SNSM nations to recover the territory they had lost by colonialism since the 16th century. One of the immediate goals of OGT was to reclaim Ciudad Perdida as an ancestral Kogui site (Julio Barragán, personal communication); yet, it rapidly understood that the struggle ought to be more extensive, including territorial expansion and the exercise of autonomy—regarding education and traditional medicine. In a sense, the creation of OGT was intended to close the gap created by the disciplinary rupture between past and present. The organization, unlike the archaeologists, did not look for traces in the present to interpret sites from the past; instead, it claimed that the sites of the past were to be understood as evidence of the attempt to erase them from the present. In any case, the most important feature in the 1980s regarding the Indigenous nations of the SNSM was the strengthening of their organization.

The 1990s witnessed the formation of a new social movement; it also witnessed another cycle of violence that flooded the SNSM anew with blood. Cocaine was the new commodity produced for global markets. Several armed groups disputed the territory in order to control the production and shipment of the alkaloid. That caused forced displacements and the killing of Indigenous leaders (Prado 2018). There also was an increase in tourism, mostly because the PNNT was given to a private operator (*El Espectador* 2009). The war of the 1990s was the previous step for a normalization of the territory that sought its rearrangement geared to tourism.

At the beginning of the 2000s, archaeological research in the SNSM gained a new impetus (Langebaek 2005). A decade later, a doctoral dissertation appealed to a century-old imaginary to see in the Tairona the power of *caciques* (Giraldo 2010). For many years, researching archaeological Tairona sites has been a male issue, so Tairona archaeology is not just an expression of US ideology but an androcentric narrative (Gero & Scattolin 2002).

The 18th-century imaginary reproduced by authors such as Father Julián posited that the builders of the villages looted by peasants or excavated by the archaeologists were powerful tribes who posed strong resistance to the Spaniards and who were related to the Kogui, yet without being their ancestors. It was up to ethnography to study contemporary tribes and for archaeology to do the same for the missing ones. Both disciplines plied their trades within this dichotomy. Despite the early- and mid-20th century violence against the Kogui, archaeologists such as G. Mason and Reichel-Dolmatoff considered them only to the extent that they were a likely source of analogies to understand the archaeological record; their political claims were mere appendices that did not deserve any attention in their reports. Ethno-archaeological research, after all, is uncritical and helps perpetuate stereotypes (González-Ruibal 2006).

The 20th century ended with a quite particular understanding of northern Colombia's history: contemporary Indigenous people only had a relationship with past peoples if it served to make intelligible archaeological objects or if it served to emphasize sound environmental practices. It served no political claims. During much of the 20th century, the complicity between academia and the state denied the natives their right to further their own historical visions, which included a forceful critique of colonialism. Once the Tairona notion was in place, the social imaginary took charge of constructing souvenirs, monuments, and images of those mythical natives; it also gave the state the legitimacy to turn pre-Hispanic villages into archaeological sites disconnected from contemporary Indigenous communities. "Vacant" areas were declared Natural Parks to be administered by Parques Nacionales Naturales (National Natural Parks, PNN hereafter). ICANH was to administer the archaeological sites. These interventions implied conceptual constructions of the territories, seeing them as ecosystems or as archaeological records void of people. Culture was an item intentionally excluded.

The second experience besides OGT is the Palmor Intercultural School. In this scenario, the aim is to apply oral memory methodologies to generate a history that allows us to understand hegemonic history. We can say that these intercultural experiences began to emerge after a constant practice of criticism of traditional archaeology. So we must understand this book in that sense, as a history of more than a decade of generating a decolonization of archaeology and the past.

When looking in detail at the process of expropriation of territory suffered by Indigenous peoples, we see that archaeology played a role of complicity by serving as a witness to the cultural breakdown. This involved a process of archaeologizing sacred sites. Thus, it is understandable that the agenda of the Indigenous social movement of the SNSM does not use the expression "archaeology" for any of its practices. On the contrary, the word de-archaeologization has been useful in communicating the desire of Indigenous peoples to no longer be objects of historical or ethnographic characterizations. In the workshops that we have developed at the Universidad del Magdalena, the notion of decolonial archaeology has been useful to encompass those practices that seek to understand the impact of colonialism on Indigenous peoples. Then decolonial archaeology has allowed the opening of a border area where Indigenous and academics seek to understand colonialism. This has allowed the formation of two experiences. The first is the archaeology school in the Taganga community. In this case, archaeological and ethnographic recording methods have begun to be used to understand local history and culture.

The management of Tairona's archaeological sites

At the beginning of the 2000s, there was optimism about the benefits that could be obtained from archaeological parks. It was clear to bureaucrats that there was something out there called an archaeological park that needed to be controlled and exploited for the benefit of the state. So in this period, it was difficult to imagine that the state would recognize that these places were not archaeological parks but sacred sites.

At the end of the 2000s, I arrived in Santa Marta as a newly appointed anthropology professor at the University of Magdalena. The guns of the paramilitary war that had just ended were still smoking, and a timid optimism was beginning to grow in a society heavily hit by violence. But that was not enough. Some anthropology students, committed to the defense of human rights, were threatened before our eyes and forced to emigrate. Those threats were made by the paramilitary group known as the "Tairona block," still trying to impose its law in the region. It was no accident that the block had that name, as those paramilitaries were defending their control of the territory that Reichel-Dolmatoff defined as Tairona. In that complex environment, the ICANH sought to order the territories with archaeological parks; as some simply did not have management plans, their limits and property titles were

unknown. On the other hand, PNN intended to do the same, but not to archaeological sites but to "natural" areas. For both, the natives were unwanted guests.

As an anthropology professor, I was summoned to a meeting with an ICANH officer and a representative of the GHF. They wanted the university to propose a management plan for Ciudad Perdida and Pueblito Chairama, that is, a plan for improving tourists' access conditions, measuring carrying capacities, and getting to know the legal status of property rights. In short, the meeting was about ordering the Tairona villages open to the public from the point of view of state planning. Prior to the meeting, I had visited Pueblito Chairama for the first time, and I was shocked by its beauty. The well-kept terraces, forming a perfect circumference, made the site unlikely in the middle of the jungle with its irregular shapes. I found two PNN officers who stood out, with the green of the forest in the background, in their cargo pants, black hiking boots, and blue shirts. One of them had been my student. We started talking, and I asked him about the situation of the PNNT: the plans for the area, the situation of the Indigenous people that had been occupying surrounding areas, the fate of the archaeological sites within the park. He told me that they had been ordered to evict the Kogui families who lived in adjoining areas, and who visited the site regularly to make their payments—by doing so, they were renewing their links with the territory, which they considered their own, but was at that time managed by PNN and the ICANH; by doing so, they were superimposing the concrete and collective power of the families on the abstract and unilateral power of the state. A payment is not a purely magical activity, but a recognition and reproduction of the kinship network and its relationship to the territory. We need to explain this a little more. Bruno Latour (2008) pointed out that there are no groups but group formation; in this sense, payments allow the reproduction of Kogui clans and give meaning to the territory as a part of such an organization. ICANH officers were worried that payments at the site would increase, making it difficult to subsequently evict those families. It was, indeed, a well-founded premonition. A senior officer of the ICANH had said to me that "we will return to the 18th century when only a few chosen had the right to know." He meant that if the Kogui recovered Pueblito the archaeologists would be excluded from the site. Because of this fear, pressure was put on PNN to evict the Kogui families. The headquarters in Bogotá pressed the regional branch to use its "available pressure" to block the Indigenous attempts to occupy the site. "Available pressure" amounted to the two officers I had met, who were locals in a way and thus did not dare to touch the Kogui sanctuaries, much less to expel the families and leaders who were setting them up. As one of them told me, "there was nothing wrong with putting little rocks on the floor, or planting manioc, *palangana*, or plantain on unproductive land." At this time, various documents were sent from the central government so that the anthropology department of the Universidad del Magdalena could make expert reports. In all cases, the results indicated that Indigenous peoples were there before the state; therefore, it was necessary to attend to claims for territory and autonomy.

The argument legitimizing these institutional pretensions was the supposed right of the state over the archaeological heritage of Pueblito Chairama, backed by the power of a modern discipline, archaeology (Londoño 2007). As Michel Foucault (2013) noted, scientific disciplines are a part of the conditions of possibility of discursive objects, along with legal frameworks and other institutional arrangements. There would be no archaeology of northern Colombia without the network of archaeological collections, which allowed the United States to declare dead all the Indigenous people of the countries where the UFC operated. Nor would it have existed without disciplinary institutionalization happening in Colombia in 1941, reviving the postulates of G. Mason, Marshall H. Saville and Father Julián—a robust, centuries-old discursive archive. Such an imaginary—imposed by global designs, first by the Spanish crown in the 16th century (Mignolo 2012), and then at the beginning of the 20th century by the UFC—has nowadays materialized in unusual forms: in sculptures of Tairona giants, located on the promenade of Santa Marta bay and representing the antediluvian Tairona of Father Julián; in the Tairona Palace, a former hotel from the 1950s, currently the seat of the government of Magdalena; in the ferocity of the paramilitary of the "Tairona block"; and in the grandeur of the Tairona Gold Museum. The latter is housed in a colonial building first used for customs, then as the headquarters of the UFC in Santa Marta, and now for exhibiting pre-Hispanic objects. These materialities, the landscapes that form around historical imagination, have unleashed state intervention processes responsible for maintaining and reproducing those ideologies. For example, the quite elaborate script of the-Tairona Gold Museum does not question the archaeological images institutionalized by the UFC. Likewise, the ICANH requests that all CRM reports include a regional background, which implies quoting Reichel-Dolmatoff; if an archaeologist does not quote Reichel or takes distance from him, he or she could be sanctioned by a reviewer, who may demand the inclusion of Reichel's work.

By the early 2010s, with the decline of paramilitarism in the SNSM, several state institutions sought to order and control the territory. In Pueblito Chairama the institutional presence was weak, and the indigenes, through their rituals and resettlements (that even involved buying land from peasants), consolidated a constant presence in the site and its surroundings. This did not happen in other areas of the SNSM. The number of visitors to Ciudad Perdida increased dramatically. In 2016, I took a tour to the site as if I were a simple tourist and climbed in early January. According to the *baquianos* with whom I spoke, about 250 people were doing the tour every day at an average cost of US$250. That fare was redistributed between a Kogui reservation, a peasant community, the ICANH, and other actors.

The growth of tourism to Ciudad Perdida in the last decade results from its global publicity based on the past/present separation, which exalts Indigenous peoples from the past while condemning contemporary ones. Foreign visitors to Colombia increased by 10 percent per year in the last decade, the same

increase reported for Ciudad Perdida. Yet, statistics are unclear because tour operators do not always report the real number of visitors, although they have to register with the ICANH. My observations from 2015 to 2017 indicate that a single ICANH officer is handling the registry; given that this control is limited, access to the site rests entirely in private hands. Growing tourism in the region has forced state institutions to intervene with specialized constructions of the territory and its people—pure governmentality (Dean 2017). In some areas, those policies cannot be enforced because territorial control is in other hands, such as in Ciudad Perdida. State controls do operate over fishing communities, evicted from their usual fishing sites, because those areas are now considered strategic in the provision of environmental services (Martínez-Dueñas 2016).

The discourses more widely used in this biopolitics are heritage and environmental conservation. As for the former, in the last two decades, the state has enforced laws prohibiting the commercialization of pre-Hispanic objects, which also broadened the scope of intervention of CRM (Londoño 2016). Archaeology has become a technical practice serving environmental assessments of development projects; no room for analysis and discussion exists. The biopolitical effect is that the past becomes a matter of experts; local populations are considered variables of alteration that ought to be contained. Along with the SNSM Indigenous peoples, peasants and Afro-descendants are separated from their pasts, built and distributed by the experts; their voices, at most, are the folkloric images that nourished the 1960s images, such as that of a cheerful and tropical Caribbean. According to these images, a multi-ethnic society emerged from the darkness of conquest, and then blacks, whites, and Indians merged through *cumbia* and carnival (Buelvas 1993), forming a harmonious collective. This idealization bypasses how Caribbean landowners expropriated communities and killed leaders to increase their landholdings. As Figueroa (2009) has shown, these idealizations of the Colombian Caribbean contributed to deactivate struggles for a fair redistribution of the land, while creating images of Caribbean peoples as lazy and unproductive—just eager to sing and play the accordion. The ultimate expression of this large-scale paramilitary ideology is Colombian pop singer Carlos Vives, who in 2007 won a Grammy Award for *vallenato* (Figueroa 2009). At a concert of Vives in Santa Marta in 2014, the tri-ethnic society materialized on stage: Arhuaco accordionists and Afro-descendant percussionists joined Vives, the white fellow, to perform *cumbia*, considered to be the authentic rhythm of the region. This performance ignored the violence that has plagued the SNSM only to mobilize images that are functional to the expansion of large estates. This all culminated in 2018 when Vives was named honorary president of the "Tairona Indian" *vallenato* festival.

As for the discourse on environmental conservation, the region is a factory of natural services. As in the case of heritage, this discourse considers Indigenous people as mere variables that hinder the profit to be made out of environmental services. No wonder peasants, fishermen and Indigenous people inhabiting the SNSM are routinely harassed (Cantillo 2012). This

discourse creates the conditions for a corporate takeover of natural goods. The natural services offered by the PNNT are managed and exploited by a private company. In this regard, the most important management artifact in the PNNT is the park itself, which, along with the Navy, controls the old fishing areas of the Indigenous community of Taganga, generating as yet unresolved conflicts. Communities like those of Taganga are caught between two fires: on the one hand, the state limits their traditional fishing areas, and on the other, the real estate market pressures them to sell their territories for tourist ventures.

These two discourses, heritage and environmental conservation, translate into regulations and impositions that disadvantage local communities while supporting multinational enterprises promoting sustainable economic exploitation and a form of tourism that does not question the traditional historical accounts of the region. A former director of the ICANH, Fabián Sanabria, wrote in the report with which he ended his term that given his alliance with the GHF the institute had been able to preserve and maintain the "garden of forking paths, after the traces of the disappeared civilization of the Tayrona" (Sanabria 2014: 22). ICANH's management, Sanabria commented, had been very useful because it allowed the site to be kept open to tourists. The most interesting thing about Sanabria's report is not that a high state officer reproduces images that were used by the UFC to disqualify contemporary peasants and Indigenous people; the most interesting thing is that it states that this is how the ICANH manages a complex territory with diverse social movements fighting to preserve their lives before the attempts of multinationals to evict them. Sanabria also pointed out that regarding Indigenous peoples, the ICANH had been forced to mediate between the antagonistic positions of development and preservation (Sanabria 2014: 34). Local peoples, once more, are portrayed as cumbersome fellows in a territory ripe for foreign investment.

An interesting fact that Sanabria recounts in his report, and that is illustrative of how the state tries to intervene in the territory through a neo-colonial policy, are the archaeology field schools that he mentions as a positive asset of his term. Since the beginning of the 2000s, various archaeology field schools have been established, mostly linked to American universities, designed for foreign students paying significant sums of money for digging and being in ruins associated with the Tairona. The website of the GHF states that "the buildings of Ciudad Perdida formed the political, economic, and social center of the Tayrona society before it mysteriously disappeared in the 16th century." It suffices to go to the nearest library and consult the Anonymous Report of the beginning of the 16th century to unravel that mystery: a troop of conquerors, packed in caravels, who came for as much gold as possible. The idea of an archaeological culture, Tairona—built at the beginning of the 20th century by the archaeologists, some of them spies associated with the UFC—now serves to sell educational services that reproduce the hegemonic archaeological imaginary. The youngsters attending these schools are in small bubbles,

isolated from any contact with the social reality of the territory; no wonder they incorporate all these discourses uncritically. The archaeological field schools designed for foreign students convey essentialized visions of the territory; the past thus consumed is that crafted since the beginning of the 20th century by fellows such as G. Mason, for whom the inhabitants of the present, their problems, their demands, are derisory, and must be erased and neutralized, as appropriate, to ensure the effective operation of American capitalism. The current UFC-rebranded Chiquita Brand, a few decades ago, sponsored the paramilitarism that sought an ethnic cleansing of the territory (Nieto & Sudarsky 2008).

An interesting issue in these narratives, such as the one expressed on the website of the GHF, is the apparent neutrality of the argument that states that no one knows what happened to the Tairona as if the earth had swallowed them ("mysteriously disappeared in the 16th century"). Bypassing how local populations were banished and destroyed is not naïve; it is intentional and helps to promote ideologies that are useful to extractivist economies—not of gold, as in the 16th century, but of archaeological experiences associated with digging sites of ancient giants. The contemporary imagination will not look for antediluvian beings, but the traces of chiefs using sampling models protected by the aseptic hypothetical deductive method.

While we are in one of the precincts of the Universidad del Magdalena, I relate my historical research on the history of archaeology. I show photos of G. Mason, of J. A. Mason, of Heye, of Reichel. Mama Ramón Gil suggests to me that I make these past events known, which will be of great help in understanding the history of the mountains.

I hope I have achieved that goal.

Conclusions

The development of archaeology in northern Colombia was linked to the consolidation of the UFC. As archaeological collections were assembled in the United States, political interventions guaranteed the expansion of US companies. Within this political logic emerged the collection of Colombian archaeological objects in the United States under the idea of Tairona culture. The latter fostered research programs aimed to characterize tribes that had supposedly disappeared. Such a discourse was essential for generating the public opinion that contemporary communities had nothing to do with the tribes of the past. This disconnection justified US interventions and the expansion of companies like the UFC.

References

Aide, T. M. & Cavelier, J. (1994). Barriers to lowland tropical forest restoration in the Sierra Nevada de Santa Marta, Colombia. *Restoration Ecology*, vol. 2, no. 3, pp. 219–229.

Arocha, J. (1984). Antropología propia: un programa en formación. Arocha, J., de Friedemann, N. & Herrera, X. (eds.). *Un siglo de investigación social: antropología en Colombia* (pp. 253–300). Bogotá, Colombia. Etno.

Barringer, T. & Flynn, T. (2012). *Colonialism and the object: empire, material culture and the museum.* United States. Routledge.

Bischof, H. (1983). Indígenas y españoles en la Sierra Nevada de Santa Marta, siglo XVI. *Revista Colombiana de Antropología*, vol. 24, Colombia, pp. 75–124.

Bohórquez, C. (2006). Miranda y Bolívar: dos concepciones de la unidad de la América hispana. *Procesos Históricos: Revista de Historia, Arte y Ciencias Sociales*, no. 10. Venezuela, pp. 1–20.

Bonilla, V. (2006). *Siervos de Dios y amos de los indios.* Colombia. Universidad del Cauca.

Bonomo, M. & Farro, M. (2014). El contexto sociohistórico de las investigaciones de Samuel K. Lothrop en el Delta del Paraná, Argentina. *Chungará (Arica)*, vol. 46, no. 1, pp. 131–144. DOI: http://dx.doi.org/10.4067/S0717-73562014000100008

Browman D. & Williams, S. (2013). *Anthropology at Harvard. A biographical history, 1790–1940.* Boston. Peabody Museum Press.

Bucheli, M. (2005). *Bananas and business: the United Fruit Company in Colombia, 1899–2000.* United States. New York University Press.

Buelvas, M. (1993). La tri-etnia en el carnaval de Barranquilla. Villa, E. & Morales, J. *El folclor en la construcción de las Américas* (pp. 116–136). University of Pittsburgh, Latin American Archeology Publications.

Cantillo, L. (2012). Informe del conflicto en el Magdalena: los subregistros y la impunidad. *Revista de Estudios Sociales*, no. 42. Colombia, pp. 160–163.

Chapman, P. (2014). *Bananas: how the United Fruit Company shaped the world.* New York. Open Road + Grove/Atlantic.

Condarco, R. & Murra, J. (1987). *La teoría de la complementariedad vertical eco-simbiótica.* Breve biblioteca de bolsillo no. 2. La Paz, Bolivia. Hisbol.

Dean, M. (2017). Governmentality. *The Wiley-Blackwell encyclopedia of social theory*, pp. 1–2. New York. Wiley-Blackwell.

Delumeau, J. (2012). *El miedo en Occidente (Siglos XIV–XVIII). Una ciudad sitiada.* Spain. Taurus.

El Espectador.com (2009, 10 October). El Tayrona es de muy pocos colombianos. Retrieved 12 November 2014, from: http://www.elespectador.com/impreso/naciona l/articuloimpreso165962-el-tayrona-demuy-pocos-colombianos

Fabian, J. (1983). *Time and the other: how anthropology makes its object.* New York, United States. Columbia Univerity Press.

Fabian, J. (2014). *Time and the other: how anthropology makes its object.* Reprint edition. United States. Columbia University Press.

Field, L. (2012). El sistema del oro: exploraciones sobre el destino (emergente) de los objetos de oro precolombinos en Colombia. *Antípoda. Revista de Antropología y Arqueología*, no. 14. Colombia, pp. 67–94. DOI: https://doi.org/10.7440/antipoda14. 2012.04

Figueroa, J. (2009). *Realismo mágico, vallenato y violencia política en el Caribe colombiano.* Colección Antropología en la Modernidad. Bogotá, Colombia. Instituto Colombiano de Antropología e Historia.

Foucault, M. (2013). *History of madness.* London & New York. Routledge.

Friede, J. (1955). *Documentos inéditos para la historia de Colombia: coleccionados en el Archivo General de Indias de Sevilla.* Bogotá, Colombia. Academia de Historia.

Friede, J. (1963). *La explotación indígena en Colombia bajo el gobierno de las misiones: el caso de los aruacos de la Sierra Nevada de Santa Marta, vol. 3.* Bogotá, Colombia. Punta de Lanza.

Friede, J. (1976). *El indio en lucha por la tierra* (No. HD1265. C6. F74 1976). Bogotá, Colombia. Punta de Lanza.

Galvis, S. & Donadío, A. (1986). *Colombia nazi, 1939–1945: espionaje alemán: la cacería del FBI: Santos, López y los pactos secretos.* Bogotá, Colombia. Planeta.

Gero, J. M. & Scattolin, M. C. (2002). Beyond complementarity and hierarchy: new definitions for archeological gender relations. Millegde, S. & Rosen-Ayalon, M. (eds.). *Pursuit of gender: worldwide archeological approaches* (pp. 155–171). United States. Rowman & Littlefield.

Giraldo, S. (2010). Lords of the snowy ranges: politics, place, and landscape transformation in two Tairona towns in the Sierra Nevada de Santa Marta, Colombia. (Doctoral thesis). University of Chicago, Division of the Social Sciences, Department of Anthropology.

Gnecco, C. (1999). *Multivocalidad histórica hacia una cartografía postcolonial de la arqueología.* Bogotá, Colombia. Universidad de los Andes.

González-Ruibal, A. (2006). *El giro poscolonial: hacia una etnoarqueología crítica.* Spain. Consejo Superior de Investigaciones Científicas.

Groot, A. (1980). Buritaca-200: una fecha de radiocarbono asociada con objetos de orfebrería tairona. *Boletín Museo del Oro*, no. 8. Colombia, pp. 21–34.

Harris, C. & Sadler, L. (2003). *The archeologist was a spy: Sylvanus G. Morley and the office of naval intelligence.* United States. University of New Mexico Press.

Herrera Ángel, M. (2002). *Ordenar para controlar. Ordenamiento espacial y control político en las llanuras del Caribe y en los Andes centrales neogranadinos. Siglo XVIII.* Bogotá, Colombia. Instituto Colombiano de Antropología e Historia. https://doi.org/10.1111/j.1526-100X.1994.tb00054.x

Jameson, F. (1991). *Ensayos sobre el posmodernismo.* Buenos Aires, Argentina. Imago Mundi.

Jones, S. (1997). *The archaeology of ethnicity: constructing identities in the past and present.* London. Routledge.

Joyce, R. (2017). *Painted pottery of Honduras: object lives and itineraries.* Leiden, The Netherlands. Brill.

Julián, A. (1787). *La perla de la América, provincia de Santa Marta, reconocida, observada y expuesta en discursos históricos, por el sacerdote Don Antonio Julián.* Madrid, Spain. Antonio de Sancha.

Langebaek, C. H. (2005). De los Alpes a las selvas y montañas de Colombia: el legado de Gerardo Reichel-Dolmatoff. *Antípoda: Revista de Antropología y Arqueología*, no. 1. Colombia, pp. 139–171. DOI: https://doi.org/10.7440/antipoda1.2005.08

Langebaek, C. (2015). *Indios y españoles en la antigua provincia de Santa Marta, Colombia: documentos de los siglos XVI y XVII.* Bogotá, Colombia. Ediciones Uniandes-Universidad de los Andes.

Latour, B. (2007). *Nunca fuimos modernos: ensayo de antropología simétrica.* Madrid, Spain. Siglo XXI Editores.

Latour, B. (2008). *Re-ensamblar lo social: una introducción a la teoría del actor-red.* Buenos Aires, Argentina. Ediciones Manantial.

Laurière, C. (2010). Los vínculos científicos de Gerardo Reichel-Dolmatoff con los antropólogos americanistas franceses (Paul Rivet, Claude Lévi-Strauss). *Antípoda:*

Revista de Antropología y Arqueología, no. 11. Colombia, pp. 101–124. DOI: http s://doi.org/10.7440/antipoda11.2010.07

Lawton, L. (1987). Cruise ship industry: patterns in the Caribbean 1880–1986. *Tourism Management*, vol. 8, no. 4. Hong Kong, pp. 329–343. DOI: https://doi.org/ 10.1016/0261-5177(87)90091-4

Lindquist, G. (1997). Shamanic performances on the urban scene: neo-shamanism in contemporary Sweden. (Doctoral dissertation). Stockholm University. Department of Social Anthropology.

Livingstone, G. (2013). *America's backyard: the United States and Latin America from the Monroe Doctrine to the War on Terror*. London. Zed Books.

Londoño, W. (2003). La "reducción de salvajes" y el mantenimiento de la tradición. *Boletín de Antropología*, vol. 34, Colombia, pp. 235–251.

Londoño, W. (2007). Enunciados prescritos y no prescritos en arqueología: una eva-luación. *Boletín de Antropología*, vol. 21, no. 38. Colombia, pp. 312–336.

Londoño, W. (2016). Arqueología por contrato y nuevos contratos arqueológicos. *Jangwa Pana*, vol. 15, no. 1. Colombia, pp. 117–128. DOI: https://doi.org/10.21676/ 16574923.1756

López de Mesa, L. (1970). *De cómo se ha formado la nación colombiana* [1934]. Medellin. Bedout.

Lothrop, S. K. (1957). *Pre-columbian art*. London & New York. Phaidon.

Malavialle, R. (2008). Temps, récit et vérité historique chez Antonio de Herrera y Tordesillas. *Cahiers de Narratologie: Analyse et théorie narratives*, no. 15. Paris, France, pp. 1–18. DOI: https://doi.org/10.4000/narratologie.698

Martínez-Dueñas, W. (2016). *Flujos y redes multinaturales: un recorrido por mundos no [solo] modernos en Puracé*. Popayán, Colombia. Universidad del Cauca.

Mason, G. (1923). The riddles of our own Egypt. *The Century Magazine*, vol. 107. New York, pp. 43–59.

Mason, G. (1938). *The culture of the Taironas*. Los Angeles, United States. University of Southern California.

Mason, J. (1931). *Archeology of Santa Marta, Colombia: the Tairona culture. Part I. Report on field work*. Chicago. Field Museum Press, pp. 1–130.

Mejía-Cáceres, M. (2018). Representación de actores sociales e ideologías en los dis-cursos del "Acuerdo para la terminación del conflicto y la construcción de la paz estable y duradera en Colombia". *Discurso y Sociedad*, vol. 1, Colombia, pp. 55–89.

Mignolo, W. (1986). La lengua, la letra, el territorio (o la crisis de los estudios litera-rios coloniales). *Dispositivo*, vol. 11, nos. 28/29, pp. 137–160.

Mignolo, W. (1995). Occidentalización, imperialismo, globalización: herencias colo-niales y teorías postcoloniales. *Revista Iberoamericana*, vol. 61, no. 170, pp. 27–40. DOI: https://doi.org/10.5195/reviberoamer.1995.6392

Mignolo, W. (2009). La colonialidad: la cara oculta de la modernidad. *Modernologies*. Catalog of museum exhibits. Barcelona, Spain. Museo de Arte Moderno de Barcelona, pp. 39–49.

Mignolo, W. (2010). *La colonialidad: la cara oculta de la modernidad*. Buenos Aires. Ediciones del Signo.

Mignolo, W. (2012). *Local histories/global designs: coloniality, subaltern knowledges, and border thinking*. United States. Princeton University Press.

Moberg, M. (1996). Crown colony as banana republic: the United Fruit Company in British Honduras, 1900–1920. *Journal of Latin American Studies*, vol. 28, no. 2, pp. 357–381. DOI: https://doi.org/10.1017/S0022216X00013043

Nieto, P. & Sudarsky, J. (2008). El caso de los pagos de Chiquita Brands a los paramilitares en Colombia durante el período 1997–2004: un análisis de stakeholders. (Master's thesis). Universidad de los Andes. Facultad de Administración.

Ojeda, M. (2014). América Latina y la Gran Guerra: un acercamiento a la cuestión. *Política y Cultura*, vol. 42. México, pp. 7–30.

Oyuela, A. (1986). De los Taironas a los Kogi: una interpretación del cambio cultural. *Boletín Museo del Oro*, no. 17, Colombia, pp. 32–43.

Oyuela, A. (2012). Arqueología biográfica: las raíces nazis de Erasmus Reichel, la vida en Austria (1912–1933). *Memorias*, no. 18, Colombia, pp. 1–21.

Patterson, T. C. (1986). The last sixty years: toward a social history of Americanist archeology in the United States. *American Anthropologist*, vol. 88, pp. 7–26.

Pineda Camacho, R. (1984). La reivindicación del indio en el pensamiento social colombiano (1850–1950). Arocha, J. & Fridemann, N. (eds.). *Un siglo de investigación social. Antropología en Colombia* (pp. 197–252). Bogotá. Etno.

Pineda, R. (2012). La aventura de ser antropología en Colombia: Alicia Dussán de Reichel- Dolmatoff y la antropología social en Colombia. *Maguaré*, vol. 26, no. 1, Colombia, pp. 15–40.

Prado, A. (2018). Aproximaciones al proceso de reparación de los kággaba. *Oraloteca*, no. 9, Colombia, pp. 96–111.

Preuss, K. T. (1993). *Visita a los indígenas kágaba de la Sierra Nevada de Santa Marta: observaciones, recopilación de textos y estudios lingüísticos.* (Vol. 1). Bogotá. Instituto Colombiano de Antropología.

Price, D. H. (2008). *Anthropological intelligence: the deployment and neglect of American anthropology in the Second World War.* Durham, United States. Duke University Press.

Reichel-Dolmatoff, G. (1977). Las bases agrícolas de los Cacicazgos Sub-Andinos de Colombia. Reichel-Dolmatoff, G. & Dussan, A. (eds.). *Estudios antropológicos*, pp. 23–48. Bogotá. Instituto Colombiano de Cultura.

Reichel-Dolmatoff, G. (1951). *Datos histórico-culturales sobre las tribus de la antigua gobernación de Santa Marta.* Colombia. Banco de la República.

Reichel-Dolmatoff, G. (1953). Contactos y cambios culturales en la Sierra Nevada de Santa Marta. *Revista Colombiana de Antropología*, vol. 1, pp. 16–122.

Reichel-Dolmatoff, G. (1965). *Colombia: ancient peoples and places.* London and New York. Thames and Hudson.

Reichel-Dolmatoff, G. (1968). *Desana: simbolismo de los indios Tukano del Vaupés.* Colombia. Universidad de los Andes.

Reichel-Dolmatoff, G. (1982). *Colombia indígena, manual de la historia de Colombia.* Vol. 1, pp. 33–115. Bogotá. Colombia. Procultura.

Reyes, A. (2017). Ensamblando una colección. Trayectos biográficos de sujetos, objetos y conocimientos antropológicos en Konrad Theodor Preuss a partir de su expedición a Colombia (1913–1919). (Doctoral thesis). Freie Universität Berlin. DOI: http://dx.doi.org/10.17169/refubium-6396

Rodríguez, Á. (2003). *Reformas borbónicas: mutis catedrático, discípulos y corrientes ilustradas 1750–1816.* Colombia. Universidad del Rosario.

Sanabria, F. (2014). *Presentación de logros del ICANH 2014.* Colombia. Instituto Colombiano de Antropología e Historia.

Serje, M. (2008). La invención de la Sierra Nevada. *Antípoda: Revista de Antropología y Arqueología*, no. 7, Colombia, pp. 197–229. DOI: https://doi.org/10.7440/antipoda 7.2008.09

Tovar, H. (1994). *Relaciones y visitas a los Andes*. Vol. II. Bogotá. Colcultura, Instituto de Cultura Hispánica.

Trigger, B. G. (1989). *A history of archaeological thought*. United Kingdom. Cambridge University Press.

Trouillot, M. (2011). *Transformaciones globales. La antropología y el mundo moderno*. Popayán, Colombia. Universidad del Cauca.

Ulloa, A. (2004). *La construcción del nativo ecológico: complejidades, paradojas y dilemas de la relación entre los movimientos indígenas y el ambientalismo en Colombia*. Bogotá, Colombia. Colciencias.

Vicente, R. (2014). Un castillo armado: el primer golpe de la CIA en América Latina. *Ciclos en la Historia, la Economía y la Sociedad*, vol. 22, no. 43. Argentina, pp. 147–183.

Viloria, J. (2019). Aroma de café: economía y empresas cafeteras en la Sierra Nevada de Santa Marta. *Jangwa Pana*, vol. 18, no. 2, Colombia, pp. 163–181. DOI: https://doi.org/10.21676/16574923.2924

White, L. (1949). *The science of culture: a study of man and civilization*. New York. Farrar, Straus and Company. 2nd edition published 1969, New York: Grove Press.

Wiley, J. (2008). *The banana: empires, trade wars, and globalization*. United States. University of Nebraska Press.

3 Pueblito Chairama

From archaeological park to sacred site

After the Conquest: the "vacant lands" of Parque Tairona

The chronicles of the 16th century indicate that the Spaniards began their plundering to the south of Santa Marta, in the towns of Pueblo Grande and Pocigueica, after they had founded Santa Marta and subjected the surrounding populations (Tovar 1994; Friede 1955). Those conquerors, mostly from southern Spain, were looking for gold and silver, and labor to maintain the nascent population of Santa Marta, erected to be the gateway to ship the riches of the Americas to the Old World (Elías 2009). There were Indigenous populations on the shores of the SNSM with ritual goldwork. The goldsmith production by hammering or casting, the two main techniques (Falchetti 1987), was not done by principles of efficiency or volume; they were made into ritual activities. When the Spaniards arrived, they looted the ezuamas where there were offerings in metal; they also pillaged the cemeteries, taking away the gold that had been produced, under the Indigenous religious system, over two millennia. For example, the 1504 campaigns of Juan de la Cosa in the interior region of Cartagena, upstream of the Magdalena—known in the archaeological literature as Zenú (Falchetti 1996), reported almost 50 kilos of gold, of which 10 kilos were a tribute to the crown (Tovar 1994:32). In the vicinity of Cartagena de Indias, the 1533 campaigns produced 1.7 tons of gold (Tovar 1994:40); in Santa Marta the attacks from 1502 to 1514 produced 28 tons of gold; another 3 tons was obtained between 1526 and 1539 (Tovar 1994:50). As gold was not mass-produced, these figures resulted from the melting of all ritual objects used by the living and the dead and made over several millennia. As archaeological research has shown, between the north of Colombia, Panama and Costa Rica there existed a goldwork stylistic commonality that involved a system of exchanges that covered much of the so-called Intermediate Area (Cooke & Bray 1985), in which gold was not a means for the accumulation of wealth—as it was for the mercantilist economies based on the accumulation of metals up to the 18th century (Hamilton 1984). The looting of Indigenous gold destroyed its ritual value.

Most of the Spaniards who plundered the SNSM arrived in Santa Marta funded by expensive loans. They bought commodities at exorbitant prices,

given the monopoly instituted by the crown. For example, during the first years after the founding of Santa Marta, raising cattle was forbidden; the meat had to be purchased on request from Santa Domingo (Castaño 2006). Fabrics, buttons, plates, spoons and other supplies were to be bought from the official markets of the empire. The conquerors who arrived in the Americas had to repay what they owed, and, additionally, they had to have the necessary cash to buy supplies. Conquering and founding in the so-called New World were profitable and parts of an incipient process of primitive accumulation of capital (De Angelis 2012).

By the end of the 1520s, the regions south of Santa Marta were devastated, and few indigenes were living there. Extant gold inventories of the 16th century are dated from 1502 to 1514, and from 1526 to 1539 (Tovar 1994:32–50). Once the conquerors devastated the region, they turned to settlements to the north, in the Tairona valley—located to the north of Santa Marta, by the basins of the Don Diego and Buritaca rivers, which offered the prospective of mobilizing local populations for the production of gold. The beginning of the 1530s saw the linking of new regions to the Spanish taxation system, such as the Tairona valley. In 1535, Governor Fernández de Lugo commissioned raids to the villages adjacent to Santa Marta to subdue the natives. Among them was Pueblito Chairama (Rodríguez 1979:82), whose fate was no different to those of Pueblo Grande and Pocigueica: the Spaniards destroyed the plantations, murdered the women and enslaved the men. The village was depopulated early in the 16th century. It was not a demographic collapse, but the displacement of native populations towards the inland regions not controlled by the Spaniards. As Juan Nieves, from Pueblito Chairama, recounts, after those events, people kept remembering the *jabas* and *jates* who still inhabited the site; they were never forgotten and always, from generation to generation, families longed to make payments again in the ezuamas of Pueblito (Teykú). Unlike what happened with other areas, Pueblito Chairama was left unoccupied after the Conquest, and thus it was spared the evangelizing zeal of the missions. Since the Kogui have a particular way of remembering, the 16th-century campaigns are remembered through employing a Spanish sword and axe, collected during the battles at Pueblo Grande. Yet, there is no similar story regarding Pueblito, no objects that recall the encounters that ended up expelling its inhabitants from the territory—but expulsion is a malaise that dominates the community vision of history.

The first land titles were granted in the 18th century; as a result, some parts of what is now the PNNT have real documents that certify land ownership (Campo 2011). It was not until the 20th century that a land market began, especially in the 1960s, when families displaced from the interior of the country occupied the territory. Those displacements had to do with two related pressures: the establishment of large estates in the center and east of the country that displaced peasant communities; and the political violence of the 1950s, which facilitated the formation of guerrilla groups such as the FARC-EP (Ferro 2002). As the number of large landowners grew, so did guerrilla

resistance; the ensuing conflict displaced thousands of peasant communities, for some of whom the SNSM was an excellent destination given the vast amounts of "vacant lands," that is, Indigenous territories that could be occupied.

Ethnographies carried out by anthropologists from the University of Magdalena (Carrasquilla & Silva 2010) record peasant testimonies that tell how they came to the area fleeing violence; they occupied regions of the PNNT before it was declared a park. Those testimonies talk of vacant lands and virgin territories, making no mention of Indigenous people. Peasants and Indigenous people have kept themselves apart, and only in very few cases could one speak of social relations between them. Research into the land titles of the PNNT shows that significant land appropriations occurred in the 1980s when powerful families began marketing PNNT land. The state's attempts to put a halt to that process in the 1990s cost the lives of two directors of the PNNT (Leal 2014). Their deaths were related to paramilitary control exercised in the area until the demobilization of those armed groups in the 2000s; despite that, the area is currently controlled by local criminal gangs (Latorre & Fare 2014).

While Juan Manuel Santos was president (2014–2018) he pushed for a revision of land titles. This action generated some control over the privatization of protected areas and Indigenous peoples' areas. State pressure has prevented the delivery of the area to regional capitals eager to transform the virgin beaches into resorts; for a couple of decades, foreign investors have requested that the state lift its prohibitions over the protected area, so that hotel construction might proceed (Nates 2010). State control over the area has been a consequence of the organization of Indigenous movements in the SNSM; their requests for controlling areas with ezuamas have been interpreted as a guarantee of environmental conservation. Concessions made by the state to the Indigenous communities see them as conservationists by nature but don't recognize their different ontologies nor their right to autonomy. This is not exclusive to Colombia, though; it seems to be a contemporary constant in the relationships between Indigenous peoples and the state more generally (De la Cadena 2009). In any case, despite the control that PNN has had over conservation areas, even appealing to the conceding of territorial control to Indigenous communities, there is enormous pressure from right-wing political parties to develop eco-tourism projects within the PNNT (Ojeda 2012).

The formation of large estates since the 18th century meant that several ezuamas passed into private hands; this intensified with the land plundering associated with the arrival of the UFC at the beginning of the 20th century. Banana production mostly affected Chimila Indigenous communities living in the savannas to the south of the CGSM (Castillo 2009); unlike the SNSM communities, the Chimila were characterized by a high mobility, since rather than being farmers they were hunters and foragers. Their language is recognized as one of the oldest in northern Colombia, and today they are reduced

to two reservations, one south of Santa Marta (Sabanas de San Ángel), and another one recently formed near the city (Niño 2016). In these communities, especially in the reservation near Santa Marta, there is a high rate of conversion to Pentecostalism, threatening the language and traditional forms of social organization—by the way, this phenomenon dramatically affects all Indigenous communities of the SNSM.

Despite the occupation of "vacant territories"—in some cases, Indigenous communal property and in other cases ownership of the nation—in the last third of the 20th century, some areas were defined as natural reserves, territories for environmental conservation. In 1960s, the PNNT was delimited and some borders were established. The southern limit was Punta Aguja, while the northern limit was the mouth of the Piedras River. These two points delimit the south–north strip of the park, paralleling the Caribbean Highway. Although there was a process of setting up a land market within this polygon, major interventions were forbidden because it was protected for environmental reasons. This guaranteed that some territories were preserved. Although Pueblito Chairama had been ransacked since the 16th century, environmental conservation policies in the 20th century prevented the destruction of the surviving terraces and permitted the control of *guaquería*. Despite that, archaeology as a scientific practice was an external way of destroying sacred sites through its scientific methods of excavation. So, passing from *guaquería* practices to archaeological ones did not make a big difference to Indigenous people; the inhabitants of Teykú are right when they point out that there is no difference between what the Spaniards did in the 16th century and what the archaeologists did in recent years.

As the Arhuaco filmmaker Amado Villafaña said, collecting tumas from ezuamas is equivalent to someone entering a Catholic cathedral and stealing the images of the virgin, the child-god, and Jesus Christ, but not before destroying the benches and defacing the walls. The most horrifying thing about all this is that the tumas are considered garbage by the archaeologists—small deposits of materials that have no value, neither cultural nor archaeological (Gutiérrez 2013). An ezuama was even confused with a "trash pit," a type of "granite slab structure against the protruding walls" (Cadavid 1993:16). The conceptualization of the ezuamas as pre-Hispanic garbage dumps was possible insofar as it was considered that they belonged to the "missing tribes of the Tairona," with no relationship to the Kogui. This temporal rupture reinforced the "mysterious disappearance" of the Tairona. Traditionally, the archaeologists have pointed out that the Kogui have nothing to say about Tairona sites, simply because they don't know anything about them. They ignore the ritual role of silence among the Kogui (Campo & Turbay 2015). The "experts" in things Tairona are the emissaries of a violence that still unfolds throughout the territory, a living, and interconnected being. From the local perspective, the archaeologists are nothing more than destroyers of ezuamas, voracious consumers of tumas, children of Nuanase.

The archaeological motive of the past has allowed the consideration of contemporary Indigenous peoples as outsiders with no rights to the collective possession of the land. They are accepted as long as they demonstrate sustainable ecological practices, useful for the new consumption of nature (Moore & Salvatore 2018). Contemporary communities decorate public spaces or lend their names to be used for sustainable architectural projects. Claudia Helena Vázquez, wife of singer Carlos Vives, founded a Spa in Bogotá that she named "Chairama" and publicized as a wonder of ingenuity: the SNSM materializes in the cold highlands of Bogotá (Straczynski 2010). Vives himself used Arhuaco accordionists in his attempt to emphasize the Indigenous, the only prominent place accorded to the natives. Vives performs the ideal tri-ethnic fusion that materializes the dream of a musical miscegenation, of which colonialism was only a collateral effect. For Vives, Spanish conqueror Rodrigo de Bastidas just wanted to live on the white beaches of the Caribbean, surrounded by the jungle and bathed by crystalline streams (Vives 2016). Vives represents the ideology of large estate holders and paramilitaries who have created bucolic scenes to legitimize and disguise the usurping of territories (Figueroa 2009:233). The figures for the encroachment of land in Colombia are chilling: in 1987 there were 35 million hectares dedicated to livestock; in 2001 the number exceeded 41 million hectares, a 30 percent growth in 14 years; by 1984, 32.7 percent of all productive land had less than 500 hectares; by 2001, the figure increased to almost 63 percent; by 2004, 0.4 percent of owners owned 61 percent of all titled land (Figueroa 2009:233).

Further, rural poverty in Colombia is almost 90 percent (Hylton 2006), making the country one of the most unequal in the world. In contrast, the media and the music industry portray Indigenous people and peasants as apolitical, voiceless, decorative. *Cumbia* is the representation of the harmony that unites the three ethnic groups that are the purported basis of the Colombian nation. The story of regional equality assumes racial differences as veins that nourish *mestizaje*. The mestizo world thus prevails, generating a "sonority"—as it is called by the apologists of the music formed as a commodity (Sevilla et al. 2014). But this harmonious vision of reality hides the systematic violence that has tried to erase the agendas of social movements; the latter have shaped dissenting forms of organizing the territory, quite at odds with agribusiness (bananas in the past; African palms in the present). As contemporary economic policies demonstrate, the coast of the SNSM awaits a boom of agribusiness and tourism, a serious threat to Indigenous peoples.

The reification of ethnic societies—represented as apolitical and ecologically sustainable, plus the undervaluing of the peasantry, officially represented as lazy and prone to feasting, occurred after social movements (formed after the Second World War) were attacked by various means, ranging from prosecution to extermination. From the 1960s on, when agrarian reforms that attempted an equitable distribution of land were prevented, right-wing armed groups killed peasant leaders (Afro, mestizo and Indigenous), confiscated

land, and organized livestock farms. This new arrangement of the territory led to the dissolution of the former province of Magdalena, and the creation of the Department of Cesar. During the first part of the 20th century, there was a final process of land appropriation by the elites. This provided support for the Colombian state in the second part of the 20th century to generate a representation of the Caribbean as a territory to explore and dominate.

Local elites turned culture—expressed in carnivals and Indigenous and peasant traditions—into festive representations that hid the violence exerted upon regional communities. The natives were, and still are, presented as souvenir-makers, and the names of their villages are used to name spas, resorts, VIP lounges. Yet, those elites complain when Indigenous peoples make territorial claims, oppose tourism, or block roads. Activist Imelda Daza, a state officer in the 1970s who witnessed several attempts by the central government to redistribute land, told me how the powerful families of Santa Marta and Valledupar threatened those willing to make agrarian reform a reality. Because of this, Daza decided to run for Municipal Councilor in the Department of Cesar in 1986 representing the Patriotic Union (UP), a party formed after the failed peace process with the FARC-EP in the 1980s (Gómez-Suárez 2018; Betancur 2006). The Colombian right-wing, along with the drug traffickers, exterminated the UP. Daza had no choice but to go into exile in Sweden. She told me: "At that time, it was impossible to stop the formation of large estates." The extermination of the UP was frightening. The party, popular because it represented the peasantry who were the victims of landowners, had won several regional elections, prompting the bitter alliance of mercenaries and landowners for exterminating the social movements that, in the 1980s, had a peasant base but also involved Indigenous groups.

The second part of the 20th century in the Department of Magdalena saw reforms that favored large estate holders. The stereotype of submissive and folkloric peasants was also created, which served to assist the heritage management of the Caribbean. The images were produced and popularized in parallel to the violence exerted over the peasantry. Heritage plans were designed, especially by elites from the city of Valledupar, who demanded the creation of the Department of Cesar in 1967, seceding from Magdalena and its capital Santa Marta. Three years after the creation of the Ministry of Culture in 1997 a regional leader, Consuelo Araújo, known as *La cacica*, was appointed Minister—the power she wielded gained her that nickname, not only because she promoted the Caribbean culture, but because she defined what that culture was and what were its expressions (De la Hoz & Sanjuanelo 2018; Muñoz Gallego 2019). Given the success of the cultural project carried out in the Department of Cesar, management of the cultural realm then passed to her niece, María Consuelo Araujo, Minister of Culture between 2002 and 2006. Those two women, from the landowning families of Valledupar, promoted the commodification of "Colombian culture." Those families were involved in the promotion of paramilitarism in the 2000s; even though

their power diminished (*El Tiempo* 2009), they left their mark on the region because they managed to impose *vallenato*, a genre of folk music that came to displace other local rhythms; besides this, they also helped to consolidate the image of the peasantry as lazy and unwilling to advance themselves.

Whenever the Indigenous social movement has asked for political autonomy it has met with resistance. In the 1980s, it encountered obstacles such as the idea that land claims and political self-determination were issues that Indigenous people simply could not ask for. Starting in the 1980s, Indigenous people had a higher media profile and recognition for being ancestral guardians of the territory, that is, of its ecological function. So, within the heritage citation processes, Indigenous peoples were configured as conservationists. This has limited the political participation of the Indigenous peoples of the SNSM, especially in relation to their land claims.

The heritage boom in Colombia is well exemplified by the story of flute music on the banks of the Magdalena river (Carrasquilla & Silva 2010). Tamalameque is well known for its riverside music with roots in the traditions of cumbia and chandé, severely crushed in 1967 with the creation of the Department of Cesar, when vallenato took over as a source of local identity. Flute and chandé schools have been working against the current ideological project since their arts are not conceived as part of Cesar identity. Cesar is a fiction that consolidated the symbolic capital of regional landlords. Consuelo Araújo was an important businesswoman in the growing radio system of Valledupar; she spread vallenato to reach out to various sectors of the population, catapulting presidential candidates to power at the time when mayors and governors were not elected by popular vote. The media played an essential role as a source of cultural criteria and cultural hierarchy—what Anderson (2006) called an "imagined community." This was an instance in which a political project of large landowners used the media to generate an image of community solidarity amidst a context of structural violence.

The "culture" of the Colombian Caribbean was created in the 1960s; it was composed of a harmonious mosaic of cultures dedicated to cumbia and vallenato. It evokes submission and peace, not criticism and debate. The Caribbean inhabitant is depicted as smiling, naive, bustling, cheerful, but never critical and phlegmatic. In the meantime, regional elites (such as the Araújo) linked the territory to global economies, primarily through extractivism (coal and oil) and agribusiness. This was the framework that gave way to the 2000s and its heritage boom. Since the terms of the two Araujo women as Ministers of Culture, no minister has opposed this cultural mechanism that reduces communities to being mere referents of cultural services or employees of large tourism projects, at the expense of local cultures (Alonso et al. 2018; Chaves et al. 2010; Del Pozo & Alonso 2012). Meanwhile, the Indigenous nations of the SNSM began reclaiming their territory, up till then mostly devoted to tourism. Kogui, Arhuaco, Wiwa and Kankuamo are of the same ethnicity, but they position themselves differently vis-à-vis tourism—the Wiwa and Arhuaco have already entered the

business fully (Morales & López 2019)—yet their collective position regarding Pueblito Chairama has always been to reclaim it for the functioning of its ezuamas.

Pueblito Chairama was in the spotlight of the heritage industry, informed by the past–present rupture. Pueblito was a national archaeological park belonging to the state; its acknowledgment of a relationship between Indigenous peoples and the site was based on the assumption that their management strategies are equivalent to environmental conservation measures, but not as expressions of their political autonomy. It did not recognize that the Kogui had been dispossessed of Chairama, but it did recognize their need to make payments at the site—understood as part of the PNNT management plan. Further, the Presidential Decree 1500 of 2018 recognized the importance of the territory for the four nations of the SNSM, without affecting private property, nor existing environmental restrictions.

Culture is currently conceived in Colombia as a commodity. When visiting the Department of Magdalena, you can go to Kogui villages to take pictures with the natives, and you can also visit the Tairona ruins while you travel through the jungle. In these tours, there is no conflict; there is no war, there are no tensions, no claims for historical reparations. They are just a part of the current heritage dynamics in northern Colombia (Alonso et al. 2018). Regional cultures are folklorized and converted into commodities for the tourism industry.

In northern Colombia, as in many other areas of the world, some regions are sold as pristine destinations where tourists can enjoy nature and escape the artificial realms in which they live. Areas such as the PNNT become true "non places," to use Marc Augé's expression (Augé 1995), where culture is offered as a space which consumers pay to inhabit for short segments of time, to experience the jungle, the natives, and the ancient ruins of lost civilizations. Culture is recognised, consumed really, in paths of consumption that involve constant mobility through previously demarcated circuits. Tourists, especially international ones (those who visit villages like Ciudad Perdida), consume the representations of the natives as silent and taciturn from the moment they get off the plane; they will later corroborate these representations during the walks offered by tour operators. The Indigenous "culture" is displayed in airports, public squares, shopping centers, tourism brochures: an ethnic landscape whose function is to sell the experience of a tropical paradise free of conflict (Londoño & Alonso 2017). Today as yesterday, cities such as Cartagena de Indias are centers for the commodification of bodies—in the past as enslaved humans; in the present as prostitutes (Sarabia & Ardila 2019).

The heritage process in Pueblito Chairama

Pueblito Chairama (Teykú) is a pre-Hispanic village located in the PNNT. It was closed to tourism by PNN Resolution 039 of 2018, a response to a legal

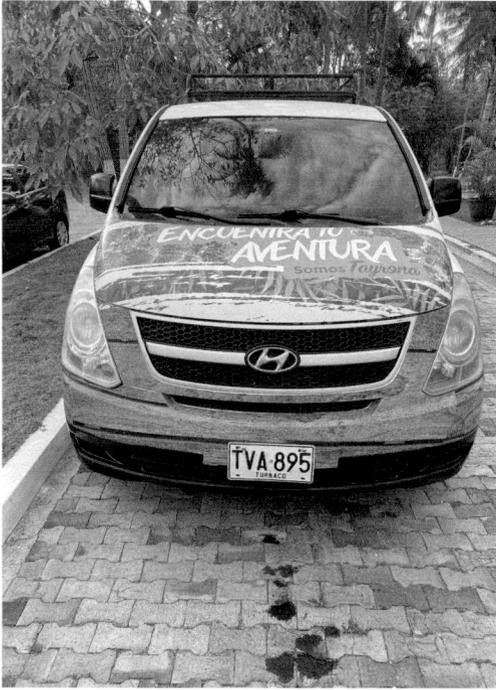

Figure 3.1 A van advertising tourism in Ciudad Perdida, 2016
Source: Photo by the author, 2016.

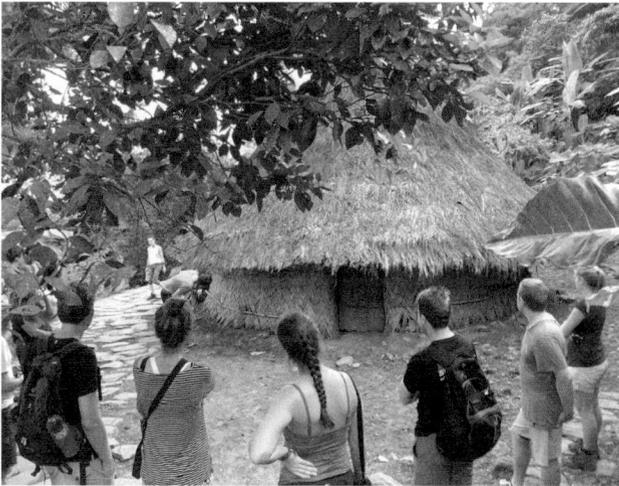

Figure 3.2 Tourists in Ciudad Perdida visiting a Kogui dwelling
Source: Photo by the author, 2016.

action for the protection of ethnic collective rights brought before a Magdalena court by an NGO acting on behalf of the Kogui associated with OGT; along with Presidential Decree 1500 of 2018, it offers some autonomy to ethnic communities—yet within an essentialized conception of things Indigenous. At present, those regulations are under direct fire by the Colombian right-wing seeking the opening of the SNSM coast to foreign investors. The reclaiming of areas with ezuamas, therefore, is ridden with conflict and tensions.

Once the PNNT was declared a protected area in the 1960s, a slow process of territorial organization began using the model of natural parks. The idea was to have native forests protected from intensive agriculture (Londoño 2002). The organization of the area occurred with greater force in the 1990s. Park officers sought to enforce strict environmental regulations, even at enormous cost. Marta Lucía Hernández, director of the PNNT, was murdered on January 29, 2004. In 2003 two tourists and three *baquianos* were killed, and 13 foreign tourists were kidnapped by the ELN (*El Tiempo* 2003).

These initial stages of environmental management sought to prevent the fraudulent titling of properties and the invasion of the park by individuals who were not always displaced farmers. At the same time, illegal armed groups launched violent actions for upsetting the state's control of the park, freeing the bays from where cocaine was exported—local newspapers reported discoveries of hundreds of kilos of cocaine, even in sacred sites of the PNNT, such as Chengue (Caracol 2011).

In a conversation I had in 2017 with peasants who worked as *baquianos* taking tourists to the SNSM, they told me that paramilitary leaders summoned political candidates to their camps to give them orders on how to govern. What was agreed upon was the right to campaign in paramilitary areas in exchange for the future receipt of funds from local governments. Elected mayors had to divert resources to illegal armed organizations, which made corruption the rule in public management. There was little investment in the territory, and the PNNT was configured as a space for the sale of tourism services, favoring private capital. Under the concession model, the park became a cash cow, even for companies owned by paramilitaries (Semana 2011).

Drug lords feared PNN officers' intervention, especially when they allied with some corrupt local authorities. They used violence to intimidate them and prevent patrols and checkpoints. It was the policy of "money or lead" (Dal Bó et al. 2006). In the 1980s, the controls were not rigid as nobody was prepared for drug trafficking, which made it easier for the marijuana business to prosper. Porter's book (Porter 2014) on the drug trafficker George Jung describes how in the 1970s, young Americans could fly to Colombia and return with bags full of marijuana, without any trouble. Northern Colombia witnessed a boom in consignments of marijuana sent to Florida in small planes that took off from clandestine airfields on the SNSM coast. By that time the Capuchin missions had ceased, the communities were freed from the

yoke of the Catholic church, and the first social movements of the SNSM emerged (Duarte 2018). It could not have been otherwise, because if the communities had not organized they would have risked the collapse of their social structures, that would have fragmented in the vortex produced by drug trafficking. This happened with some Wayuu clans that were dispersed by the war which caused the drug trafficking boom to contract. Regarding this period, Ramón Gil says: "after the marijuana growers left, they left the territory destroyed. It took us almost 30 years to recover the forests that were razed."

The 1980s were decisive in Colombian history. At the end of that decade, drug cartels dominated the territory and made alliances with left or right factions, as necessary. The drug lords infiltrated the political system. In 1989, liberal leader Luis Carlos Galán was killed. Galán, marginal to the traditional Liberal Party, had fiercely opposed drug trafficking (Daza 2007). That party, together with the Conservative Party, had dominated Colombian politics for over a century and championed the country's entry into the global market without implying social extermination, unlike the Conservatives, who had appealed to eugenics for improving racial conditions. Since Galán had rejected monies offered by drug lord Pablo Escobar, he was shot down at a political rally near Bogotá. With him died a part of Colombia's hope. However, he did not represent the most popular segments of society, although he had offered to nationalize oil production (Galán 1982); and the middle class saw in him a necessary ally for its growth and strengthening. After his death, the Colombian state allowed multinational companies to exploit coal deposits under contracts that exempted them from paying taxes because they generated employment. Once these regional ventures were established the top jobs went to foreigners, mostly US citizens; the few Colombians hired were the worst paid.

In addition to Galán, another popular leader was killed. Carlos Pizarro had led the demobilization of the M-19 guerrillas, and given his charisma had managed to gain the support of important parts of the electorate. Pizarro had fought to curtail large landholdings and guarantee decent living conditions for indigenes and peasants. In the troubled world of the late 1990s, social movements resisted through legal and *de facto* means. They raised the need for political reforms (Archila & Pardo 2001) that were eventually achieved in the 1991 Constitution. Among many other things, the constitutional change allowed reflection on the archaeological heritage; it also allowed to people to think about the relations of the state with Indigenous people. As for the former, Article 72 of the Constitution followed legal theories of a sovereign state that owns most of the nation's assets and established that things archaeological were unseizable, inalienable, and imprescriptible. Individuals were forbidden to own archaeological materials. In practice, this provision made it difficult for Indigenous people to reclaim their sacred places or objects that were older than 500 years.

The state claimed the right to think, intervene, represent and conserve all pre-Hispanic materials, excluding the participation of Indigenous peoples, who were considered to be strangers who would put constitutional definitions of the archaeological project at risk. Faced with an Indigenous claim over an "archaeological" asset (a site, an object, a body, a collection), the state would evaluate possible outcomes, yet without compromising constitutional mandates. For instance, the Arhuaco had rejected the planned building of an electrical facility on a sacred spot. The company responsible for its design and construction sent an anthropologist to negotiate. The natives responded: in addition to financial compensation, the mamos would say what was to be done with the tumas, pottery vessels and human remains eventually found at the site—which happened to be a cemetery. However, upon excavation, the objects and human remains found were ultimately treated as archaeological materials; after their analysis, a few weeks later, a reburial ceremony of the tumas, pottery vessels, and human remains took place. The archaeologists who had made the rescue received approval from the ICANH because reburial was considered a measure of heritage management. But the mamos were not performing within the heritage logic; they were trying to heal something as serious as disinterring human remains and moving them elsewhere. Despite this, the archaeologists made an instrumental reading of the situation, defining it as a heritage transaction, a negotiation between equivalent forces: the market, the state, the Indigenous people. But this was not so. Communities are almost obliged to negotiate with the companies involved; in this case, they could not oppose the construction of the electrical facility at El Copey, the point that divides the western and eastern flanks of the SNSM (Moscoso 2013). The facility was necessary to provide energy to the northern sector of the Sierra, and it was difficult for the Arhuaco to oppose the improvement of energy services.

Article 246 of the 1991 Constitution established that Indigenous people were to have exclusive jurisdictions, that is, a limited autonomy in education, the law, and in the management of the territory. Yet, after almost three decades of enacting the new political constitution, Indigenous people still await the legal ratification of that article. This has not happened because governments have not wanted to face the substantial reforms necessary. For instance, it would have to be accepted that Indigenous people are autonomous within their territories—even in defining the fate of artifacts or human remains that are considered archaeological by the state. In this, there is a clear difference with the law of the Commonwealth, where Indigenous jurisdiction is equivalent to territorial jurisdiction (Charters 2011). Colombian law recognizes cultural rights even on private lands, but the enjoyment of those rights must not affect the private property; thus, Indigenous peoples have to ask for permission to access sites with ezuamas or sites for payments.

Article 72 of the Constitution was only ratified in 1997, with the creation of the Ministry of Culture. Colombia then engaged global heritage models championed by UNESCO, which demanded regulations for the management

of culture as a commodity (González 2006). This was not meant to democratize society; the consumption of culture was disguised as a development of political autonomy. This heritage model is not exclusive to Colombia nor Latin America as a whole. There is a global tendency towards the essentialization of culture, geared to its commodity transformation. Communities are encouraged to think of ties with mythical figures, such as the Celts or the Saxons, to form landscapes of cultural consumption through festivals and souvenirs. Heritage has spatial dimensions needed for the enjoyment of cultural experiences (Alonso 2014). The sites with ezuamas in the SNSM have been conceived as pre-Hispanic villages where ancient goldsmith-warriors lived. Visiting them also means trail walking through the middle of the jungle. Tourists feel that they are entering the "heart of darkness" when walking the 24 kilometers between Machete Pelao and Ciudad Perdida. Despite this short, brief journey, foreign tourists feel they are in the jungle's most remote place, and that is precisely the experience they buy. That is not the case, though, because the trail is globally interconnected through illegal economies, making the area one of the most cosmopolitan in South America: from those mountains, transactions are made with Europe and the United States at various levels.

Traditional festivals such as the Barranquilla Carnival, or the Valledupar Vallenato Festival, became mass events run by for-profit companies (De Oro 2010). Although the Vallenato Festival was, since its inception, a celebration with a political end, its redistributive logic came to a halt. There would no longer be a "cacique" who would distribute alcohol to the accordionist in exchange for votes for his political clans. It gave way to the massive event that exists today, mostly for wealthy people from Bogotá, Cali or Medellín who can afford the high price of the tickets. Likewise, Pueblito Chairama and Ciudad Perdida became tourist destinations, prompting their essentialization. Tourists are accompanied by young Colombian translators with bachelor's degrees in English, or who are simply bilingual. They put themselves at the service of the endless hordes of foreigners, especially those going to Ciudad Perdida. Tourists make their tours with a *baquiano*, a cook, and a translator with little contact with this staff. The fundamental premise is that nothing out of order can happen to the tourists. But they do not help much: they eat excessive amounts of papaya and banana (consequently suffering gastrointestinal poisoning) and disregard the order not to touch snakes and poisonous frogs. Franky Rey told me that the most absurd thing he had seen was a tourist who put a poisonous snake in the pocket of the pants of one of his friends. The tourist had to be hastily carried down to a hospital in Santa Marta, where he nearly died.

Heritage processes were accompanied by legal developments, such as the General Law of Culture (1997, reformed in 2008), and by the creation of the Ministry of Culture and of "concertation programs"; the latter subsidized local communities to identify and strengthen assets that could be turned into heritage (Chavez et al. 2010). Those reforms established that the ICAN would

become part of the Ministry of Culture, together with Coldeportes, in charge of sports, and the Instituto Caro y Cuervo, to investigate languages. In the case of the ICAN, the change involved adding history to anthropology, so the institute was renamed ICANH. Through much of the late 1990s and early 2000s, the ICANH consolidated its position as an authority on archaeological management, establishing when and where to do contract archaeology (known as CRM in the US). The ICANH ruled that development companies had to apply for CRM programs, opening up a labor market that absorbed many Colombian anthropologists and archaeologists. The heritage turn resulted in anthropology in Colombia becoming more a technique for consulting, rather than a space for cultural criticism (Gnecco & Dias 2015).

Before the end of the 2010s, there was a robust regulation of the archaeological record—disregarding that it could have different meanings. The areas declared as archaeological parks were beginning to be organized, yet amidst budget cuts. By the end of the 2010s, the ICANH had failed in its attempt to make management plans for the archaeological sites of Colombia, and its directors, some already retired, had given up organizing visits to the villages to increase the cash flow. Between 2008 and 2010 there was an attempt to organize the sites and improve the tourist experience and make it more responsible, at least from a technical point of view. This meant measuring the carrying capacity of the sites and regulating visits. The planners did not consult the Kogui, who, by the end of the 2000s, were already beginning to inhabit the surroundings of Pueblito, and to activate the payments to connect its ezuamas with the territory. It was a time of enormous pressure for the Kogui families from Teykú. They were practically compelled to see how the archaeologists were destroy their sites.

In 2005 the Caribbean branch of PNN issued a document called "Plan de Manejo Parque Nacional Natural Tayrona" (Tayrona National Natural Park Management Plan) (Sánchez et al. 2006). In that document, Pueblito Chairama was considered as an asset that produces "non-marketable" services, given its archaeological value (Sánchez et al. 2006: 47). In official documents such as this, nature and the archaeological record are conceived as sources of services to be administered by experts with biological and archaeological knowledge; they establish who can intervene in those sites, and exclude non-scientific knowledge—the knowledge of Indigenous peoples. This disciplining is enacted by professionals in the social and biological sciences who talk about plants and animals, rivers and seas, as sources of environmental services, and of sacred sites as sources of tourism services.

As reported in the same document, Park officers were already beginning to consider small vegetable gardens close to Pueblito as an anomaly to be halted (Sánchez et al. 2006: 122). It was unthinkable that humans dared to plant vegetables with juicy carbohydrate roots in a conservation area that also contained an archaeological site—in addition to building *nujués* near a Natural Park. In 2007, when I was invited to a meeting to talk about the communities along the SNSM coast—where I met "experts" from the PNNT and the Magdalena Environmental Regulation Corporation, CORPAMAG—the

first thing a biologist told me was that the management of the beaches did not contemplate cultural variables because they altered ecosystems. In 2014, I acted as an advisor to the Santa Marta District to assess what was happening to cultural diversity. A workshop in the fishing community of Taganga showed the difficulties fishers had with maritime authorities because they were not allowed to fish in their ancestral territories. Heritage and environmental policies delink local communities from their lands to guarantee the sale of cultural and heritage services.

An essential element of the PNNT management plan is that it recognizes that Pueblito is a sacred place for Indigenous people; yet, it does not give them the site's management. Quite the opposite. Since it is a sacred place, conservation objectives are equivalent to Indigenous practices, so PNN considers that it must continue to manage and take care of the site under comparable Indigenous traditions (Sánchez et al. 2006). For the Kogui, the non-intervention on sacred sites is not a guarantee of environmental services, but a dialogue with the principles of life. Not touching the ezuama not only guarantees the survival of entire ecosystems but also the reproduction of clans. On the contrary, the management plan is a modern design: human populations vanish to give way to nature, a machine that offers services such as white beaches with crystal clear waters full of coral and fish. Those "resources" must be paid for, so local communities are excluded from those spaces. Conservation is a form of expropriation for the reproduction of capital, and not a policy for generating horizontal, democratic, and fair societies.

From the point of view of environmental services, Pueblito was conceived as an area of archaeological preservation, where the objectives of conservation, from the point of view of archaeology, were harmonious with the Kogui conception of sacred places. But such a harmony only exists in the document. The indigenes were upset because this political configuration disregards the local vision. Management and conversation policies paralleled ICANH's archaeological excavations at sacred sites. In a conversation with Juan Nieves, held at the beginning of 2019, he pointed out that "the archaeologists come here, take away the pottery vessels, generate disorder, want to do archaeology and do not understand anything." This phrase well explains the local vision, even though it is typical of the borderland: the Kogui understand what the archaeological plunder means, but when narrating it in Spanish, to an anthropologist, they make an analytical effort belonging to border epistemology—which also informs this book.

The archaeologists, like those of 100 years ago, only want the Kogui to help them with their projects, to carry their gear silently. At the same time, science designs a past that guides future thinking by describing these communities as mere accessories of a mosaic of exotic cultures. The Kogui are there to decorate, as in the thousands of photographs made of them or in their frequent appearance in symbolic events such as the performance of the national anthem on TV channels, every day at 6:00 a.m. and 6:00 p.m. as mandated by law.

The existence of indigenes has always been problematic in Colombia. Despite this, Indigenous people have been accepted as long as they represent artisans and not deliberative political agents (Giraldo 2005). At the end of the 20th century, the sustainable knowledge of past Indigenous people was also accepted, for it fits well with the vision of Colombia as a territory of ecological and heritage tourism. This second cycle of the exaltation of Indigenous people created the Koguis as perfect natives. Kogui leaders are cherished by the media; there are those such as Rumualdo, the mamo who inhabits Ciudad Perdida. He has become a heritage object frequently seen in the advertisements of the SNSM. That has brought him some privileges, such as becoming the highest authority of the Upper Buritaca. In this region, epic battles between the Spaniards and the natives were held at the end of the 16th century. I visited Rumualdo at his home in Ciudad Perdida, and he was kind enough to go out and explain to the group I was going with what his vision of Ciudad Perdida was. In his opinion, it was OK for people to walk the trails of the village because the Fathers and Mothers would surely be happy. However, tours should be guided by mamos because they ought to be undertaken with a purpose, a question that could be answered with riddles, the *yátekua*. But that is difficult, because the archaeologists dismantled the ezuamas, flung some slabs to the ground, took the tumas, and left the Fathers and Mothers distressed. Further, the tourists walk the trails without a fixed course, they tour the city and learn nothing. Rumualdo was right; most people who tour Ciudad Perdida consume a story prefigured by almost a century.

The management plan that I mentioned above was formulated in 2005, and the first time I went to Pueblito was in 2008. I noticed a fragmentation between Indigenous activities and the actions ordered by PNN. Payments to

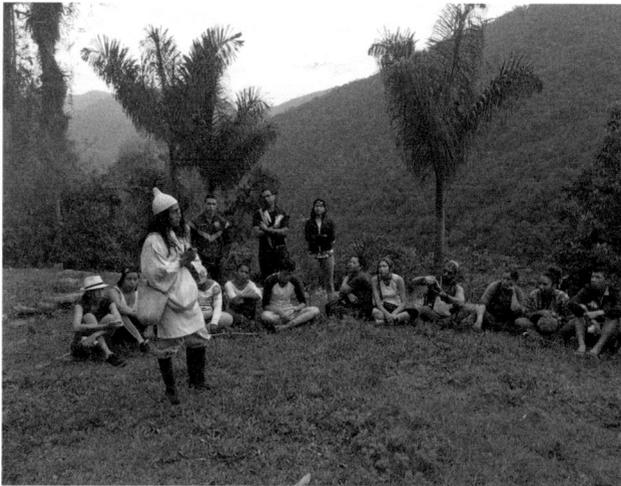

Figure 3.3 Mamo Rumualdo lecturing anthropology students
Source: Photo by the author, 2016.

the ezuamas were clandestine! When one of the officers discovered that I was a professor of anthropology, he took me to Teilluna and asked me to act with discretion because if in Bogotá they learned that the Indians were visiting the site, that they were making payments, that they were cultivating, his job could be at risk.

The ezuamas were just beginning to be activated, so it was likely that some tourists could take tumas or other material. By that time, and in violation of the agreements that had been recorded in the management plan, archaeological work was resumed in Pueblito, a huge insult to the community's culture. This motivated the formation of a working group for the reclaiming of Pueblito through legal means. With the end of paramilitary conflict in the 2010s, and consolidation of the PNNT model of exploitation by a tourism company, the frequency of tourists increased. Within that framework, an agreement was forged between the University of Magdalena, the Andean Community of Nations, and the PNNT, to extend the path from Calabazo to Pueblito (Avendaño 2013). Since the Park could not be touched, the project only intervened up to the farms of peasants living near Juan Nieves, in Taikú. As the conditions for animal traction improved, traffic in the area increased.

Tourism has been on the rise, reconfiguring the territory and its populations. Although the Colombian state does its best to take advantage of tourism, there is little or no agreement with local communities on how they could benefit from the new economic boom; further, state agencies, full of qualified professionals, have little room for maneuver in a land with armed groups that impose their law. State officers must face the lobbying of large multinationals for relaxing controls, so capitals can continue with territorial transformations. It is no easy task to be a PNNT officer: while they impose on the communities the ontology of conservation for transforming nature into a commodity,

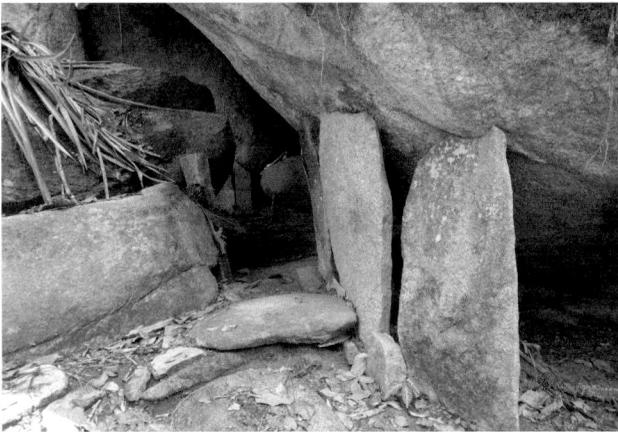

Figure 3.4 Ezuama Teilluna in Teykú
Source: Photo by the author, 2008.

they must face the drug cartels that do not want any intervention in these strategically located territories.

In the 2000s, the state began managing Pueblito Chairama as a conventional archaeological park. PNNT officers were to keep the central square pruned and clean, and the site's carrying capacity was to be measured to ensure a full tourist exploitation. Good intentions notwithstanding, the heritage process did not move on, greatly benefitting Indigenous plans.

Under the route we have taken, the heritagization processes in the SNSM during the 20th century meant that Indigenous people were represented as lacking political claims and as exceptionally ecological. These bases determined the mechanisms with which the Indigenous social movement negotiated autonomy with the Colombian state. For this reason, when the case is presented to the judicial courts, the Kogui claim their sacred sites under the logic that payments must be made there. The state responds that it will allow this exclusive management of the sites since that practice favors the state's conservation policy. Even the local Indigenous movement was still premature. On that occasion (April 2008), we held the first workshop between Nasa leaders from the southwest of Colombia and some leaders of the SNSM; that happened in the middle of a national archaeological congress. We had some financial resources from the World Archaeological Congress and the Universidad del Magdalena to held the meeting. In a country as traditional as Colombia, the fact that there was talk of the need to generate a joint agenda between archaeologists and Indigenous peoples was undoubtedly challenging.

The reclaiming of Pueblito Chairama (Teykú)

I arrived in Santa Marta in 2007, so most of the processes I have so far described were unknown to me first-hand. However, in that same year the anthropologist Julio Marino Barragán told me that the Indigenous organizations of northern Colombia were pressing for the reclaimation of the pre-Hispanic villages that had been converted into archaeological parks. Barragán, an important actor in those processes, told me that the first meetings and the first steps for the organization had as a clear goal the reclaiming of Pueblito Chairama and Ciudad Perdida. I had not been to PNNT because living as I was in southwestern Colombia, it was challenging and extremely expensive to research a territory dominated by tourism. By sheer chance, I ended up teaching archaeology in the newly-formed Department of Anthropology of the University of Magdalena, where Barragán was also teaching. This is how I got acquainted with Indigenous leaders and researchers who were working on the political complexities of the SNSM. Once settled at the university and armed with my experiences in archaeology and local communities in Colombia and Argentina (Haber et al. 2016), I wanted to know what the indigenes thought about the handling of archaeological sites in the SNSM. The University of Magdalena had taken a stand in favor of Indigenous social movements, because several of its professors, such as Barragán,

were their advisors. There was no interest in approaching social movements as mere ethnographic objects or in thinking of "archaeological sites" disconnected from local communities.

I made my first trip to Pueblito in 2008. To get there, I took the traditional bus that leaves from the city market to the village of Calabazo. Rumors of a paramilitary occupation were still circulating.

In the ascent to Pueblito, in 2008, there were not as many houses as now, when the population density has increased and the land valuation has encouraged the fragmentation and titling of "vacant lands." The new homes, mostly owned by peasants, are precarious, with concrete blocks that form enclosures covered with zinc tiles. Many are built over old pre-Hispanic terraces, giving them an archaeological flair. As one moves away from Calabazo, the number of houses decreases and the paths to ascend to the site begin. After walking these trails for about two hours, I reached the main square of Pueblito, and I could see that the terraces were perfectly pruned, and the trails duly swept of leaves. There were some Park officers in the shadows above the creek. In that place, there is a site for payments formed by two large slabs with concave perforations the size of half a billiard ball, the concavities for the *zhátekua*.

Beyond the central square was the cabin of the PNNT, where Park officers lived while they undertook their periods of duty. Behind that cabin, I spotted a sanctuary. A series of tumas were arranged in clay pots against slabs. It was an ezuama.

After being at the ceremonial sites, I set out from Pueblito Chairama down to Cabo San Juan de Guía, established by the Spaniards in the 16th century. A stone path makes the descent from Chairama to Cabo San Juan with large

Figure 3.5 Calabazo
Source: Photo by the author, 2016.

stone bridges that evoke the tremendous civil works of the Kogui before the onslaught of the conquerors. The Presidential Decree 1500 of 2018 notes that there are several ezuamas in the PNNT that, joined together, form the "Black Line." It recognizes that Pueblito Chairama belongs to the Kogui, implying that coastal sites also do. Despite this, the coastal strip of the SNSM, at least to the mouth of the Palomino river, is recognized as belonging to the Taganga. However, the Cabildo Mayor of Taganga, Ariel Daniels, told me that formerly there were relations between the Kogui and the Taganga, since the latter, well into the 20th century, sailed from Taganga to Palomino, then went on foot up the Palomino river valley looking for wives among Kogui clans. As mentioned by Taganga anthropologist David Cantillo, "they went to Palomino to steal Kogui wives." When in the 1940s, Reichel interviewed Kogui mamos they told him that there were Tuxe clans on the shoreline (Reichel-Dolmatoff 1953). People like mamo Rumualdo, high Kogui authority of Ciudad Perdida, have their childhood friends in Taganga, since Taganga connects with all the hills of the northern basins, especially with Makotama.

Unfortunately, because of political problems, and because Taganga is overflowing with foreigners and people from Bogotá and Medellín, OGT does not recognize its inhabitants as indigenes; nevertheless, the Kogui mamos know that the tangangueros are part of their families. Yet, beyond tensions, the fundamental purpose is to strengthen regional autonomy, seeking an internal balance of forces. Although internal asymmetries exist, they do not invalidate or disqualify collective processes; on the contrary, domestic questioning helps to consolidate the agendas needed for political activism.

Cabo San Juan de Guía is mentioned in many colonial documents (Friede 1955), which recount the extermination campaigns that the Spaniards organized against peasants and fishers; there is also mention of Pueblito. They were days of terror until the Spaniards took all the gold found at the ezuamas—where connections were made with the training spheres of the leaders. Pueblito has the function of connecting with the *jabas* and *jates* that facilitate leadership. After the Presidential Decree 1500 of 2018 was issued, the first thing that the communities did was to organize a school for mamos. That was the message given by the Kogui to national society. Beyond a school for mamos, the functions of ezuamas were resumed—as those of Teykú, which recall the civilizing mamo of those territories, known for his wisdom. Juan Nieves named his property at the entrance of PNNT as Teykú, in the peasant area of Calabazo.

After Cabo San Juan, full of foreign tourists and with beaches considered among the best in South America, one has to cross creeks that are sites for payments. When reaching the beach of Cañaverales, one has to take the path to Arrecifes, another beach, where the cars that return tourists to Santa Marta arrive. In that first visit, I went to the Museum Alicia Dussán, which functioned for a few years with the archaeological collection formed by Reichel after his work in Chairama. About this time, the late Franky Rey said that the wages paid by Reichel were fair, but that he was a despot who spared

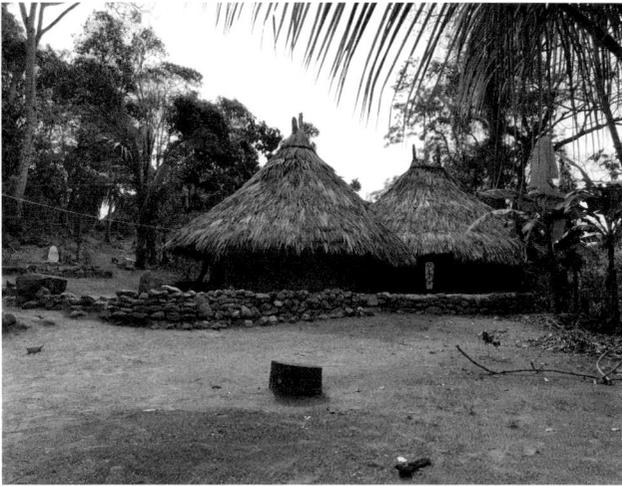

Figure 3.6 New Teykú
Source: Photo by the author, 2016.

no effort in letting the peasants know the contempt he felt for them. Farmers from Bonda still remember that Reichel mistreated them (Ortiz 2009).

In 2009, the Chairama collection that had been stored in a PNNT warehouse arrived at the University of Magdalena. What to do with it and how to organize it? The chancellor at that time, Juan Carlos Dib, invited me to be one of the university commission in charge of managing the collection—an indeterminate set of objects with pottery vessels, tumas, rock pipes, carved bones and grinding tools. Before the collection arrived at the university, it had agreed with PNNT and ICANH officers during a working meeting at PNNT facilities to define work plans and possible commitments. The atmosphere at the meeting was tense because there were clear differences between my vision of archaeology and the institutional visions of ICANH and PNNT officers; the latter proposed to remodel the Park museum (named after Alicia Dussán, Reichel's widow). The idea was to clean the pieces, make new signage, and enliven the space for tourism purposes. The logic of the proposal was based on the idea that the museum would serve to train anthropology students. The project was simple: the university received a space for practices, and in return it had to take care of the pieces and redesign the museum. The collection, composed of no less than 1,000 pottery items and the same number of lithics, resulted from Reichel's research in the 1940s. On one occasion Juan Nieves, while we were talking in Teykú, suggested that this collection was composed of the payments made for centuries by the Kogui to the *jabas* and *jates* that populated the ancient lands of mamo Teykú. We can understand the ontological violence unleashed by the archaeologists, especially by Reichel, when they ransacked the ezuamas, taking away the pottery vessels and the tumas which supported the relations of human beings with the clans. I didn't know

how long the items had been stored, but they were stained with bat droppings, and rats had gnawed at old shelves. The sacred pieces, the materials on which the foundations of the world were built, the rocks that were an extension of the clans—everything was converted into garbage.

Juan Carlos Dib, the chancellor who led the meetings between the University of Magdalena, PNNT, and ICANH regarding the collection, is a medical doctor with a long history of working with the communities of the SNSM. His work has furthered the understanding of tropical diseases, and his support has been decisive in the training of Kogui medical doctors. He was aware that the institution could not participate in a museum for a privately managed Natural Park and whose main interest was international tourism. He was aware that we could not commit our students to work on a heritage project, prepared to produce mnemonic commodities for a global audience, at the expense of local memories. He was aware that we were not interested in creating essentialized stories of antediluvian tribes. We proposed that if a museum was to be created, it should be designed as a space to support the political activism of the peasant and Indigenous people who live around the PNNT. To that extent, the university could commit its staff and even resources, given that professors and students fully supported these initiatives. While we were making our presentation, Dib requested a mamo to evaluate the collection; he knew it was necessary to do this, because no decision could be made without due authorizations, especially by the mamos responsible for the ezuamas located in the PNNT. The meeting was called off, and PNNT and ICANH officers left the room. We later learnt that their untimely departure was prompted by our decisions, which rejected those objects' instrumentalizing to conform to commodity definitions of heritage. We returned to Santa Marta, feeling that we had won a battle against the intransigence of power. A few weeks after the event, the university received dozens of boxes, with pottery from the Chairama collection, a pair of Reichel's boots, and rat-eaten files—the remains of the materials accumulated by Reichel while he directed the Magdalena Ethnological Institute. An archaeological archive was converted into an archaeological record. We wanted to exhibit it, but we were warned that Reichel's family might sue us.

In those years, between 2008 and 2010, the ICANH conducted excavations in Pueblito Chairama, and experts measured the site's carrying capacity. By 2010 there was an important presence of Kogui families between Calabazo and Pueblito Chairama, who expressed dissatisfaction with the invasive actions taking place in Pueblito. Juan Nieves's work was also beginning to be seen in Teykú, his architectural and spiritual project. Juan decided to build a *nujué* on terraces outside the PNNT, leading to some settlers describing Teykú as "the other Pueblito."

In 2016, and after intense negotiations involving the presentation of judicial complaints by which the Indigenous communities sued the state, PNNT authorities agreed to put up two signs to recognize that the SNSM communities had already won. The first sign was placed at the entrance of Chairama,

and the other was placed at the exit; both indicated that they were sacred sites and that they could not be visited. The sign at the entrance read: "No entry. Teilluna, chief of all stones." Upon leaving Pueblito, there was another sign warning that the site had profound meanings for the natives. These signs were decisive in the legitimacy acquired by the Kogui against tour operators and Park officers, as they saw that it was not a mere whim of the indigenes but a struggle for the re-establishment of an order that had been broken, precisely by the presence of the national society. The case of Chairama showed that Teilluna (slightly less than 100 square meters) had been alienated in favor of the natives. The strategy was to adduce the parallelism between conservation and the religious dynamics of the Kogui.

Indigenous peoples' claims before judicial courts for the reclaiming of their sacred sites were based on Resolution 837 of 1995, issued by the Ministry of Interior, in which Pueblito was recognized as one of the sacred sites forming the "Black Line," the union between all the points that make up each ezuama. The legal pressure of Indigenous authorities led the PNN to issue Resolution 070 of 2013 that ordered the temporary closure of the sacred sites of *Jate* Teluama, Uleillaka, Terúgama, Teugamun, Teilluna and *Jaba* Namukake, all located in Pueblito Chairama. The signs that announced this decision were only put in place three years later, as I indicated above. The first closures followed legal decisions taken in 1995 as part of the agreements between the state and Indigenous communities as a result of the 1991 Constitution. Those decisions allowed the demarcation of Pueblito as "Site Number 25," recognizing the existence of Terúgama and Teilluna.

Resolution 0391 of 2018 of PNN, acting on behalf of the Ministry of Environment and Sustainable Development, came to complement the 2013 resolution issued at a time when an NGO, acting on behalf of the Kogui, called for the definitive closure of Pueblito. The resolution accepted the ruling of a judge who indicated that the cultural rights of the Kogui, recognized by the 1991 Constitution and by the resolution of the Ministry of Interior of 1995, were violated. The Presidential Decree 1500 of 2018 also had a remarkable effect. It has facilitated the understanding of the importance of the "Black Line" for the reproduction of the territory of the SNSM peoples.

Resolution 0391 of 2018 recognizes three significant sacred areas: Chengue, Pueblito and Los Naranjos. In the specific case of Pueblito, it indicates that an agreement was made between the state and the natives, recognizing that Pueblito was Teykú Bunkuanezhaka, the space where the ideas of mamo Teykú came true. Pueblito itself is Nikuma, where agreements are reached to work in compliance with the Sé law. When the Kogui are asked what they will do with Pueblito, they say that it will be a school for mamos. Since for the Kogui the time to come is the time announced in the past, Nikuma is a project of consolidation of the Sé law duly followed by Teykú—who dominated, with his teachings, the entire region. In Kogui cosmology, *jate* Teykú is fundamental because he is the father of the tumas, along with *jaba* Tezhuna, who is the mother. That explains why there is such a large amount of these

materials in the Chairama collection assembled by Reichel and other archaeologists and *guaqueros*, because for many years, maybe centuries, people went to Nikuma to make payments to Teykú and Tezhuna. So, it is not really about making a school for mamos, but instead letting the site materialize the teachings of *jates* and *jabas* who permit Pueblito the concretion of the word and actions that allow the fulfillment of Sé. Pueblito is the place where those who are destined to be mamos make payments to Teykú and Tezhuna, connected with the principles of the universe, of creation. Pueblito serves as a connection with the pre-established laws that demand payments for the necessary connections that must be done within the system of ezuamas. But although there is ontological clarity, a serious political problem remains: Pueblito Chairama is considered a Kogui site shared with the three other nations of the Sierra (Wiwa, Arhuaco and Kankuamo), but the Taganga are excluded. Although OGT political officers do not accept the existence of the Taganga, the mamos do accept them as their Tuxe relatives. Mamo Rumualdo, for example, is related to Joselito, who is a Tanguero, since childhood. Joselito, an older man who could easily play the character of *The Old Man and the Sea*, told me that he was raised in the Kogui lands of Makotama, and that he spent some summers in Taganga with Rumualdo, his best friend. The last time I saw them together, the army had taken Rumualdo to Santa Marta, by helicopter, and he had gone to visit Joselito; I found them in a bar drinking beer and eating.

In addition to the tension between OGT and the *tangueros*, GKM aspires to manage its own resources since it does not belong to the clans that defend the interests of OGT. In any case, OGT has been at the forefront of the reclaiming of Pueblito Chairama, which is not on the agenda of GKM since its area of influence is the southern basins of the SNSM.

In sum, since 1995, legal instruments have been developed in Colombia that grant recognition to Indigenous people as administrators of sacred areas. The documents mentioned above state that the sites' sacred nature is compatible with the conservation policies promoted by the state. However, before 2016 the Kogui were uneasy because the sanctuaries to make the payments were open to tourists. In 2018, when that situation was reversed, the entire central square of Pueblito, with its adjacent terraces, came to be managed exclusively by the Kogui. Pueblito is no longer an archaeological park. It has become, again, what it was for centuries before the Spanish invasion: the place where the connections with *jate* Teykú and *jaba* Tezhuna, father and mother of the tumas, are established. In Kogui, cosmological sites such as Pueblito were people of a time before this Sun, as the mamos often say, remembering the principles responsible for the visible and non-visible worlds. The mamos say that the ezuamas understood that the society of the future would need the following elements for territorial management: Kogtuma stone, where the connections with the feminine are established, such as lagoons, the earth, the sea, the stars; and Jaksínkana stone, which connects with the masculine, like the sun and the hills. The mamos believe that

libations with gold came first, then were made with stones (the tumas), and finally with masks known as Kalgwaká. In the lower ezuamas the payments are made with fish figures, while those above are made with masks for dancing to connect what is in the earth below with what is above it (Mestre 2019:46–47).

The Kogui think that by taking the tumas and destroying the ezuamas, the archaeologists prevented the community from establishing connections with *jabas* and *jates*, affecting their governance, social balance and territorial conformation. The most complex effect was to prevent them from accessing the territory because, without the payments to *jates* and *jabas*, social reproduction was impossible. Hence the strategic importance of Pueblito in the social movement associated with OGT. Yet, *jate* Teykú and *jaba* Tezhuna of Pueblito are not exclusively associated with the Kogui; rather, Pueblito is a space of convergence of all Indigenous peoples to enforce universal laws. If all the peoples of the SNSM make payments in Teilluna, the Sé world will settle down and the order broken by colonialism will be restored—not as a return to a past dislocated by globalization, but as a willingness to live a life on the planet capable of healing the open wounds of colonialism.

The document that has served as a basis for explaining the agreements between the state and the Kogui established that archaeological investigations

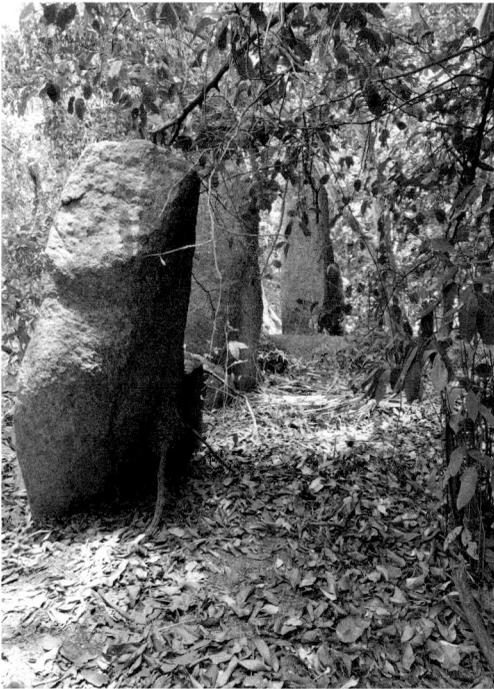

Figure 3.7 An ezuama abandoned in the PNNT
Source: Photo by the author, 2016.

must be banned immediately in the PNNT (Parques Nacionales Naturales de Colombia 2019:48). This is an important turning point in the centuries-old Indigenous resistance. Currently, the old entrance to the main square of Pueblito is closed to tourists, indicating the PNN resolution, and they are warned that the Kogui guard this place. Tourists must take a detour along ancient paths, crossing some of the village's central neighborhoods full of pottery fragments as if they had been recently abandoned. Beyond the terrace on which the village was built, there is the ancient pre-Hispanic trail leading downwards, even with an old ezuama excluded from the spaces that were recognized by the state. The recognition of Indigenous cultural rights is carefully managed to not affect the private property and the provision of environmental services, such as the visit to the PNNT. Despite these normatives, there is strong pressure from foreign capital exerted on the PNNT to permit the building of five-star hotels. To prevent this from happening, former president Juan Manuel Santos issued Decree 1500 in 2018, which the media labeled as "controversial." Elites in Santa Marta assert that the decree affects the right to development. Since it was issued in 2018, at the end of Santos' term, the current government has limited its application and has tended to favor foreign capital. Colombia's right-wing politicians want to give strategic areas of environmental sustainability to foreign capital, in order to generate employment in the region—which, by the way, foreign capital keeps to a minimum. At present, such pressure is manifested in the debate over the PNNT management plan, especially as the concession made to private operators to exploit the Park's environmental services has ended. In northern Colombia, social movements fear that a new wave of violence could take a toll on themselves and their territories. Such fears are not unfounded; the end of the 2010s is witnessing a transformation of the internal conflict, as it becomes even more subjected to illicit drug production and trafficking (Livingstone 2004).

Reclaiming the sacred spaces has been a decades-long process and has mainly involved a symbolic struggle staged in the courts. Although the Kogui have regained some rights, for others the struggles are just beginning, such as those for the expansion of the territories and the strengthening of organizations other than OGT.

Conclusions

Throughout the 20th century, the Colombian state used legal mechanisms to appropriate Indigenous territories considered vacant; so did landowners, who established their farms on sites with old ezuamas. Different layers of meaning were thus imposed upon those territories, which first were theorized as conservation areas and later as archaeological sites. Many sacred sites were suddenly found outside the reach of the Indigenous people—an obstacle to the consolidation of the clans and their territorial dominance. At the same time that the state tried to specify a heritage policy for the management of

archaeological sites, the Indigenous reclaiming of pre-Hispanic villages began. This shows that, in contexts like those of the SNSM, heritage is not given, but historically enacted and continuously disputed.

References

Alonso, P. (2014). From a given to a construct: heritage as a commons. *Cultural Studies*, vol. 28, no. 3. London, pp. 359–390.

Alonso, P., González-Álvarez, D. & Roura-Expósito, J. (2018). ParticiPat: exploring the Impact of Participatory Governance in the Heritage Field. *Political and Legal Anthropology Review*, vol. 41, no. 2. United States, p. 306–318. DOI: https://doi.org/10.1111 / plar.12263

Anderson, B. (2006). *Imagined communities*. London, United Kingdom. Verso.

Archila, M. & Pardo, M. (2001). *Movimientos sociales: estado y democracia en Colombia*. Pensamiento y Cultura, vol. 4. Colombia, pp. 255–257.

Augé, M. (1995). *Los no lugares: espacios del anonimato: una antropología de la sobremodernidazl*. Barcelona, Spain. Gedisa.

Avendaño, Y. (2013). Entre los caminos de la Sierra Nevada. (Pregrad thesis). Universidad del Magdalena, Programa de Antropología.

Betancur, María. (2006). Del estatuto de seguridad al estado comunitario: veinticinco años de criminalización de la protesta social en Colombia. *Observatorio Social de América Latina*, no. 19. Argentina, pp. 179–224.

Cadavid, G. (1993). Proyecto de preservación y restauración de Pueblito (Parque Nacional Tairona). *Boletín de Arqueología de La Fian*, vol. 8, no. 1. Colombia, pp. 35–45.

Campo, A. & Turbay, S. (2015). The silence of the Kogi in front of tourists. *Annals of Tourism Research*, vol. 52. Australia, pp. 44–59. DOI: https://doi.org/10.1016/j.annals.2015.02.014

Campo, O. (2011). Playa del muerto. Caracterización de una problemática socio-ambiental. (Pregrad thesis). Universidad del Magdalena, Programa de Antropología.

Caracol Radio. (2011, 20 October). *Incautan importante cargamento de droga en el Parque Tayrona*. Santa Marta, Colombia.

Carrasquilla, D. & Silva, F. (2010). El Parque Nacional Natural Tayrona aproximaciones a una historia desde abajo. *Oraloteca*, no. 2. Colombia, pp. 14–23.

Castaño, Y. (2006). De bestias y de hombres: la introducción de la actividad ganadera en el Occidente Neogranadino, siglo XVI. *Historia y Sociedad*, no. 12. Colombia, pp. 251–284.

Castillo, M. (2009). Prácticas y relaciones sociales asociadas a la producción de banano de la Zona Bananera del Magdalena. (Pregrad thesis). Universidad del Magdalena, Programa de Antropología.

Charters, C. (2011). 10. Comparative constitutional law and Indigenous peoples: Canada, New Zealand and the USA. Ginsburg, T., & Dixon, R. *Comparative constitutional law* (p. 170). Northampton, UK. Edward Elgar. DOI: https://doi.org/10.4337/9780857931214.00017

Chaves, M., Montenegro, M. & Zambrano, M. (2010). Mercado, consumo y patrimonialización cultural. *Revista Colombiana de Antropología*, vol. 46, no. 1. Colombia, pp. 7–26.

Cooke, R. & Bray, W. (1985). The goldwork of Panama: an iconographic and chronological perspective. Jones, J. *The art of Precolumbian gold: the Jan Mitchell collection* (pp. 35–49). London. Weidenfeld and Nicolson.

Dal Bó, E., Dal Bó, P. & Di Tella, R. (2006). "Plata o Plomo?": bribe and punishment in a theory of political influence. *American Political Science Review*, vol. 100, no. 1. United States, pp. 41–53.

Daza, J. (2007). Institucionalización organizativa y procesos de selección de candidatos presidenciales en los partidos Liberal y Conservador colombianos 1974–2006. *Estudios Políticos*, no. 31. Colombia, pp. 141–181.

De Angelis, M. (2012). Marx y la acumulación primitiva. El carácter continuo de los "cercamientos" capitalistas. *Theomai*, no. 26. Argentina.

De la Cadena, M. (2009). Política indígena: un análisis más allá de "la política". *Red de Antropologías del Mundo*, vol. 4, pp. 139–142.

De la Hoz, E. & Sanjuanelo, J. (2018). Las leyendas no nacen solas: el origen de un mito llamado Vallenato. *Revista Estudios Sociohumanísticos*, vol. 1, no. 4. Colombia.

Del Pozo, P., & Alonso, P. (2012). Industrial heritage and place identity in Spain: from monuments to landscapes. *Geographical Review*, vol. 102, no. 4. United States, pp. 446–464. DOI: https://doi.org/10.1111/j.1931-0846.2012.00169.x

De Oro, C. (2010). Las paradojas de la preservación de las tradiciones del carnaval de Barranquilla en medio del mercantilismo, la globalización y el desarrollo cultural. *Revista Brasileira do Caribe*, vol. 10, no. 20. Brazil, pp. 401–422.

Duarte, J. (2018). Expulsión de los misioneros capuchinos por la comunidad arhuaco en la Sierra Nevada de Santa Marta. (Pregrad thesis). Pontifica Universidad Javeriana. Facultad de Ciencias Sociales.

El Tiempo. (2003, 10 August). La ronda de la muerte en el Parque Tayrona. Bogotá, Colombia.

El Tiempo. (2009, 17 April). Los Araújo son una de las dinastías políticas de mayor tradición en la Costa Caribe. Bogotá, Colombia.

Escobar, J. (1997). *Derecho constitucional colombiano*. Bogotá, Colombia. Temis.

Falchetti, A. M. (1987). Desarrollo de la orfebrería tairona en la provincia metalúrgica del norte colombiano. *Boletín Museo del Oro*, no. 19. Colombia, pp. 3–23.

Falchetti, A. M. (1996). El territorio del Gran Zenú, en las llanuras del caribe Colombiano: Arqueología y etnohistoria. *Revista de Arqueología Americana*, no. 11. Brazil, pp. 7–41.

Ferro, J. & Ramon, G. U. (2002). *El orden de la guerra. Las FARC-EP entre la organización y la política*. Bogotá, Colombia. Pontificia Universidad Javeriana.

Figueroa, J. (2009). *Realismo mágico, vallenato y violencia política en el Caribe colombiano*. Bogotá, Colombia. Instituto Colombiano de Antropología e Historia.

Friede, J. (1955). *Documentos inéditos para la historia de Colombia: coleccionados en el Archivo General de Indias de Sevilla*. Bogotá, Colombia. Academia Colombiana de Historia.

Galán, L. (1982). *Los carbones de Colombia*. Bogotá, Colombia. Oveja Negra.

Giraldo, P. (2005). Adiós a la inocencia crónica de una visita al estilo nacional de hacer antropología. *Antípoda. Revista de Antropología y Arqueología*, no. 1. Colombia, pp. 185–199.

Gnecco, C. & Dias, A. (2015). Sobre a arqueología de contrato. *Revista de Arqueología*, vol. 28, no. 2. Brazil, pp. 3–19.

Gómez-Suárez, A. (2018). Una con-textualización de la diáspora de la Unión Patriótica (1985–2015). Iranzo, A. & Edson, W. (eds.). *Entre la guerra y la paz: los lugares de la diáspora colombiana* (pp. 143–162). Bogotá, Colombia. Pontificia Universidad Javeriana. DOI: http://dx.doi.org/10.30778/2018.21

González, L. G. (2006). El origen del patrimonio como política pública en Colombia, y su relevancia para la interpretación de los vínculos entre cultura y naturaleza. *Revista Ópera*, vol. 1, no. 1. Colombia, pp. 169–187.

Gutiérrez, N. (2013). Las ciudades olvidadas. Ocupación espacial y desarrollo arquitectónico de las sociedades originarias en la Sierra Nevada de Santa Marta. (Doctoral thesis). Universidad Pedro de Olavide. Departamento de Geografía, Historia y Filosofía.

Haber, A., Londoño, W., Mamaní, E. & Roda, L. (2016). Part of the conversation: Archaeology and locality. Allen, H. & Phillips, C. *Bridging the divide. Indigenous communities and archaeology into the 21st century* (pp. 81–92). London. Routledge.

Hamilton, E. J. (1984). *El florecimiento del capitalismo: ensayos de historia económica.* Madrid, Spain. Alianza Editorial.

Hylton, F. (2006). *Evil hour in Colombia.* London. Verso.

Jorge Elías, C. (2009). *Santa Marta del olvido al recuerdo: Historia económica y social de más de cuatro siglos.* Santa Marta, Colombia. Editorial Unimagdalena.

Latorre, E. & Fare, A. (2014). Caracterización de la formación y estructuración de las bandas criminales en el Departamento del Magdalena. *Advocatus*, no. 22. Colombia, pp. 261–279. DOI: https://doi.org/10.18041/0124-0102/a.22.3581

Leal, A. (2014). Ontología política del ecoturismo en el Parque Nacional Natural Tayrona. (Pregrad thesis). Universidad del Magdalena. Programa de Antropología.

Livingstone, G. (2004). *Inside Colombia: drugs, democracy and war.* New Jersey, United States. Rutgers University Press.

Londoño, L. (2002). Semblanza biográfica de Federico Carlos Lehmann Valencia. *Revista de la Academia Colombiana de Ciencias Exactas, Físicas y Naturales*, vol. 26, no. 99. Colombia, pp. 213–229.

Londoño, W. & Alonso, P. (2017). From plantation to proletariat: Raizals in San Andrés, Providencia and Santa Catalina. *Race and Class*, vol. 59, no. 1. United Kingdom, pp. 84–92. DOI: https://doi.org/10.1177/0306396817701680

Ministerio de Cultura de Colombia. (1997). Ley General de Cultura. Ley 397 de 1997.

Mestre, Y. *et al.* (2019). *Hacia una política pública ambiental del territorio ancestral de la línea negra de los pueblos Iku, Kággaba Wiwa y Kankuamo de la SNSM en la construcción conjunta con Parques Nacionales Naturales.* Santa Marta, Colombia. CTC.

Moore, J. & Salvatore, E. (2018). Capitalism in the web of life: ecology and the accumulation of capital. *Human Geography*, vol. 11, no. 2. United States, pp. 72–78. DOI: https://doi.org/10.2458/v24i1.21075

Morales, N. & López, M. (2019). Propuesta para el fortalecimiento del turismo sustentable en la ruta a Ciudad Perdida realizada por la agencia indígena Wiwa Tour. (Pregrad thesis). Universidad Externado de Colombia. Programa de Administración de Empresas Turísticas y Hoteleras.

Moscoso, J. (2013). Arqueología, memoria y patrimonio: un caso de transacción patrimonial en el sur de la Sierra Nevada de Santa Marta. *Boletín de Antropología*, vol. 28, no. 46. Colombia, pp. 218–243.

Muñoz Gallego, M. (2019). Crímenes y parapolítica en Colombia en el siglo XXI. Análisis de tres casos a partir de los medios escritos de comunicación. (Doctoral

thesis). Universidad Nacional de La Plata. Facultad de Humanidades y Ciencias de la Educación.

Nates, I. (2010). La maldición del paraíso: tenencia y territorialidad en el parque nacional natural Tairona. Serje, M. (ed.). *Desarrollo y conflicto: territorios, recursos y paisajes en la historia oculta de proyectos y políticas* (pp. 187–216). Bogotá, Colombia. Universidad de los Andes.

Niño, J. (2016). La anatomía de la casa. Humanización y ciclo vital de la vivienda ette (Chimila). Dearq. *Revista de Arquitectura*, no. 19. Colombia, pp. 62–73. DOI: http://dx.doi.org/10.18389/dearq19.2016.06

Ojeda, D. (2012). Green pretexts: ecotourism, neoliberal conservation and land grabbing in Tayrona National Natural Park, Colombia. *Journal of Peasant Studies*, vol. 39, no. 2. United States, pp. 357–375. DOI: https://doi.org/10.1080/03066150.2012.658777

Ortiz, F. (2009). Patrimonio arqueología y guaquería un debate inconcluso: caso específico ciudad de Santa Marta. (Pregrad thesis). Universidad del Magdalena, Programa de Antropología.

Parque Nacionales Naturales de Colombia. (2019). *Plan de Manejo de los Parques Nacionales Naturales Sierra Nevada de Santa Marta y Tayrona "Hacia una política pública ambiental del territorio ancestral de la línea negra de los pueblos Iku, Kággaba, Wiwa y Kankuamo de la Sierra Nevada de Santa Marta en la construcción conjunta con Parques Nacionales Naturales Jwisinka Jwisintama—Mama Sushi— She Mamashiga"*. Bogotá, Colombia.

Porter, B. (2014). *Blow: how a small-town boy made $100 million with the Medellín cocaine cartel and lost it all*. New York. St. Martin's Press/Griffin.

Reichel-Dolmatoff, G. (1953). Contactos y cambios culturales en la Sierra Nevada de Santa Marta. *Revista Colombiana de Antropología*, vol. 1, no. 1. Bogotá, Colombia, pp. 15–122.

Rodríguez, J. (1979). *El carnero*. Bogotá, Colombia. Fundación Biblioteca Ayacuch.

Sánchez, G.*et al.* (2006). *Plan de Manejo Parque Nacional Natural Tayrona 2005–2009*. Santa Marta, Colombia. Parques Nacionales Naturales de Colombia.

Sarabia, C. & Ardila, E. (2019). La ciudad erotizada: análisis discursivo de un blog turístico sobre Cartagena de Indias. *Actas Icono 14*, vol. 1, no. 1. Spain, pp. 164–181. DOI: https://doi.org/10.7195/ri14.v14i1.926

Semana.com (2011). *Novela en el Tayrona*. Bogotá, Colombia.

Sevilla, M.*et al.* (2014). *Travesías por la tierra del olvido: modernidad y colombianidad en la música de Carlos Vives y La Provincia*. Bogotá, Colombia. Pontificia Universidad Javeriana.

Straczynski, S. (2010, October). *Of sea and stone: Chairama Spa*. Contract Design. com.

Tovar, H. (1994). *Relaciones y visitas a los Andes*, vol. II. Bogotá. Colcultura, Instituto de Cultura Hispánica.

Vallejo, F.*et al.* (2012). *Cuerpo y músicas "mulatas": navegación fluvial y transculturación de los bailes cantaos en el Bajo Magdalena*. (Informe de investigación). Universidad del Magdalena, Programa de Antropología.

Vives, C. (2016). *Viaje por un lugar increíble*. El Heraldo, 29 May.

4 Linking the divided

Sacred rocks and libations

Processes of rupture

The Indigenous people of the SNSM have opposed colonialism since the 16th century. Surviving colonialism has not only been a facet of their lives, but a daily fight against modernity/coloniality. Mamos, and *jabas* today, are aware that colonialism is not an abstract concept, but a concrete form: the destruction of ezuamas by the archaeologists, the reification of Indigenous peoples' possessions as decorative elements of a tourism-based economy, the pressure exerted on their territories by paramilitary groups. Mamos from SNSM reiterate time and again the violence suffered at the end of the 19th century when the state sought, through the use of force, religion, and education, to dissolve their communities into the homogeneous mass of the modern nation (Mestre & Rawitscher 2018). The state ceded territories and resources to religious orders for them to turn the Indigenous people into Colombian citizens (Restrepo 2006; Bosa 2015). The *mestizaje* that took place in the republic was based on the idea of a homogeneous nation that should emerge from itself and not through migration (Londoño 2003).

The memories of the mamos, especially those of the south, recall that their ancestors preferred to leave their villages near Makotama only to found new settlements near the sacred sites of the Tucurinca lagoon at the foot of the CGSM. The pilgrimage occurred because of the constant harassment of police inspectors who abused their power, preventing the natives from developing their ceremonies, singing their songs, and dancing their dances. This was done within a neo-Catholic regime that prevailed at the end of the 19th century after the conservative elites took power (Andrade 2011). The state sought to control all facets of its citizens' lives under a patriarchal and predatory model based on the extension of large estates, through logging, to increase the land available for agriculture and livestock. By the beginning of the 20th century, northern Colombia saw the aggressive presence of the banana industry led by the UFC (Bucheli 2008). This transfer of land, from its original owners to transnational companies, has been the mark of the region's economic history. Within the broad spectrum of areas that the SNSM harbors, this phenomenon of appropriation of Indigenous territory occurred,

for example, in the lower basins of Palomino and Don Diego river, devoted to banana cultivation; it also occurred to the south of the CGSM, in the Aracataca region.

With the control exercised by commissaries at the end of the 19th century, the expropriation of coastal territories in the first decades of the 20th century, and the tensions generated by the arrival of peasants in the 1950s, the SNSM communities endured paramilitary presence and violence for the rest of the century. Illegal armed actors prevented their transit through their territories, as it was believed that they were supplying the guerrillas with ammunition, weapons and food (Prado 2018). To make it clear to the Kogui that they should not support the guerrillas, some members of the northern and southern clans were killed. At present, the responsibility for these crimes and the methods of compensating the victims are being dealt with by the Special Justice for Peace—a model of transitional justice that emerged from the peace agreements between the Colombian government and the Revolutionary Armed Forces of Colombia, People's Army, FARC-EP (Santos 2019).

However, these questions are beyond the reach of the academy. The SNSM has been presented as an archaeological zone and not as a site of resistance.

As we can see, the attempts to disintegrate Indigenous peoples have been a constant throughout the centuries. In general terms, Indigenous peoples have had to rebuild their cultures to face the violence of colonialism and not perish. As claimed by Indigenous leaders, this should be the research goal of anthropologists and archaeologists.

Northern Colombia has suffered a low-intensity war for several decades. Just as the UFC was responsible for the formation of a proletariat in northern Colombia through the expropriation of territories and the conversion of individuals into workers, the war on drugs, defined as a strategy that involves the United States supplying complex financing structures to countries like Colombia (Andrade 2011), means that the local population has no choice but to swell the ranks of private armies that not only expropriate the territory but even the state. These armies are financed by drug cartels that have multiple objectives: to produce and market cocaine, to control the territory and its legitimate businesses through extortion, and to control local governments by supporting mayors and governors. The war on drugs guarantees the existence of political and financial structures that profit from pursuing a project that will always be ongoing because it is the very condition of the possibility of their existence. It is not something that occurs for a purely legal reasons. It even implies constructing a racially designed subject (Provine 2008) that should be civilized; on the other hand, this subject would be a subject of resistance (Oliveira 2019). In the case of the war on drugs, the new alterity is the Latin drug trafficker who intoxicates America's youth.

From the perspective of world-system theory (Robinson 2011), the cycles of violence that have been perpetuated across the region correspond to global configurations that go beyond the region that are turning it into a theater for capital accumulation. Territories such as northern Colombia have been

created as spaces for capital reproduction by the subalternization of populations. Colonialism has produced these territories as free zones in which extractivist permits are granted to companies located beyond their borders and where local populations are intimidated and coerced. This happened in Cartagena de Indias, for example, when the 18th-century slave traders ferried enslaved people there for sale (Aguilera-Díaz & Meisel-Roca 2009). Cartagena has been a city for the trade in bodies from then until now, when it enjoys the shameful reputation of a destination for sexual tourism (Cunin 2006). Enclaves of foreign companies operate in these areas. This is how Israeli groups, through prostitution, appropriate the value generated by local bodies and move their illegal profits to Europe, laundered as the proceeds of legitimate tourism. Northern Colombia has been built as a peripheral region where the fight against drugs takes place; local communities are targeted by armed actors that still linger because they are the raison d'être of the structures that comprise those very projects. The "Plan Colombia," for example, was a strategy designed to militarize Colombia with resources from the United States, money which had to be invested in weapons that the Colombian state must buy from US companies (Chomsky et al. 2000). This "plan" enabled corrupt payoffs to supporters of presidential campaigns within a dynamic of capital reproduction—in which the commodities are not specific objects but situations, such as Colombia's internal conflicts (Vargas 2005). The impact of Plan Colombia on the SNSM was devastating. After the paramilitary groups were armed, they started a war for the territory, which added a new cycle of violence.

In these new configurations of the global economy of violence, the construction of internal enemies is profitable for the weapons industry. In recent years, unlike the 2000s with "Plan Colombia," the enemy is not the narco-guerrilla, but the self-proclaimed Bolivarian revolution of Venezuela. The turn to the right that Latin America is experiencing (Modonesi 2015), has allowed the creation of recycled enemies such as the current savagery of the Indigenous people, expressed in the coup against Evo Morales in Bolivia, or as the impossibility of popular governments, expressed in the blockade against the Venezuelan government. These pressures are expressed in Indigenous territories in various ways, such as the appearance of military and paramilitary camps in the ezuamas, the presence of more tourists, and the bans on travelling through certain areas.

The cohesion of Indigenous communities in Latin America has occurred within the constant tension caused by external actors seeking their disintegration and eviction—every time there are more hectares planted with coca, more laboratories for the processing of cocaine, more resources available to buy weapons and technologies that will be used to control drug trafficking. Nevertheless, the local communities of the SNSM have resisted. In the 1990s, a group of academics pointed out that this constant struggle ought to be understood as a cultural politics, different from the dominant political culture that sought, at all costs, to erase the indigenes from the cultural spectrum of

the nation (Escobar et al. 2001). Thinking about the daily life of the Indigenous nations of the SNSM means thinking about their constant struggle for their culture, not defined by a set of essential features but by the possibility of engaging with globalization differently. Their particularity is their ability to heal the wounds left by colonialism. As mamo Ramón Gil explains, the importance of the Wiwa and the other nations of the SNSM is that they may restore health to a world fragmented by modernity and its logic of fracturing and segmentation. Consequently, the agenda of the Indigenous people of the SNSM implies closing gaps—the dislocations that occurred with the establishment of the modern/colonial world. The communities are currently engaged in healing the territory; this is not easy because it continues to fall prey to the market. While fragmentation has been achieved by colonialism since the 16th century, the closing of gaps has also been a constant, and has been expressed in various ways, as in the increased mobilization throughout the territory, and the social cohesion generated by the payments to the ezuamas. Despite the archaeological reading of high mobility as social disintegration and of the ezuamas as mere "cultural waste," the history embodied in them and the wisdom of mamos and *jabas* points to the clans' constant effort to hold together.

In the description that follows, I will recount how some Indigenous people have strived since 2015 to unite what was divided. In this experiment, we sought to understand the cultural heritage of the SNSM communities, not as a series of discrete practices, but as a potential method of rebuilding the territory from their ontologies. Archaeology has not been a priority in these processes of recovering territory because everything archaeological is associated with desacralizing practices. In the Taganga clans, there has been an interest in using archaeology to document ancient fishing practices. However, this is a process that is just beginning. In fact, in the bay, there is a small museum that contains archaeological record. In that museum, there is a polished anchor believed to be the only existing evidence of pre-Hispanic navigation. In this case, we could talk about an emerging process of Indigenous archaeology.

Linking the divided: experiments on suture

In 2015 I was contacted by a local NGO in order to assess Santa Marta District's heritage. I had just finished a heritage inventory in several localities of the Department of Magdalena within a Ministry of Culture initiative to know the movable (objects), immovable and intangible elements constituting regional identity. It was an institutional vision of heritage, akin to the commodification of culture, but alien to the understanding of local dynamics. Those heritage definitions were technical and did not allow us to see the interconnection between material and non-material elements in the reproduction of local societies, nor were they sensible to the local critique of centralized policies, often expressed in songs and sculptures. Those definitions,

issued from the Ministry of Culture, highlighted the folkloric or festive side of cultural expressions, downplaying their role in local cultural politics. It was the authorized heritage discourse at work, splitting the constitutive dimensions of local communities.

I enlisted two expert anthropologists from the region, Daisy Bohórquez and David Elías. OGT appointed a person who helped us doing the survey requested by the city of Santa Marta. It was about understanding the local value of certain sacred places for the Indigenous people of the SNSM, located within the District of Santa Marta. In Colombia, there are two types of territorial entities at the municipal level: municipalities and districts—ruled by different norms, given their geographic and administrative specificities. Most districts are ports, Bogotá being the exception: it is a district because it is the capital of the republic and the center of a large metropolitan area. Although Santa Marta is a district, little has been done to order its territory and its autonomy. The PNNT and the PNNSNSM are within the district but are managed by foreign entities ignoring that they are inhabited by Indigenous or peasant communities. The same goes for the sea, managed by the maritime authority, which prosecutes traditional fishers for fishing in natural reserves or conservation areas. Even the historic center of Santa Marta is directly controlled by the Ministry of Culture, with its headquarters in Bogotá. This all results in a centralism that prevents the local appropriation and management of heritage. Even so, the current administration allocated monies for an initial understanding of the territory, as a scenario of multiple ontologies. With Bohórquez and Elias, we requested OGT to assign advisors to validate the exercise. The political authorities met and decided that the person who could best represent OGT in the project would be Julio Torres. Bohórquez had managed to get the OGT board to consider supporting the project since he had worked with them and was their acquaintance. From that work, Bohórquez had obtained her degree dissertation as an anthropologist; it was a biographical sketch of some OGT leaders. I directed this investigation. In this sense, the permits we obtained to do the fieldwork were a vote of confidence in us.

This confidence was based on the idea that we would be dispersers of the thinking of the Indigenous peoples of the SNSM. This vote of confidence was given because the project did not involve any type of archaeological excavation. On the contrary, the project aimed to reflect on the damage that archaeology had done for more than a hundred years. Thus, we came to know Julio Torres, who proposed a tour of the main sacred sites of the Santa Marta District. Julio is a recognized Arhuaco activist and is knowledgeable about the sacred territoriality of the district. Through Julio, we visited sacred sites in the company of some mamos. The person who led the payments was mamo Gabriel Torres, a recognized Arhuaco authority.

The first place we went to was Katoriwan, in the Wiwa language.

According to mamo Gabriel Torres, the payments made in Katoriwan serve to identify the negative aspects of things. Mamo Gabriel indicated—in Julio

Torres' translation of what he said—that this place helps to achieve social and natural control. It is important to note that if there are people from the four Indigenous peoples of the SNSM in a ritual, it is likely that much simultaneous translation will be required because each community has its language. So translation is a common element within social interactions in the territory. In Katoriwan nothing can escape the control that other beings perform, and thus it is pertinent to notice when negative energies gain ground. That is why people visit this ezuama, to know when negative energies have advanced in such a way that they endanger the health of clans and their crops. Despite the importance of Katoriwan, the site has been taken by bathers who cure their Sunday hangovers, flooding it with garbage and noise. Little remains of Katoriwan as a site for meditation, although knowledgeable people recognize its importance and do not hesitate to visit it when fewer people are in. The place is a small bank of a ravine in the Minca district, some 10 miles from Santa Marta. There are horizontal slabs hinting at rock formations; they are the indelible marks of the ezuama of the site with which a connection with entities of the beginning of time is possible. Unlike other ezuamas, such as those of Teykú in Pueblito Chairama, here the slabs are natural and have not been arranged by human hand. In that place, mamo Gabriel threw coca leaves, closed his eyes, opened them, and whispered something that was not translated. After that, Julio told us that he had wondered about the success of this project, and discovered that it could effectively be carried out because its negative aspects were controlled.

Minca is a small peasant village that has become a tourist destination for backpackers looking to walk through the humid tropical forest. For several years, foreigners from First World countries have bought land to start hostels in such a way that the area is now visited year-round. Just as Minca is a long-awaited ecotourism destination, it is also a disputed land given its fertility for profitable hydroponic marijuana crops. Katoriwan must face the use of its territory for drug trafficking and tourism. So Minca is not a place to tour or make money; it is a place to reflect on the negative aspects of the world and how to deal with them. The payment we made with mamo Gabriel Torres was a first, minimal, silent gesture, by which Katoriwan must regain its importance—beyond Minca as a place of cultural consumption. As mamo Gabriel said, Katoriwan, despite being silenced by the noise of tourism, and despite being threatened by environmental depredation, will be able to make its voice heard to make a call for sanity. In the film record of Rafael Mojica, a young Wiwa filmmaker, Julio and Gabriel can be heard talking about the need to allow the territory to heal. This care policy is critical when a pandemic by COVID-19 has exposed the injustices with which the current world is woven.

In retrospect, it was clear that the predatory system of modernity was unfeasible: thousands of tourists dirtying the territory. In the gestures of the mamos with whom we spoke, there were the explicit manifestations that announced an imminent collapse.

We went afterward to Duanama or Donama. It is a carved stone with rounded grooves that is located in the village of Bonda. There mamo Gabriel Torres proceeded likewise: planted coca leaves at the base of the rock, whispered a few words, and began to talk about the importance of Donama, a place that represents duality, complements, things that are dual and inseparable. It suffices to look at the world's routine to see that all cycles could not exist without their complementary opposites. Julio commented that perhaps most representative of this was the fact that there could not be a mamo without his respective partner, as there could be no offspring without the relationship between men and women. What struck me the most about what mamo Gabriel said was that there would be no clan without ezuama. Another essential characteristic of that stone is its timelessness since it has been there since the beginning of time; to admire it is to have a connection with the principles of the creation of the world. In this trip through the territory Minca served to consult about the negativity, and Donama served to consult on dualities. (Gómez [2000] has shown that duality is a constitutive element of Amerindian cosmologies, positing that good corresponds to the duality of evil; the latter is considered familiar, not something that should be denied, as in the Judeo-Christian tradition.) Both sites endure enormous pressure from external actors who see only a vacation experience of trails and jungles.

As Amado Villafaña expressed it in a conversation, the problem with archaeology is that it has no complement but does not have a pair. There is no one ezuama to pay it in order to do archaeological research.

Archaeology is a practice without sympathy because the sympathetic is what has a complement in analogical thought. This is why in the Amerindian world doing archaeology is such a dangerous practice, since it is a practice of destabilization. Even in projects where archaeological excavations have been made, Indigenous peoples have preferred to call these practices history studies.

After visiting Minca and Donama, we went to a shocking place because of the amount of garbage deposited in it. It is the mouth of the Gaira river in El Rodadero in Santa Marta. On this occasion, we were also accompanied by mamo Gabriel and the translator, Julio Torres; the former presented the coca leaves as payment and whispered words that were imperceptible because the wind was blowing. We were at the mouth of a polluted river, which flows into a sea whose coastline is covered by apartment buildings and resorts, a kind of wall that separates the rich from the poor (Londoño 2019). The payment we made in Gaira was the most shocking of all because there was little to say. The experience was a kind of recognition of the disdain of modernity in dumping its waste on an area for payments. The only thing I could take from my notes was a phrase from mamo Gabriel that Julio translated as something like, "The Sierra is a human being and here protrudes a point, Gaira." I imagined the Sierra as a person sitting on the seashore, and Gaira as the toe getting wet with the waves. This ezuama is now full of garbage deposited on muddy ground where herons stop to eat worms.

After Gaira, we went to the sacred site of Mamotoco, located on the grounds of Quinta de San Pedro Alejandrino, where Simón Bolívar died. Mamotoco is a traditional neighborhood that was once a village of Indians (Rey Sinning 2009) and recognized worldwide for its San Agatón festival. San Agatón, as the lyrics go, is "the holy drunkard." The *mamatoqueros*, in the middle of carnival, take San Agatón out of the church and carry him through the neighborhood; hundreds of people go out to throw him rum shots. As the saint passes by, parents with their children seek to touch him in any way because it is a sign of a good upbringing. It is a rite of contagion in all its splendor. This mestizo party is recurrent in the Andes. Its composition is simple. The rite is based on the cult of an image that, for unknown reasons, appears in a creek to one or more people. They are usually subalterns, generally indigenes or peasants, so the miracle raises the status of the group and allows us to think of a social mobility based on the idea of being a good devotee, which is nothing more than being a good subaltern. As Taussig (2010) has pointed out, these rites are colonial and involve resignified local networks in a world of asymmetries, as is the world of colonialism in the Americas. Perhaps the most famous image of Colombia with this origin is the Lord of the Miracles, in Buga (Echeverry 2014). The image is said to have appeared to an Indigenous washerwoman who had to buy another image of Christ because the one she had was spoiled. An appearance to an indigene or a peasant has an effect: it takes away the church's monopoly over the management and control of religious images and celebrations, and symbolically produces upward social mobility. This is what happened in San Agatón: Agatón's image appeared to a group of peasants, and his cult was instituted at the time of the carnival. San Agatón recreates the struggle of the community to reject the outright imposition of Christianity, proposing instead a practice that does not question Catholicism or its underlying social structure, but its morality and asceticism.

Mamatoco is thus a place full of power that serves as a melting pot for expressions of Indigenous ontology, but also the ontology of peasant and Indigenous Catholicism.

The father of an anthropologist from Mamotoco, Luis Cadena, told me that at the beginning of the 20th century the original image of San Agatón was stolen with the permission of the priest so that the carnival involving the saint could no longer be celebrated, The current image of San Agatón is not the original, but that does not matter much at the time of the celebration. San Agatón is the most important festival in Mamotoco, but it is not an Indigenous celebration because the people of the SNSM do not recognize it as their own. The festival is based on an animistic principle that recalls the moments when Mamotoco was indeed an Indigenous village. The Indigenous anthropologist David Cantillo commented that, in the past, the tagangueros had strong relations with the mamotoqueros, not only by friendship but also by marriage and *compadrazgo*. With migration occurring in both places, those relations weakened to the point that today they are practically extinct. Now,

with the recognition of Taganga as an Indigenous council, one fundamental task is the reconstruction of these social relationships.

There must be a kilometer from the resting place of San Agatón to the sacred site of Mamotoco, within San Pedro Alejandrino. This distance is not only physical, but political: the indigenes from Mamotoco were turned into citizens by the early 19th century, right after independence; their lands were divided and appropriated, and the old church served to form a small town that housed the new spatial configuration. Although the maelstrom of the republic subsumed Mamotoco, its ezuama is still visited as it is there where the mamos remember their duties and reaffirm their knowledge. Here, too, mamo Gabriel was silent, and I remember a phrase I wrote when Julio translated his words, pointing out that in Mamotoco, "the language of respect" was uttered.

Unlike the sacred sites of Minca and Gaira, Mamotoco is well protected because it is within the old hacienda of San Pedro Alejandrino. This farm belonged to an elite family responsible for opening land markets in the Magdalena in the 18th century (Viloria 2000). When the current land tenure model was set up in the 18th century, many areas with sacred sites went into private hands, such as Mamotoco and its ezuama. San Pedro Alejandrino has a theater, where events are held regularly; there is also a space for exhibits and conferences, and the famous "Altar a la Patria" (Shrine to the Homeland) commissioned by former president Enrique Olaya in 1930 to commemorate the death of Simón Bolívar. The altar was designed by architect Gustavo Santos and executed by architect Manuel Carrerá, who in 1948 built the famous Hotel Tayrona. Subsequently, the sacred site of Mamotoco was superimposed by the colonial layer of the hacienda, and then by the republican layer. In any case, the sacred site of Mamotoco has never been disconnected from the network of relations in which the SNSM peoples are inserted. One of its most important dimensions is to serve as a stage to reaffirm the continuity that is the purpose of all mountain cultures, as mamo Gabriel points out. Remembering Donama's duality, mamo Gabriel explained that there was a community if there was an ezuama. It is in this way that the policy of payment in the ezuama mobilizes the construction of society. There could be no society without ezuama, and there could be no ezuama without territory. Furthermore, there could be no territory if the Fathers and Mothers had not left their marks to remind us that the world is made up of a reciprocity system.

Once we had finished making the payments in Mamotoco, we went to Matuna, a hill located in El Cundí, a neighborhood of Santa Marta. It is a geographically unique place because it is the only elevation in the sector from where the coastline and the mountain range can be seen at once. It is a kind of lookout in the middle of the valley where Santa Marta sits. At the top of the hill there is a statue of the Virgin Mary, indicating its importance within the moral geography of Santa Marta. The statue is of the Virgin of the Miraculous Medal, an image worshiped by a French tradition that spread

throughout Latin America in the late 19th century. The first churches in honor of this image were built in the 1950s (Thrall & Garlock 2010). The image on the hilltop was made in the late 1950s by the sculptor Antonio Sánchez Jiménez (*Revista Memorias* 2010), who graduated from the School of Fine Arts in Bogotá. He was in charge of making a sculpture to be placed on the hill from where the ships that came to Santa Marta were formerly observed. Sánchez, apparently against his wife's wishes, decided to use her face for the 5-meter-high statue, which follows the original French model of a virgin levitating with open arms and palms facing outward, dressed in a belted white shift and a blue cloak. In the 1950s, when the parish honoring the Virgin was founded in Santa Marta, her image was located atop the hill where the natives make their payments to Matuna. It is the old routine of colonialism, that of imposing religious meanings on local communities, destroying their temples, and erecting its own. This location was related to the suppression of Indigenous features around Santa Marta, aiming to turn Indigenous villages into neighborhoods. This had begun in 1930 when the 100th anniversary of Liberator Simón Bolívar's death was commemorated; a road was built that ran from the Cathedral of Santa Marta to San Pedro Alejandrino. That route is called Avenida del Libertador nowadays, and is dotted with the mansions of UFC executives and Santa Marta landowners who rented their land to the UFC. For many Indigenous people of the SNSM, walking the streets of Santa Marta means walking a colonial geography that has been imposed throughout the territory.

In 2016 a local newspaper (*Opinión Caribe* 2016) reported on the hill of Cundí; it emphasized that the temple where the statue had been placed, which provided shade and a good view, had appropriated by drug users, indifferent to the garbage they generated in their constant *jaranas*. The article also indicated, almost ironically, that Sánchez Jiménez had died abandoned in a sanitarium in Barranquilla, forgotten by history and by his wife. For local newspapers that represent citizen opinion, the problem of Cundí is that drug addicts use it. Yet, I contend that its main problem is that the matrix of civilization still operates forcefully, ignoring the fact that this hill is the ezuama of Matuna and that it was called that long before there was something called "the Spaniards" or "the French" who believe in the myth of the Virgin Mary and its multiple appearances. As Julito Torres puts it, "nobody wants to deal with the fact that the sacred territory of the SNSM had its own names before the world was invented."

The Kogui, Wiwa, and Arhuaco continue to recognize Matuna as an articulate being who merges times and places in the theory of the unfolding of the world. Upon climbing the hill, mamo Gabriel makes the payments, whispers the right words, and sows the coca leaves deposited on a rocky surface, where small shrubs grow in whose thorny branches are entangled bits of plastic debris left by the drug users. After making the payment, mamo Gabriel spoke vehemently, looking at the horizon and extending his hands, looking towards the mountain range and joining the palms of his hands; with

the fingers joined, he remarks that this place connects with the mountain massif. It is so bright, he says: from Matuna the sea can be seen, the city can be seen, the mountains are seen, and everything seems to come together. Then he looks around, and his face contracts in a grimace of disgust. This was clearly a reaction to the colonization of Matuna with the Virgin, and its later transformation into a garbage dump. Julio began translating, saying that mamo Gabriel emphasized that Matuna was a point of connection between all other sites, including those on the coast and those of the SNSM. He said that it was not exclusive to any nation, but that it represented a center for payments for the four nations, and that it was decisive because in it the mamos asked for the first permit. In the sacred cartography, Matuma was protected by Santa Marta, that is, by *jaba* Sé, the mother of everything. Mamo Gabriel also said, in a diplomatic tone, that it was not right that the ezuamas were being used for illicit activities. He referred to the positioning of the Virgin, a clear manifestation of the animosity that the society of Santa Marta feels towards Indigenous beliefs. For now, the recovery of the Matuna ezuama is a complicated process. However, at least it is possible to understand its importance within the ontology of the peoples of the SNSM.

After Matuna, we left for Taganga, a place that worries the mamos; turned into a destination for sex tourism by members of the Israeli army, the sacred sites are contaminated with auto tires and plastic bags that are slowly decaying in the sea. According to mamo Gabriel, Taganga is the sacred place of the sacred, so the current situation of its ezuamas is undoubtedly worrisome. The group of ezuamas in Taganga is significant for its houses, among others Due Julaka, the protective ezuama of all ezuamas; and Munué, the father of howler monkeys. Munué is connected with Yuga Yiwurungue, the access portal to the SNSM, a kind of door that controls access to the territory.

Once in Taganga, mamo Gabriel observed the northern hill of the bay and spoke a few words. I looked at the part of the ezuama that had been excavated for the construction of a road servicing a hotel that eventually burned down in November 2019. That road had disrupted *jaba* Sebake, a place of healing and joy. When a person looks at her life path, she should go to Sebake to understand the years of work as a process of personal edification. But today, Sebake is known as Playa Grande, which explodes every year with hundreds of tourists who dirty the beaches. After mamo Gabriel's comments, it was clear that the hotel had violated the sacred site by intervening there; it had been done without consulting the Indigenous authorities, and without taking into account that, from a legal point of view, its construction should have gone through a formal consultation process with the communities.

There is a *cabildo* of Indigenous authorities in Taganga that has now achieved recognition by the Colombian state as an ethnic group. Although political autonomy is one of the claims of the tangueros, they also seek control over their ancestral territory, which includes most of the PNNT. This action is urgent since the bay is the focus of various ventures such as a multi-purpose port for a company that produces African palm oil; it is also the

focus of real estate speculation for tourism. The Cabildo's Governor Ariel Daniels and native anthropologist David Cantillo have carried out actions with local youngsters, such as payments and other rituals, to recognize themselves as belonging to the community. Most activities involve Indigenous toponymy and traditional rituals. As David Cantillo points out, they are about sowing the seed of identity in the taganguero youngsters despite the temptations they face to leave the territory. As the Kogui mamos point out, Taganga is connected to Makotama, the SNSM sacred place where the mamos are formed as political leaders.

As we can see, in Makotama (see Figure 0.2), the houses are similar to *namantos,* which are the hats that men wear. At the back of the houses are the sacred hills that are like slabs that form the great ezuama that is the SNSM. In this way, the Taganga ezuama, in a vision shared by various clans, must rebuild their namantos to connect with the main ezuamas. So the most important message that the Indigenous peoples of the SNSM have is that they be allowed to reconnect their ezuama systems, and by that end the pressure on the territory.

The next place we visited after Taganga was El Morro de Santa Marta, a rocky formation located at the bay's entrance. It is known as Shibaldigeka. Although the Presidential Decree 1500 of 2018 states that its ezuama is entrusted to receiving complaints about improper behavior on the part of the mamos, it also is a starting point that collects the spiritual energies of the Fathers and Mothers of creation. Shibaldigeka faces a big problem, though: since colonial times, it has been used as a strategic area for the security of the city of Santa Marta. It has long had a lighthouse, currently managed by the Colombian Navy. One of the great features of this ezuama is the 18th century

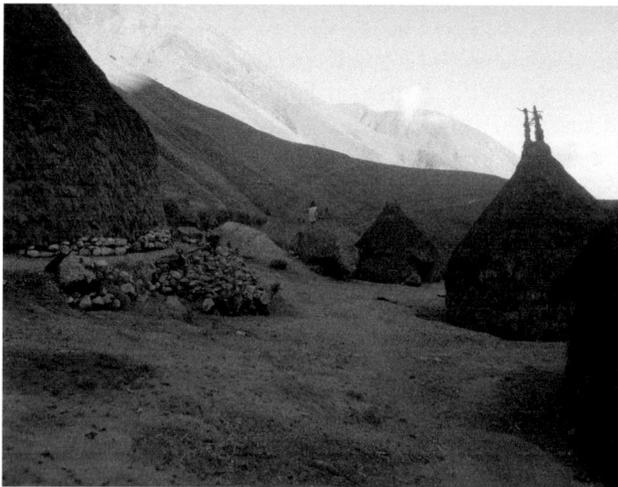

Figure 4.1 Makotama
Source: Photo by the author and Anghie Prado, 2017.

military barracks. For local and national governments, the value of the site is as a colonial ruin; for Indigenous peoples, it is valued as an ezuama.

We then headed for Pueblito Chairama. There we met mamo Alejandro Nieves and his son, Juan Nieves. As we started the conversation, we made payments in the ezuama of Nikuna. As recognized by the four nations of the SNSM, Nikuma is a space for dialogue. After making the payments, Juan Nieves began to talk about the importance of Teykú for the Indigenous people of the SNSM, because in addition to the agreements that can be achieved through the intermediation of Nikuma, Teykú also houses Terugama, where the payments "of the origin of the whole" are made. After finishing the payments, the Nieves pointed out that Teykú is essential for an overall healing because it allows the reclaiming of other ezuamas, such as those on the coastline of the PNNT, sought after by tourism companies. The coastline houses ezuamas such as Jibakseishi, where controversies are resolved, and *jaba* Senaneishi, where arts and crafts were learned. The balance of the region depends on the reclaiming of the current territory of the PNNT because it harbors *jate* Wakawazhi, the entity in charge of water control.

The next stop was the sacred site of Tolezhi, on the western side of the SNSM. Mamo Ramón Gil was waiting for us there. Ramón stressed the need to speak, even if he was not an "academic." He noted that ignoring the territoriality of the SNSM is causing the temperature to rise so that droughts will be longer lasting. Ramón said, in line with what was explained by the Nieves, that the constant looting of tumas in villages such as Ciudad Perdida or Pueblito Chairama is accelerating the destruction of the territory. Ramón also discussed the need to recover the lost wisdom expressed in the dances once performed in the lower parts. Ramón's words refer to the ezuamas north of the SNSM, such as *jaba* Sakleizhi, where the principles of the spoken word are concentrated; this place connects with Nabuwuizhi, the place of dancing with masks. When Gregory Mason was offered a dance, he was being offered the word of Sakleizhi through Nabuwuizhi.

After this conversation with mamo Ramón, we set out to visit the sites at the mouth of the Buritaca river, where we met Arhuaco mamo Daniel Solís. The mouth of the Buritaca is a tremendously important place for local communities because it houses the ezuamas of Nañiba Alduamiku, nothing less than the one responsible for obtaining the first quartz payments. In addition to Nañiba, it houses *jaba* Siashkaka, the mother of quartz. There payments are made explicitly for "insurances" (*aseguranzas*), rituals to ensure well-being. The river mouth also harbors *jaba* Teyunashikaka, mother of the tumas and the *zhátukua*, the consultation of the oracle that is the ezuama. This mother must accompany the construction of villages because she is the mother of the stones with which they are made. Every time the archaeologists "find" a village in the SNSM, they do not understand that many are uninhabited because it is not yet time to occupy them as they are made with fragments of the primal world, the world of rocks.

Mamo Daniel made it clear that payments must be respected; otherwise, it is likely that the heat will rise to the *páramo* (the humid highlands) and desiccate the region. Yet, his warning vanishes in the air as hundreds of tourists scream as they play among the waves or get carried away by the relentless current of the Buritaca.

Our journey came to an end at the mouth of the Palomino River, home to the mother of summers and rains, and where payments are made to further the balance between drought and rain. Palomino, not just the village but the beach and the rivers that flow there, is of great importance for the Indigenous people of the SNSM, because it is the place to perform baptisms, marriages, and funeral ceremonies. As mentioned by mamo Camilo Izquierdo in Ukuklekan, payments are made for the flowering of the world; the more flowers there are, the more flowering of the crops and the work of the clans is guaranteed. The rewards for payments in Ukuklekan are essential and expressed in the health of the fruits, the high flour content in manioc, the size of yams, and the general good health of the entire planting.

A documentary on our tour was made by filmmaker Rafael Mojica, a recognized talent of Colombian Indigenous cinematography. It is currently an educational resource in local circulation—it has never been disseminated through the mass media. The information collected shows that the payments imply a relationship with the territory that is alien to the conceptions of the state and civil society. The Colombian Caribbean is seen as a paradisiacal coastline that can be sold to tourism; from the local perspective, it is a network of ezuamas with which to control everything that makes up the human and non-human world.

The cultural politics of payments

The Indigenous world of the SNSM is made up of a network of networks where all things are interconnected. Every feeling, every action, every corner of the landscape, is determined by a precedent law known to the mamos and residing in the corresponding ezuama. The territory is not conceived as property or as a resource; it is the space where the word of the original law is deployed through the ezuamas, so that the message is read in the divinations (*zhátekua*).

The *zhátekua* is done with tumas on the ezuamas. Paying and *zhátekua* are two simultaneous activities that allow a line of thought and action consistent with local ontology.

Due to the accumulation of land that existed since colonial times, many ezuamas fell prey to the transformation of forests into farms, as was the case with the ezuamas of Mamotoco that remained inside San Pedro Alejandrino. Despite this, the Indigenous people of the SNSM did not forget their sacred geography and continued to remember *jabas* and *jates* and their respective ezuamas. Pueblito Chairama was in private hands since the 18th century, but some clans knew its importance because it was the homeland of Teykú, the

great mamo of this part of the coast who brought the word and civilization. The same has been happening with places that, to date, are outside Indigenous control. In Taganga, for example, a police station was built atop an ezuama still recognized; although it cannot be visited, it is evoked to keep alive the network of relations that is the territory and the clans. Seen from a historical perspective, payments have been an instrument of resistance and cohesion throughout centuries of colonialism; they truly imply a cultural politics of payments, a local practice by which the leaders communicate with the territory through visits to ezuamas and their interpretation utilizing *zhátekua*. The Indigenous life cannot be lived without making the daily payments that give meaning to the world with its cycles, contradictions and surprises.

Leaders such as Ramón Gil, Francisco Gil and David Cantillo promote the relationship with the territory by analogism and animism. Ramón has been pointing out the need to restore the territory through spiritual healing. He was able to restore a forest that had been cut down for the sowing of marijuana, back in the 1970s. In order to continue with these restorations, the tumas accumulated in various museums must be returned. Based on the principles of the founding mamo, the education project of Francisco seeks to ensure that new generations do not forget the importance of payments as a way to communicate with the territory. The project partakes of Kogui ontology to articulate the demands of the contemporary world, submitting the technoscientific world to the founding mamo principles. It is not about returning to a primitive world but, with a strengthened notion of things local, to read, and to appropriate technoscientific features. Kogui youngsters, for instance, can learn mathematics from the imperatives of the ontology of the ezuama and not from the abstract and homogeneous modern/colonial world; it is about educating to live and not educating to be citizens—which is what the ideological basis of education in Colombia is all about. In Taganga, David Cantillo seeks to engage the children in local knowledge through the project known as the Taganga Ancestral Knowledge School. This project seeks to guarantee in the coming generations the Indigenous vision of the tangueros; it seeks to reappropriate the territory mainly by walking the ancestral hills or by visiting the coastal islands that have ezuamas. Taganga harbors *jaba* Senkua, on Aguja Island, the extreme southern point of the PNNT. In that place, payments are usually made along with children and teenagers to recognize the voice of the territory; during payments, and after fishing, the birds (pelicans and scavengers) are fed, indicating the relationship of the clans with the shorebirds, as was the case before the Conquest. Tanguero children can recognize the clan they belong to and know the importance of Taganga within the cosmological territory of the SNSM. David Cantillo has been careful to allow memory, thought of as a river, to resume its course and understand the place of Taganga within the network of ezuamas. David organized workshops with Kogui from Tungueka, who confirmed that the tangueros were Kogui of the lower clans. According to the oral tradition preserved in Tungueka and Taganga, the latter were allowed to abduct

wives from the former, so matrilineal ties connect them with the Upper Makotama and Upper Buritaca clans. Although the kinship network of the Kogui from the river basins north of the SNSN recognizes the tangueros as relatives, the OGT elite does not dare to accept this political recognition; this is another of the many problems of the Indigenous technocracy of the SNSM, and has little to do with ethnic legitimacy.

At the end of 2019, we carried out a workshop in Taganga that aimed to understand the local construction of wooden canoes, which have not been manufactured there for decades; as always, local technologies were abandoned as a result of the introduction of other materials, such as fiberglass. The state was responsible for distributing plastic canoes that quickly replaced the local boats, traditional dugouts called *cayucos*. For the realization of the workshop David Cantillo summoned the Cabildo Governor, Ariel Daniels, and some community members. We came to know the navigation skills of the tangueros and how they were articulated to the territory. Community members recalled that their grandparents said that at the beginning of the 20th century they would go by canoe to La Guajira, specifically to Dibulla, and from there on foot to Makotama, where they kidnapped women. Those symbolic abductions allowed families to be linked, especially those in the upper basins with those in coastal areas. The tangueros also established marriage alliances with families of Gaira and Mamotoco, which guaranteed the structuring of inter-clan alliances. The manufacture of *cayucos* required large trees such as caracolí (*Anacardium excelsum*), found in the upper parts of the SNSM. The carpenters from around Santa Marta used to go to the current PNNT to look for useful caracolí logs. Each canoe was different, so the selection of the tree depended on the navigation needs, although the *cayucos* only served to travel along the coast. Carpenters cut the logs on the Sierra's slopes and brought them back to the waterfront to carve them out into *cayucos*. The last boats, it seems, were manufactured several decades ago before the PNNT banned logging in the protected area. Along with the ban, the state distributed ships of fiberglass, easing the transition. Navigation skills were related to inter-clan relations between the coast and the mountains. This network linked Taganga, the first entrance to the SNSM—the frontal part of the territory, the one that received the impact of modernity/coloniality more brutally—and the Makotama region, which houses the ezuamas where the payments for masks and ritual dances are made.

Through the politics of payments, the elders transmit to the youngsters, and these to the children, the local knowledge and the importance of the ezuamas. At the local level payments connect the young with other ways of being; this is achieved through an education based on affection and care rather than metric evaluation, competition and discredit. This other education differs from Western education in that learning involves a commitment to the territory and its ezuamas.

The Kogui clans of Taganga are now recognized by the state after a protracted legal case (Sandoval et al. 2018). Further, grassroots organizations

such as OGT still do not recognize them, for that would imply negotiating their share of power. The Cabildo Governor of Taganga and his team are seeking to prevent the dissolution of the community in the face of real estate speculation that has reduced the tangangueros to mere spectators of the dispossession of their lands. As happened before, many natives were encouraged to sell their lands at ridiculous prices; those lands were at the foot of the mountain that separates the bays of Taganga from that of Granates, where wealthy families from Bogotá bought land and built summer mansions. The natives wasted the money from the sales and became impoverished and at the mercy of the new owners. The tangangueros, once owners of areas to graze goats and stock up on wood, had to abandon their lots and reduce themselves to living in small enclosures near the shoreline where they could still reach their *cayucos* to go fishing. Then came the wave of Israelites who flooded the village with hostels which received young people who had just performed military service in Israel and facilitated their access to drugs and prostitutes. Ever since the village has been a destination for sex and drug tourism. The fame of such a Sodom in the Caribbean was not entirely undeserved. At the beginning of the 2010s, Assi Moosh, a well-known Israeli and international drug trafficker, built the Benjamin Hostel. The place was frequented by backpackers from around the world, especially by Israelis, and was famous as a brothel where anyone could find drugs and young prostitutes. In September 2016, Israel's Prime Minister Benjamin Netanyahu asked the Colombian government to deport Moosh, as he was wanted for various crimes committed in Europe and Israel. Moosh was expelled in November 2017 and captured in Holland that same year, accused of being the leader of a network of drug traffickers (Semana 2017). Since Taganga has been a focus of Israeli reterritorialization, its fame as a sexual destination has been earned by the formation of these hostel enclaves. At the expense of Indigenous meanings which consider Taganga bay as the sacred site of sacred sites, excessive use of the bay has been made by foreigners. Things seem a little better since Moosh was expelled. The once noisy Benjamin Hostel appears silent, and the *Jaba* Nibue hotel, built impertinently on an ezuama, is in ruins, destroyed by a fire in 2019.

Before this terrifying panorama that severely impacts the ties of local clans, schools of ancestral knowledge are challenging and necessary. David Cantillo has abandoned a professional path that would lead him out of Taganga to pursue a doctorate, in exchange for leading local processes. For David, knowledge is within the territory, in the ezuamas, in the voices of the elders who are disappearing. The voice of the tangangueros is a dim flame before the overwhelming wind of the modern/colonial world; yet, it can endure through the cultural politics of payments. That is why the mamos say that without the payments life would be impossible. The payments, as I have shown, link the Kogui to the territory, and thus to social relations. Although analogical and animistic thinking has remained throughout the various phases of colonization, nowadays payments are a strategy to link what was divided, close the gaps. The cultural politics of payments is faced with the fact that the state

does not recognize the ezuamas as subjects of law or the consultations to the oracles as legal actions. Marisol de la Cadena (2009) noted that local communities are disadvantaged when local power confronts the power of the state because any possible dialogue is already predetermined. Paraphrasing Franz Fanon, de la Cadena says that the problem in these debates is that the first step of the struggle is that of recognizing an interlocutor, in such a way that "the problem of recognition is that the tools that are at hand for performing the task are those of the master" (de la Cadena 2009:156). In this sense, the Colombian state has been recognizing the importance of ezuamas, but as physical sites, not as agents in the spatial configuration of Indigenous territoriality. According to the cultural rights granted to the SNSM communities, they have the right to access ezuamas and make payments, but they cannot hold ownership of the areas. The closure of Pueblito Chairama (and the reopening of Teykú) is read more as a commitment made by the state to match conservation objectives with repatriation claims; nevertheless, it makes it easier to increase payment practices for guaranteeing Indigenous persistence.

The first obstacle that local ontologies face is a dialogue with the state within the framework of their notions and languages. The state disregards the cultural politics of payments in local ontological terms and seeks to establish its own conditions. In the language of the state, there are no ezuamas, there are no mamos, and there are no ontological principles, but physical sites for which it is necessary to define property rights and uses. In addition to this obstacle, characteristic of political ontology, there is the archaeological vision of sacred villages. In 2018, National Geographic Society explorer Albert Lin toured the surrounding areas of Ciudad Perdida and reported what the press called "the archaeological remains of the Tairona tribe" (Semana 2020). The sensationalist vision promoted by *National Geographic* runs counter to local visions as it generates the old past–present dichotomy and fragmentation that has been harmful to local processes.

Two significant tensions generated this fragmentation: the imposition by the state of a sense of citizenship; and a US-promoted historical narrative as American business expanded in Latin America. Indigenous actions activate payments to disrupt the disintegrating tensions coming from the state, with its technocratic language of the territory, and the market, with its anachronistic visions of "Lost Cities" and tribes.

As noted by environmentalist Franz Kaston Flórez, director of Fundación Nativa, an NGO dedicated to the conservation of native species in the SNSM, the Kogui are a pre-Hispanic culture that has been subjected to structural violence. That NGO works with the Kogui of Mongueka, a village located in the western basin of the SNSM, rebuilt in 2017 after its abandonment due to paramilitary attacks in the 2000s. After a long debate, the Kogui from Santa Rosa decided to return to Mongueka, and their first action was to build a ceremonial house for women, the *nuhué*, and five residential houses. The case of Mongueka is similar to that reported by Ramón Gil: it is about

rebuilding areas devastated by colonialism—without much of a difference between the paramilitarism of the 20th century or the endocolonialism of the 19th century. The practice of payments is a form of resistance that confronts the advance of modernity/coloniality and allows the strengthening of ties between clans. Yet, the building of social cohesion is not internally homogeneous. There are tensions between various clans over political and even economic issues, but they have not lost sight of the importance of the cultural politics of payments, and their contributions to building a decent world.

Pay to live

This chapter consists of two main ideas. The first idea is that the way out of the impending socio-environmental collapse is the transformation, not of the economy, but of the ontology that underlies modernity/coloniality; the way out is not sustainable development, but the abandonment of development. The second idea is that there are various experiences of living outside of the technoscientific or modern/colonial logic. A post-anthropocentric society is not a futuristic alternative but a current reality unfolding in different territories. To explore this theoretical panorama, I will take as reference points Latin American authors who have already raised these questions, and who have offered alternatives to the Anthropocene (Braje & Erlandson 2013).

The theologian and philosopher Leonardo Boff (2011) long ago posited the distinction between two periods: the Technozoic and Ecozoic. For Boff the Technozoic coincides with what some authors have called the second modernity (Dussel 1993), characterized by the use of science to accumulate capital. As Enrique Dussel (1993) has noted, liberal thought created the myth of modernity as a purely European phenomenon in which scientific knowledge allowed the construction of a civilized society. But "the myth of modernity" has a dark and parallel side, coloniality of power (Quijano 2000): the exploitation of a subjugated Other guaranteed the accumulation of capital underpinning modernity. The latter is not a philosophical phenomenon, but a political project—one of whose aspects is the production of otherness. This project has failed and is leading the planet to an almost irreversible collapse. Boff considers that the collapse of the Anthropocene (the name given to the Technozoic in the Anglophone world) will give way to the Ecozoic, whose main feature is the consolidation of a politics of life in which nature is not considered as a commodity or as a resource. This change will not only occur at the economic level, but at all levels, as it will imply the end of patriarchy and the culture of death expressed in the hyper-exploitation of natural resources and human and non-human societies. As Arturo Escobar (2011) has stated, the movements fighting for the transition to the Ecozoic come from multiple theoretical and geographical fronts; Boff represents the Latin American side, as much as Tony Fry (2009) is of the Anglophone world. For Boff and other Latin American thinkers the transition is a moral condition, while

for people like Fry it can take place even in fields colonized by technoscience, such as design.

All transformation strategies, regardless of where they come from, are based on the idea of forging new relationships between humans and non-humans. They confront naturalism, which conceives nature away from human society; regarding the latter, they confront heteronormativity and patriarchy. The Ecozoic is a reality for the ethnic groups of the SNSM because they live within a non-dualistic conception of nature; unlike modernity/coloniality, for them, nature is a source of wisdom, a subject with whom to talk. The SNSM has its own text, and the mamos are the polymaths who interpret it. In the mouths of the rivers, in the rocks of the mountains, unfolds a discourse to be read by consulting the ezuamas. Following Fry and Boff, the Indigenous nations of the SNSM live in worlds designed otherwise. As Gutiérrez (2015) has pointed out, the global south houses other designs that can be a response to the constraints imposed by the modern/colonial world.

Once the Kogui from Mongueka decided to repopulate the ezuama that bears the village's name, the first thing they did was erect the *nuhué*. Its construction expressed the cohesion of the clans involved in the re-foundation. The videos of that event that circulate on the network show how the men, armed with machetes, install the enclosure posts with trunks that end in a fork. As the posts are set in place the roof structure is woven with slats that are tied with natural fibers. In a short time, the roof of the house is finished, and the men in synchrony lift it up and place it on the forks. The enclosure is then lined with fibers. The erection of the *nuhué* thus signals the clan's commitments to the place.

The cultural politics of payments could apply to other contexts, not only those of the SNSM communities. This practice is the healing process that the planet requires. Making payments helps us to understand where contemporary commodities come from and thus assess whether it is worth buying objects that are based on the exploitation of human and non-human communities. These rituals cannot be understood as mere symbolism or metaphor; the payments that involve the ezuamas also stage an in-place corporality. The ritual, more than a symbolic action, is a spatial and social experience that produces socio-environmental associations, such as the configuration of the clan-territory. The logic of the payments cannot be understood without reference to the reading capacity of the mamos, displayed over the signals of the ezuama. The message of the ezuama is not just a word that is spoken, but a commitment to the territory and the clans, which forms the character of people and landscapes. It is terrifying for the indigenes that the ezuamas have been turned into tourist destinations, in the best of cases, or in garbage dumps in the worst cases.

The relationship with the territory through payments is not exclusive to the SNSM. In the Andean world exist various forms of relationship that oscillate between animism and analogism, with nuances determined by modernity/coloniality. In southwestern Colombia the Misak have used archaeology to

deconstruct a history that presented the indigenes as an anachronism to be overcome. The religious ban on language, knowledge and customs was resisted by the creation of historical study groups, local museums and tours of the territory, complemented by archaeological excavations carried out in the early 1980s (Urdaneta 1988). Decolonization marked local historical politics (Vasco 1992); it was about dissolving the obstacles that colonialism had imposed on local communities by forbidding them to talk about their genealogies in their languages. These local histories challenged the colonial order, which was a horizon of subjectivity installed in local ways of thinking. The colonial epistemic order was disrupted through visits to the territory that served to activate the energies needed to speak about and discuss a history that was not an alternative reading of official, scientific history; it was a way of questioning the genealogies imposed by archaeology since the 1950s, which positioned Indigenous communities as alien to an endless history of population change. In this case, which could be an example of Indigenous archaeology in Colombia, no archaeological excavations were actually made—instead there have been tours of the territory. In the case of the SNSM the word archaeology has been openly excluded, and "spiritual work" has been used as a way of naming the project of political reorganization. In any case, the Indigenous social movement in Colombia has sought a new version of history that does not exclude them.

Diffusion and migration were the pillars of a history that put the Spanish conquest at the summit of cultural development; on this ideological basis Colombian archaeology was formed (Gnecco 1999). Rather than contesting archaeological data, the indigenes questioned its conceptual structure, such as the use of the archaeological record for documenting migratory phases; they also questioned the idea of cultural discontinuity as a starting point for historical statements. As Sylvanus Morley had done in Chichén Itzá, excavations in southwestern Colombia helped to delegitimize the struggles of Indigenous communities and their land claims. The Misak case shares with the SNSM's cultural politics of payments the dynamics of the reterritorialization of objects which aims to unite the distances generated by the modern/colonial prohibition of everyday life; they also imply a return, not to an ancestral practice, but to defining things in their own terms, which is done by visiting the territory, repatriating objects, creating school curricula. These Ecozoic situations occur in northern and southwestern Colombia with relative ease, as the Indigenous communities hold large tracts of land; however, their territories are faced with the structural violence of drug traffickers and modernizers.

In Argentina ethnogenetic processes involve the archaeological record in a way similar to the cultural politics of payments in the SNSM. In the Puna de Atacama, on the border between Chile and Argentina, the Coya Atacameño community seeks its ethnic recognition by the state. As Alejandro Haber (1999, 2009a) has noted, the people of the Puna live in a relational world that can be summed up by the Aymara word *uywaña* (breeding). According to the politics of *uywaña*, human beings must know that they are raised by the hill, which is owned by *Pachamama*—who also owns vicuñas. Unlike vicuñas,

llamas are bred by humans, who, in turn raise the alfalfa fields that sprout in the desert and feed the herds of llamas and vicuñas. For this to happen, human beings are responsible for channeling the scant water that descends from the snowy hills to the salt flats—which, by the way, are sought after by lithium companies. The *vegas*—fertile lowlands—thus formed small harbor coves where alfalfa grows (Londoño 2010). Local irrigation technology has a considerable historical depth (Quesada 2007) and is a part of a regime of domesticity. Although llamas are domestic animals, they have not been the staple diet (Haber 2009b); this shows domestication is not a rule because those societies are not necessarily driven to maximize resources.

In the Puna de Atacama a network of networks relates different beings in a regime of care. This practice occurs in the *corpachadas*, rituals in which the *pachamama* drink, eats, and smokes. A hole in the ground is opened where drinks are deposited, usually alcoholic, and on whose walls cigars are placed. These activities are carried out in any relevant event—such as to celebrate the establishment of the community, when livestock is bathed, for a baptism, etc. The *corpachadas* are small actions performed by small groups but have essential effects within the ethnic politics in Argentina. In a territory that was thought to be a desert, a container of metals, the ethnic movement in Anto-falla breathed energy into the dynamics of ethnic politics in a province that used to hide its Indigenous legacy.

Payments, repatriations and *corpachadas* merge in everyday life with political agendas and the experience of living. In a broader sense, these practices based on animism and analogism could enhance the decolonization practices needed for the transition from the Technozoic to the Ecozoic.

Conclusions

The ritual of payments is essential for the reproduction of the clans and the territory. The reclaiming of Teykú did not occur in a vacuum; it sprung from the need to reclaim and connect the ezuamas that had been disarticulated by colonialism. The site is essential because it contains the civilizing tradition of mamo Teykú, who dominated that coastal area. The practice of payments pertains to an analogical ontology and the need to mantain relations between communities and their territories—seeking to ensure that the established balance is not altered. The politics of payments thus explains the reclaiming of ezuamas and their activation to consolidate the balance broken by the modern/colonial world.

References

Aguilera-Díaz, M. & Meisel-Roca, A. (2009). *Tres siglos de historia demográfica en Cartagena de Indias*. Banco de la República de Colombia.

Andrade, M. (2011). Religión, política y educación en Colombia. La presencia religiosa extranjera en la consolidación del régimen conservador durante la Regeneración. *Revista de Historia Regional y Local*, vol. 3, no. 6. Colombia, pp. 154–171.

Boff, L. (2011). El difícil paso del tecnozoico al ecozoico. *Cubadebate*, 19 February.

Bosa, B. (2015). Volver: el retorno de los capuchinos españoles al norte de Colombia a finales del siglo XIX. *Revista de Historia Regional y Local*, vol. 7, no. 14. Colombia, pp. 141–179.

Braje, T. & Erlandson, J. (2013). Human acceleration of animal and plant extinctions: a Late Pleistocene, Holocene, and Anthropocene continuum. *Anthropocene*, vol. 4, pp. 14–23. DOI: https://doi.org/10.1016/j.ancene.2013.08.003

Bucheli, M. (2008). Multinational corporations, totalitarian regimes and economic nationalism: United Fruit Company in Central America, 1899–1975. *Business History*, vol. 50, no. 4, pp. 433–454. DOI: https://doi.org/10.1080/00076790802106315

Chomsky, N., Cabuya, L. A., Miranda Cortes, B. & Martínez Becerra, C. (2000). Plan Colombia. *Innovar*, vol. 1, no. 16, pp. 9–26.

Cunin, E. (2006). "Escápate a un Mundo fuera de este Mundo": turismo, globalización y alteridad. Los cruceros por el Caribe en Cartagena de Indias (Colombia). *Boletín de Antropología*, vol. 20, no. 37. Colombia, pp. 131–151.

De la Cadena, M. (2009). Política indígena: un análisis más allá de "la política". *Red de Antropologías del Mundo*, vol. 4, pp. 139–142.

Dussel, E. (1993). Europa, modernidad y eurocentrismo. *Revista de Cultura Teológica*, no. 4. Brazil, pp. 69–81.

Echeverry, A. (2014). El milagroso de Buga: una leyenda de resistencia. Lectura desde lo simbólico. *Historia y Espacio*, vol. 4, no. 30. Colombia, pp. 169–195. DOI: https://doi.org/10.25100/hye.v4i30.1670

Escobar, A., Álvarez, S. & Dagnino, E. (eds.) (2001). *Política cultural y cultura política*. Bogotá, Colombia. Alfaguara.

Escobar, A. (2011). Sustainability: design for the pluriverse. *Development*, vol. 54, no. 2, pp. 137–140. DOI: https://doi.org/10.1057/dev.2011.28

Escobar, A. (2018). *Designs for the pluriverse: radical interdependence, autonomy, and making of the worlds*. Durham, NC. Duke University Press.

Fry, T. (2009). *Design futuring*. Sydney. University of New South Wales Press.

Gnecco, C. (1999). Sobre el discurso arqueológico en Colombia. *Boletín de Antropología*, vol. 13, no. 30. Colombia, pp. 147–165.

Gómez, H. (2000). *De la justicia y el poder indígena*. Popayán, Colombia. Universidad del Cauca.

Gutiérrez, A. (2015). Resurgimientos: sures como diseños y diseños otros. *Nómadas*, no. 43. Colombia, pp. 113–129.

Haber, A. F. (1999). Uywaña, the house and its indoor landscape: oblique approaches to, and beyond, domestication. Gosden, C. & Hather, J. *The prehistory of food: appetites for change* (pp. 57–82). London. Routledge.

Haber, A. F. (2009a). Animism, relatedness, life: post-Western perspectives. *Cambridge Archaeological Journal*, vol. 19, no. 3. United Kingdom, pp. 418–430. DOI: https://doi.org/10.1017/S0959774309000602

Haber, A. F. (2009b). *Domesticidad e interacción en los Andes Meridionales*. Popayán, Colombia. Universidad del Cauca.

Londoño, W. (2003). La "reducción de salvajes" y el mantenimiento de la tradición. *Boletín de Antropología Universidad de Antioquia*, vol. 34. Colombia, pp. 235–251.

Londoño, W. (2010). Las arqueologías indígenas o la lucha contra la tercera transformación de Fausto: reflexiones desde comunidades de Colombia y Argentina. Gnecco, C. & Ayala, P. *Pueblos indígenas y arqueología en América Latina* (pp. 373–397). Bogotá, Colombia. Universidad de los Andes, Facultad de Ciencias

Sociales/Fundación de Investigaciones Arqueológicas Nacionales/Banco de la República/CESO.

Londoño, W. (2019). Santa Marta la ciudad blanca: memoria y olvido en la configuración espacial de los hitos patrimoniales de la ciudad . *Confluenze. Rivista di Studi Iberoamericani*, vol. 11, no. 2. Italy, pp. 34–60. DOI: https://doi.org/10.6092/issn.2036–0967/10266

Lynch, J. (2007). *Simón Bolívar (Simon Bolivar): a life*. United States. Yale University Press.

Mestre, Y. & Rawitscher, P. (2018). *Shikwakala, el crujido de la Madre Tierra*. Santa Marta, Colombia. Organización Indígena Gonawindua Tayrona.

Modonesi, M. (2015). Fin de la hegemonía progresista y giro regresivo en América Latina. Una contribución gramsciana al debate sobre el fin de ciclo. *Viento Sur*, vol. 142, pp. 23–30.

Oliveira, A. (2019). Caminos de resistencia al desarrollo de la explotación en Guatemala. *World Tensions/Tensões Mundiais*, vol. 15, no. 28, pp. 179–211. DOI: https://doi.org/10.33956/tensoesmundiais.v15i28.1328

Opinión Caribe. (2016, 7 December.). *Cultura urbana e impacto social*. Santa Marta, Colombia.

Prado, A. (2018). Aproximaciones al proceso de reparación de los kággaba. *Oraloteca*, no. 9. Colombia, pp. 96–111.

Provine, D. (2008). *Unequal under law: race in the war on drugs*. United States. University of Chicago Press.

Quesada, M. (2007). Paisajes agrarios del área de Antofalla. Procesos de trabajo y escalas sociales de la producción agrícola (primer y segundo milenios D.C.). (Doctoral thesis). Universidad Nacional de La Plata. Facultad de Ciencias Naturales y Museo.

Quijano, A. (2000). Colonialidad del poder y clasificacion social. *Journal of World-systems Research*, vol. 6, no. 2, pp. 342–386. DOI: https://doi.org/10.5195/jwsr.2000.228

Restrepo, N. (2006). La iglesia católica y el Estado colombiano, construcción conjunta de una nacionalidad en el sur del país. *Tabula Rasa*, no. 5. Colombia, pp. 151–165.

Revista Memorias. (2010). Sobre el escultor samario Antonio Esteban Sánchez, primer graduado en artes del país, en la Escuela de Bellas Artes de Bogotá. Fotos de la Colección de la Familia Sánchez Molinares. No. 1, vol. 6. Colombia.

Rey Sinning, E. (2009). El carnaval de Santa Marta, la fiesta de todos: los primeros treinta años del siglo XX. *Textos Escolhidos de Cultura e Arte Populares*, vol. 6. Brazil, pp. 31–49. DOI: https://doi.org/10.12957/tecap.2009.12154

Robinson, W. (2011). Globalization and the sociology of Immanuel Wallerstein: a critical appraisal. *International Sociology*, vol. 26, no. 6, pp. 723–745. DOI: https://doi.org/10.1177/0268580910393372

Rojas, D. (2013). Much more than a war on drugs: elementos para un balance del Plan Colombia. *Análisis Político*, vol. 26, no. 77. Colombia, pp. 113–132.

Sandoval, G., Herrera Tapias, B., Mantilla Grande, L. & Carvajal Munoz, P. (2018). La consulta previa en la jurisprudencia constitucional de Colombia: análisis de línea entre 1997–2015. *Justicia*, vol. 23, no. 33. Colombia, pp. 11–36. DOI: https://doi.org/10.17081/just.23.33.2872

Santos, J. (2019). *La batalla por la paz*. Bogotá, Colombia. Planeta.

Semana. (2017, December). *La historia detrás del demonio de Taganga*. Santa Marta, Colombia. Available at www.semana.com

Semana. (2020). *Santiago Giraldo, el antropólogo colombiano que descubrió un nuevo tesoro delos tayronas*. Bogotá, Colombia. Available at www.semana.com

Taussig, M. (2010). *The devil and commodity fetishism in South America*. United States. University of North Carolina Press.

Thrall, A. & Garlock, M. (2010). Analysis of the design concept for the Iglesia de la Virgen de la Medalla Milagrosa. *Journal of the International Association for Shell and Spatial Structures*, vol. 51, no. 1, pp. 27–34.

Urdaneta, M. (1988). Investigación arqueológica en el resguardo indígena de Guambía. *Boletín Museo del Oro*, no. 22. Colombia, pp. 55–81.

Vargas, O. (2005). Economía del narcotráfico, Plan Colombia y conflicto interno en Colombia. *Revista Apuntes del CENES*, vol. 25, no. 39. Colombia, pp. 31–68.

Vasco, L. (1992). Arqueología e identidad: el caso guambiano. Politis, G. *Arqueología en América Latina hoy* (pp. 176–191). Bogotá, Colombia. Fondo de Promoción de la Cultura.

Viloria, J. (2000). *Empresarios de Santa Marta: el caso de Joaquín y Manuel Julián de Mier, 1800–1896*. Cuadernos de Historia Económica. Colombia. Banco de la República.

5 Teykú and the new controversy

Towards a reconfiguration of archaeology and heritage management

Two forces define the cultural landscapes of the SNSM at the onset of the 21st century. They are not exclusive to the region; they globally shape landscapes and social relationships. On the one hand, there is the market and its dynamics of cultural consumption. Various studies warn, even for Europe (Del Pozo & González 2012), that late capitalism configures history as a commodity consumed in the spatialities of heritage sites and in the temporal experiences of festivals. History, previously considered as a local good, has become a commodity (Alonso 2014). A commoditized past loses weight as a critical element or as a political practice, one of the most necessary dimensions of archaeology (McGuire 2008). A commoditized history is impervious to any critical stance. The (post)modern explorers visiting the SNSM on behalf of organizations such as the National Geographic Society must adhere to clear rules of representation that portray the ruins as "Lost Cities" and their builders as bizarre disappeared tribes. This is part of the action; the omission is even more telling, because the discussion of the current political situation of the Indigenous peoples is banned, as much as their role in "archaeological ruins." Although consumers have the right to access these packages of alterity, it is essential to uncover their artificiality, not because it is wrong—after all, fantasy is one of the peculiarities of contemporary capitalism (Dean 2005)—but because it silences the fact that ezuamas are being used as tourist destinations without even the slightest awareness that they are *sacred sites*, elements of a network of meaning with profound social and political implications. The market has converted the pre-Hispanic villages of the SNSM into objects of cultural consumption. Ancient sites such as Teykú and Teyuna are now the "Lost Cities" of modern explorers who, unlike their North American predecessors, use satellite images and drones. The pressure from a commoditized history is complemented by other spatialities, such as tourism advertising that presents the beaches of the Colombian Caribbean as lost paradises available to everyone.

The sign that indicates the entrance to the PNNT on the road to Calabazo is a beach sign that says "Pueblito 5 Km" (Figure 5.1). The image is telling of

Figure 5.1 The sign that indicates the entrance to the PNNT
Source: Photo by the author, 2016.

how routes connect heritage sites within a network of lived experiences of various kinds—ranging from heritage and biodiversity to sexual tourism.

This ideology is expressed not only in routes that take tourists to these villages but also in other spaces, such as the "Chairama" spa in Bogotá owned by the wife of singer Carlos Vives, where the fantasies of lost paradises with exotic tribes are made available.

The other face of the avalanche of tourists that flood the coast of the SNSM is that of the Indigenous people fighting against the commodification of their culture and history. Their struggle takes various forms. The agenda of the northern Kogui clans is not the same as that of the coastal clans or the GKM. Internal differences, however, are spurious when it comes to understanding the need to maintain the union of the clans by caring for the territory and by communicating with the principles of the world by consulting the ezuamas. There is a greater hegemony of the northern clans because they are articulated to the great Kogui-Malayo-Arhuaco reservation. Yet, the GKM gains prominence and is assertive when it comes to forming an entity that dialogues directly with regional authorities. The coastal clans, such as those of Taganga, seek to establish control over the coastline filled with *jabas* and *jates*.

An element that gains an unusual force in these agendas is the local empowerment of community identity. In the case of Palmor, the struggle of Francisco Gil and his work team is centered on the creation of alternative curricula aiming to decolonize local history. As Francisco points out, this poses particular challenges such as the production of a grammar and content for literature, art and science. Their project does not seek to abandon but to reconfigure existing educational resources for a different society. In Taganga the project revolves around maintaining the link with the territory and the sea, looking back at forgotten practices and traditions. Despite the fact that the bay has become a destination for drugs and prostitution, there is also intensive work for the consolidation of community roots: the youngsters listen to the adults, and the adults tell their stories of argonauts; as a result, the former have begun to tour the territory and see with other eyes the dugout boats and the ships that were made by the nautical carpenters of Taganga.

These two forces, the market penetrating and the communities generating roots, were well defined by Clifford (1997), for whom the world is governed by the powers that create routes and roots. Routes weave globalization, mainly economic, that connects the planet through prefabricated sites, such as airports and shopping centers. Routes take us to the non-places where history is commoditized (Augé 1993), as shown by the road sign in Figure 5.1; these places are not exceptional, but belong to (post)modern biographies (Swarts 2007). In addition to the disintegrating forces of capitalism with its routes and fantasy paradises, there are the integrating forces of the communities, not based on an essentialized return to an ancient state, but on the possibility of setting up their own education, justice and medical services. Indigenous people—including non-human beings, such as the ezuamas—are committed to worlds alternative to the world of technoscience, already in existence in the Ecozoic. Mass tourism is not contemplated, although it is expected that some organizations of Indigenous origin may share its profits. Far from the reality of an agreement between the state and local communities in relation to tourism, in Colombia, the tradition of central governments has been to transfer the territory to large corporations, with the argument that they generate jobs in the localities, in return for tax exemptions. The policies of the central government have been oriented towards tourism—with which local communities engage, in one way or another. In this regard, Gnecco (2012) has been incisive in pointing out that community participation (in archaeology projects, for instance) is just a step in the production and consumption of history. Linking local communities to cultural consumption masks epistemic subjugation with participation. The market and its routes clash with local processes and their roots—a conflict not devoid of trauma and violence.

The Colombian state did not hesitate to ally with international organizations such as the GHF, responsible for selling essentialized images of the Kogui, which represent them as outsiders, while granting historical status to the ancient Tairona. Using Clifford's idea, I can say that a tribe lost in time and found by the archaeologists in the Colombian jungles creates the route

for tourists to share the adventure of discovery. The route tramples roots and tourists simply have no contact with local communities and their political demands. Although they are tourists, not social researchers, tourism is carried out at the expense of Indigenous peoples' rights over sacred sites. It is always a bit funny to see how National Geographic explorers walk through the villages that lead to the ezuamas, presenting them as submerged in the jungle. Modern explorers visit these villages accompanied by soldiers; such is the iconography of the banana civilization with which the image of the Colombian Caribbean was created by the United States. But these explorers are not discovering anything new; they are desecrating the villages with their ezuamas to engulf them in the archaeological discourse and then spit them out as archaeological parks. There is a growing need for these destinations because tourists demand these stories, just as they wait for the sun on the beaches of Santa Marta.

Although Colombia has had no heritage conservation policies, international agencies such as the GHF have been present for years, primarily as the state seeks to improve the conditions for visiting archaeological parks. Fabián Sanabria, former director of the ICANH, noted that the Colombian state was guaranteeing the preservation of the archaeological heritage while promoting the consumption of cultural commodities. Sanabria bracketed the fact that behind the archaeological appropriation of objects and spaces there is a plundering of Indigenous sacred sites; he also ignored the claims of local communities about the sacred character of "Lost Cities." The intensification of tourism has accompanied the recognition of the sacred nature of Teykú in Teyuna. Colombian archaeology has technified its practice while refusing to discuss its arrogance in purported to be sole legitimate arbiter of the past— written according to the archaeological record, defined as a manifestation of extinct societies (Londoño 2007). Alternative historical connections are not welcomed; they are treated in the usual way, with censorship—denial of scholarships, rejection of articles, exclusion of professional meetings. In short, alternative archaeologies—those very archaeologies that use the archaeological record to discuss the present, to indicate how colonialism racialized difference in order to naturalize the privileges of the elite (those most interested in promoting archaeological cultures)—are banned. The technification of archaeology is not a minor issue. In Colombia and Latin America, the tendency has been to train uncritical archaeologists capable of clearing land for development within environmental licensing projects (Gnecco & Dias 2015; Londoño 2016). Discursive prescription has encouraged the conversion of archaeologists into civil works technicians. Observation protocols have been improved, as much as recording forms and museography. Yet, this tendency has left intact the epistemological apparatus that portrays the formation of the archaeological record by societies without agency. Behind monumentality, there is an Other distanced by the past, a builder of statues, roads and villages. Such a distancing implies that such an Other has nothing to do with contemporary natives, their land claims, and their political

participation (Gnecco 2011). Current Colombian archaeology is oriented to technoscience and the market; disciplinary practices ignore the demands and objectives of social movements, primarily Indigenous. As an irony of destiny, Colombian archaeologists work for road transport consortia that connect regions with buses and trucks that pollute the villages. To facilitate this the archaeologists raze cemeteries and ancient towns and help to swell collections that nobody visits. Following these routes, which run along the coastline, big investors build the resorts that separate communities from their sea; the communities end up engulfed in the maelstrom of capital, as manual laborers in those ventures.

Despite this trend, there are critical voices in Colombian and Latin American archaeology that fight openly against archaeological technoscience. They have structured a critical front around the Meeting of South American Archaeological Theory (TAAS). TAAS has had several meetings in Colombia, Argentina, Brazil, Bolivia and Ecuador. TAAS does not have a unified agenda. It has been nourished by the work of several South American archaeologists, such as Cristóbal Gnecco, Alejandro Haber, Pedro Funari, Andrés Zarankin, Patricia Ayala and Eduardo Neves. Since 1999, Gnecco has pointed out that the postcolonial world can be polyphonic (Gnecco 1999); the recognition of cultural difference implies the relativity of history and the need to listen to Indigenous people's voices. Gnecco's book made it clear that the future of archaeology would be determined by the oscillation between the hardening pole of technoscientific protocols and opening up of a debate on history and colonialism. Likewise, Alejandro Haber has made significant theoretical contributions from his work in the Puna de Atacama (Haber 2009). Haber has proposed of an archaeology that is not based on national identities and the universality of evolution. He argues for a relational archaeology, eager to imagine the world from the localities that it investigates. Yet, Latin America archaeology is mostly oriented to technoscience, which implies handling data disconnected from local issues. It is the old archaeology of colonial exploration, updated with technology.

Haber and Gnecco's proposal for a decolonial archaeology has emerged, an archaeology from border thinking. Decolonial archaeology distrusts the comfort of the place reserved for the archaeologist as an explorer of spaces and discoverer of objects (Haber 2011:16). Discomfort with the traditional place of disciplinary enunciation is one of the conditions of the decolonial turn in archaeology. Haber's call to epistemological dislocation, plus the criticism of multicultural archaeology proposed by Gnecco, questions the hegemony of the vestige and challenges the logic of allochronism. One only has to see the ezuamas and tumas to realize that they are not garbage dumps nor relics of missing tribes; they are not vestiges of the past but points of connection with the primal forms. The politics of the ezuamas condemn the ideology of the archaeological remains and all temporal ruptures because it bespeaks of the uninterrupted link of time and clans in the territory. The archaeology of the ezuamas, then, is an archaeology that does not seek

vestiges, nor creates historicity; it is a relational archaeology that condemns naturalism and its segmentations—especially that of nature versus culture.

The development of these archaeologies is still in progress, but they are characterized by an obvious discomfort with the logic of the vestige, and by the fact that they do not engage the classic processualist model; on the contrary, they seek to accompany social organizations, analyzing the ways in which material culture and archives can help explain land expropriation and the subjugation of societies. The Indigenous archaeology in northern Colombia is closer to an archaeology of their colonization with the goal of producing a decolonized archaeology. From the Indigenous people's side, this kind of archaeology does not use the dig as a tool because the landscape is a living being. We can find this decolonized archaeology in the narrative of Juan Nieves on how archaeologists took away the Teykú tumas. We can also find it in the Palmor educational project that seeks to generate its own curricular content. And we can see this decolonial archaeology in the historical constructions that the clans of Taganga make, to overcome the images that have been created about them.

By suppressing the vestige, allochronic production ceases, and materialities are no longer conceived from a scientific perspective, but as parts of a geography that refers to other ontologies. This displacement allows us to flee the tyranny of the object and monumentality and to think about how those materialities are part of different ontologies. Decolonial archaeology, springing from border thinking, finds an echo in the agendas of the Indigenous social movements that are leading the world towards the consolidation of roots, beyond the advance of the routes of globalization. In some ways, the agenda of roots has also sought to generate its own routes to take the thinking and logic of the ezuamas beyond their places. When these lines are read, it will mean that this message has arrived and has moved, at ease, to come within the framework of an archaeology of border thinking. I remember the first time I heard Ramón Gil speak; he told me that it was essential to listen to the mamos because, although they had not studied, they understood the territory and what they had to say was necessary. It is difficult to convey the emotion of Ramoncito's words, as his best non-Indigenous friends call him, in a text written in Spanish that will be translated into English. In any case, his statement is a powerful message that advises us to become familiar with the thinking of Indigenous people, and what it means, on the other hand, to practice a discipline that considers the tumas as waste and the ezuamas as archaeological sites.

Although decolonial archaeology is being developed in Colombia (Londoño 2012; Mantilla 2013; Franco & Alonso 2016), and some of the agendas of the Indigenous people of the SNSM are being consolidated, the current context of globalization is not appealing for those projects. When the agenda of social movements has become popular, the market does not give up. Tourism is trumpeted as the new economic miracle. As tourism is seen as a business possibility, heritage management continues to promote

the idea of Indigenous villages as "Lost Cities" that can be visited by people who become explorers for a few days. Heritage policies favor the creation of tourismscapes (Van der Duim 2005), which is seen when magazines like *National Geographic* set their sights on regions like the SNSM. This exoticization is almost an obligation and a necessity for the commoditization of the past.

The management of the pre-Hispanic villages that are currently in private hands is designed to exploit them for tourism. Since many of these spaces were left out of the "Black Line," the development of activities there does not require consultation processes. The instrumentalization of those spaces as cultural resources is a great challenge for Indigenous nations and is also criticized by decolonial archaeologists. Just as there is a process of economic decarbonization, there should be a "de-tourism" of the pre-Hispanic villages of the SNSM, which cannot occur unless there is a parallel process of de-archaeologization of history. Although the biggest problem facing these villages with ezuamas in private properties is that they are at the mercy of the landowners, it is also worrisome that tourism generates territorial disputes, especially in protected areas—Indigenous property in the jurisdiction of PNN. The Indigenous people's agenda that attempts to de-archaeologize pre-Hispanic villages is testified by the persistent complaints of the mamos about the continuing plundering of the archaeologists in the SNSM. Domestic agendas face the advancement of the heritage machinery that wishes to turn every corner of the SNSM into tourist exploitation areas. Although Indigenous nations oppose the archaeological destruction of ezuamas, countless active actors seek the heritagization of sites in order to circulate them in the tourism market.

It is clear that the Indigenous peoples of the SNSM want to stop the archaeological investigations and confront the touristification of their territories. Parallel to these claims, Indigenous peoples seek the generation of other narratives and other histories. In this desire, there are important similarities with what is known in the Anglophone world as Indigenous archaeologies (Smith & Wobst 2004).

Tourism: the new oil

On December 1, 2015, Colombian media reported the reopening of the PNNT after its closure for a full month—the first closure to occur in at least two decades (Vanguardia 2015). The media recreated the news, with awe, insinuating that the concession to the indigenes prevented the access of tourists, mainly international, who contribute most to the tourism economy in the Colombian Caribbean. The local media echoed the concern of small restaurant suppliers and drivers going from Santa Marta to Zaino, the main Park entrance. A high ranking national tourism officer said that the problem with the closure was that big tour operators had already sold packages to the PNNT. It was taken for granted that, unlike previous ones, this closure was a

result of actions based on a plan wielded by the Indigenous people of the SNSM. They had it right: the closure was prompted by the Indigenous people's attempts to recover the ezuamas in order to restore the equilibrium upset by colonialism. Without access to the ezuamas human beings cannot have their food, water, or life in order to to prosper. It is thus necessary to let rest the PNNT and the entire SNSM.

Upon the reopening of the Park, a Bogotá newspaper quoted Juan Novita as saying that the request for the closure was made due to consultations made by the mamos, the results of which had indicated the need to let the area rest. As they told me while we were making the documentary with Rafael Mojica, the *zhátekua* had indicated the need to allow the land and sea to rest. Several ezuamas had warned of the territory's overexploitation and the prompt arrival of diseases and great misfortunes. When I told Santos Sauna that he should write a book on the Teykú process, he told me that it was necessary to make it clear that without the practices of Indigenous peoples, there could be no life.

The ezuamas needed to be visited in order to make the necessary spiritual reconnections of each one with the others. In that same journal interview, Juan stressed that the definitive closure of the PNNT would not be requested, but that the claim simply sought that the area be allowed to rest regularly. Novita announced they would ask for annual routine closures (*Blu Radio* 2015), as suggested by the mamos. Park officers argued that they agreed with the closures because this would allow them to monitor the actual situation of the area's ecosystems; that is, they accepted that the measure was beneficial within the logic of conservation policies, without acknowledging social movements' claims. Indigenous peoples' requests were thus translated into conservation policies. Park officers did not question the technoscientific model—in the end, they just see frogs, monkeys, and snakes, unrelated to humans, while in fact each animal has its own ezuama that relates it to a basin and a clan. As I have discussed with José de los Santos Sauna, there is no management plan for the area derived from local ontologies, but only preservation policies for an area increasingly threatened by a predatory capitalist model. By 2015 it was uncertain that a definitive closure of areas such as the central square of Teykú or Chengue would happen. In November 2015, a Barranquilla newspaper reported, in alarmist tones, that the supreme political authorities of the SNSM would request the definitive closure of the PNNT (*El Heraldo* 2015a). Two days after, the same newspaper interviewed high ranking officers of the PNNT who indicated that the definitive closure of the Park was impossible (*El Heraldo* 2015b), because they have to ensure the rights of Colombians to recreation.

The 2015 closure was preceded by a 2013 legal ruling acknowledging the rights of the SNSN nations to be consulted on any development activities in the Park, mostly those related to the concession that the state had made to a private operator. In 2015, before the temporary closures began, the question arose as to the possibility of a complete shutdown to tourism. This issue was discussed from the beginning of the concession in 2005, but only ten years

after steps were taken in that direction. The definite closure of some areas for tourism was entertained as a result of government sympathy towards the SNSM nations, due to the affection that former president Juan Manuel Santos had for them and their political leaders. Some mamos, like those of Santa Rosa, near Palomino, point out that it was the result of the spiritual work that was done with him. In the basins frequented by Santos it is rumored that the peace talks that he launched was the result of the payments made in ezuamas to prevent conflicts and generate stability. Before ending his term as president of Colombia in 2018, Santos issued Decree 1500, known as the "Black Line Decree," which defined each of the points along the "Black Line," that is, each ezuama of the four Indigenous nations of the SNSM, and allowed PNN to issue Resolution 0391 (October 9, 2018), which ordered "the definitive closure for recreation and tourism of the Indigenous sacred spaces of Chengue, Pueblito, Los Naranjos and the eastern side of Concha Bay." These measures became powerful tools for the defense of Indigenous people's communities and landscapes; they not only drew public attention to the value of Indigenous belief systems, but also helped to halt the advance of luxury tourism projects. Yet, in 2011 Santos had endorsed the operation of the Thai company Six Senses that sought to build a luxury resort in the Arrecifes sector of the PNNT. As the media reported, this project divided the Indigenous leaders. On the one hand, Santos Sauna, representing the Kogui-Malayo-Arhuaco reservation, naively stated that the project's conservation policy was attuned to local laws; on the other hand, Kankuamo mamos, calling for order, flatly refused the project until it became unfeasible (Deracamandaca 2012). The Six Senses project was undoubtedly a sensitive issue and involved several actors located on different levels of power. According to various community members with whom I talked, the approval that some organizations had given to the hotel project was the result of economic interests. But this was a matter of speculation because there was no evidence of bribes. There was consensus, however, that several ezuamas would be destroyed, especially Dugunawi, where payments are made for bird feathers. The beach of Arrecifes houses the ezuama of Dugunawi and that of Zuldziwe, the sea itself. In the world's configuration, Arrecifes is where the first mamos and *jabas* demonstrate the difference between the land and the sea. Arrecifes is a place for spiritual works related to water, so it was insulting to build a hotel for foreign tourists there.

The first term of Santos as Colombian president (2010–2014) was characterized by systematic attempts to appropriate areas of the PNNT and transfer them to international tourism. Yet, by the end of his second term (2014–2018), he made a drastic turn as he signed the agreements with the FARC-EP guerrillas, which led him to a crusade through the country to defend the peace process. For the nations of the SNSM, this move meant their renewed political and cultural empowerment. This chain of consequences that led from predation to conservation was woven at various times, especially when Santos decided to take the oath of office symbolically before Indigenous

authorities of the SNSM. During that ritual, the mamos gave him tumas, a sign of the commitment he had shown to the preservation of payments and ezuamas. (This was surprising, though, because that same day Santos traveled to Santa Marta, and from there to Bogotá, for the official ceremony.).

Former president Álvaro Uribe (2002–2010) has long been pressing for the relaxation of environmental regulations. According to him, "tourism is the new oil" so he does not understand why the response of PNN has been out-right environmental protection (Muñoz 2019). Uribe's statement summar-ized what tourism has meant as a state policy in recent decades: exploiting the territories for extracting maximum profitability from a non-renewable resource. Like the oil industry, tourism is also extractive and polluting—the new oil of Colombian economy is as harmful to society as oil itself! Since the inauguration of the current president, Iván Duque, the threat to the SNSM does not seem to have ceased, and, again, the area's future is under discussion. The main square of Pueblito Chairama is closed, but tourism has taken to other areas with ezuamas—such as Boca del Saco. As the Indigenous reclaiming of certain ezuamas consolidates, the pressure of tourism increases, sacrificing other unprotected areas.

The current context of cultural politics in the SNSM

Although this book is academic, the scholarship that informs it does not claim the benefits of science. My political and theoretical starting point has been border thinking, well characterized by Walter Mignolo (1996), which recognizes the analytical limits of modernity/coloniality constituted under two complementary forces: accumulation of capital and the formation of the nation-state. Inhabiting the Colombian Caribbean—a border from the view of the nation-state—means not only a spatial location but also an epistemologi-cal one. This book is full of encounters in border areas because it is written in the periphery (the Caribbean) of the periphery (Colombia), and is the product of a dialogue with subjects that are within the periphery (SNSM) of that periphery. The conversations captured at the border are the speech of border thinking—much as Alejandro Haber (2011) prophesied for archaeology, beginning by questioning that archaeology is a discipline of vestiges.

We are at the beginning of 2020, and Francisco has just arrived from Bogotá after doing thousands of errands because he is the principal of the ethnoeducation project of the Kogui of Palmor. I imagine him in Bogotá, trying to get the bureaucrats in charge of alternative education to understand that the Ministry of Education should intervene the least because of epistemic autonomy. In the sphere of microscopic bureaucracy, state officers strive to preserve national identity by approving mainstream projects. They play the game of multiculturalism with the marked cards of resources and infra-structure. The indigenes have few cards of value, save the possibility that the bureaucrats read their curricula in terms of environmental conservation. In this game, the bureaucrats are willing to give in, if ethnoeducation guarantees

the unity of the nation and if it guides the Indigenous struggle towards con-
servation purposes.

At the start of our conversation in the border space, that is the Plaza de
Bolívar in Santa Marta—an ezuama, but also a colonial site, and a repub-
lican square—the first thing we want to address is the current political situa-
tion in the SNSM. We begin by tackling the political representativeness of the
different clans. When internal tension is strong, questions arise about the
unity of each of the four SNSM nations. Since there are no apparent disputes
between the Arhuaco, the Wiwa, and the Kankuamo, the first level of analy-
sis involves thinking about the Kogui. Amid the conversation, I ask Francisco
about the way the Kogui have been represented by anthropology, especially by
the work of Reichel-Dolmatoff. He replies that his work ought to be revised.
The mamos find, however, that it includes toponymic details that are worth
contrasting with the Kogui history of Mamarongo. The revision of his work is
done at border thinking because there is a history of clans and mythologies.
When I discuss this issue with the Cabildo Mayor of Taganga, Ariel Daniels,
he tells me that I must bear in mind that the Kogui respect Reichel because he
was one of a few non-indigenes lucky enough to collect first-hand
genealogical testimonies from the mamos.

While the conversation with Francisco was taking place, I wondered what
the mamos think of the Anonymous Report and the official history of Santa
Marta that revolves around the conqueror Bastidas. I asked Francisco if he
heard them talk about Pocigueica or Pueblo Grande in his research with the
mamos. Are the mamos from the basins of the southern slopes of the SNSM
aware of the Anonymous Report and what it describes? Francisco tells me
that the mamos he consulted are not aware of the name; yet, they do recog-
nize the villages that are currently uninhabited, knowing that they were
abandoned as a result of the first waves of conquest. Official history silences
the local history that recognizes another toponymy and another historicity—
bracketed in archaeological reports that only tell the story of what they con-
sider lost tribes. We talked about reviewing Reichel's work, at least as regards
to the Kogui of Ciénaga, according to what the mamos think. We also
discussed the identity of the communities. Are Kogui all those who speak
the Kogui language? This surprised me, yet it is equivalent to what Latour
(2008) notes: there are no groups but group formation. For me, this question
should guide inquiries about how the Kogui produce regional identities.
These are relevant when there are strong tensions between some clans
around the interaction with the state, and tensions that have generated non-
negligible conflicts. In border thinking, we agreed that current interclan
relations indicate that there are two fundamental tasks to be carried out: a
review of traditional representations of the Kogui, and a concern about how
the Kogui represent themselves. The former is not to be oriented to discover
errors or misunderstandings in Reichel's work but to make visible the local
notion of the territory. The latter must account for the fact that the Kogui
are present throughout northern Colombia. Thus, they have to interact with

various territorial authorities; in such cases, differences may arise, equivalent to the differences between regional governments. The government of Santos empowered the political organizations of the north, to the detriment of the participation of the southern clans. The response of the latter—plagued with internal conflicts—was to strengthen their dialogue with Magdalena's territorial entities.

It is impossible to consider the political context that engulfs the Kogui without attending to the dynamics of violence in their territory, which has been integrated into global economies through the port enclave, in two dimensions: a formal one that has turned Santa Marta into an important medium-sized port; and an informal and illegal one that makes the SNSM coast an area for the production and export of drugs. In both cases, the territory is instrumentalized to extract resources exported from the coast. This includes hordes of foreign tourists channeled by companies that obtain their capital from the region to create wealth in other latitudes.

As stated by Appadurai (2001), violence in peripheral countries helps strengthen segregation. Thus, it is up to the civil sector—in Colombia, particularly in Latin America and Asia—to build social fabric outside the state, currently seen as an ally of the market. In the SNSM, violence has always been a language that has allowed territorial expropriation and population segregation. As the Anonymous Report showed, the first forms of violence were based on the extermination of populations to get their gold. Violence in the 17th, 18th and 19th centuries meant subjecting the communities to the yoke of the Catholic church. Finally, the violence of the 20th century aimed to get Indigenous nations out of the way of drug trafficking. After the recent rise of the Colombian right, after a presidential period of relative calm, organized crime has regained power, and intimidation has returned to the SNSM. As reported by some NGOs (Pacifista 2019), the war in the SNSM that has affected the physical integrity of Park officers is directly related to the appropriation of the territory for tourism and coca crops.

The Bogotá newspaper *El Espectador* published two chronicles written by bird watcher John Edward Myers in November and December 2019. The chronicles were about the tragedy that pounced on Tito Ignacio Rodríguez, former head of the PNNSNSM, who had to flee the country due to death threats. In the first chronicle, Tito appears in the foreground. His eyes express the tragedy that consumes him. In 2019, Tito knew he was going to be killed for reporting illegal constructions in the PNNSNSM coastal area—for tourism or drug trafficking, as I gathered from conversations with PNN officers. Tito and Myers knew each other because nature conservation unites them. Tito was a public official who had the problematic mission of guarding one of the largest natural reserves in South America, in an area that is wanted by drug dealers and land invaders. When the first chronicle came out, Tito and his family had already left Colombia; by the year's end they had gone to Canada seeking political asylum. Tito's tragedy is not unique. In the last two decades, Canada has become a destination for Colombian environmentalists

who had to leave the country due to the imminent risk they were facing. In January 2019, Sandra Vilardy, conservationist and former Dean of the School of Basic Sciences of the University of Magdalena, had urged Myers to speak with Tito, given the complicated situation in La Lengüeta, located between the Don Diego and Buritaca rivers in the lower part of the SNSM. As a colleague of Sandra Vilardy, I was able to appreciate the complexity of the situation, especially the violence against environmental and human rights activists. We were able to verify with friends from the Caribbean branch of PNNT that the internal situation was critical: threats exist against high-ranking officers such as Tito, but a Park officer had already been killed in La Lengüeta in retaliation for the ban on construction in the area.

On November 18, Myers (2019b) published the second chronicle, in which he revealed what the climb to the "Lost City" was like and noted that it costs some 400 dollars—it is estimated that more than 26,000 people come to the site each year. The "Lost City" is one of the most prosperous businesses in the region and has allowed dozens of former paramilitary fighters to dedicate themselves to guiding tourists; this guarantees them almost the same income they had during the war, but from a safer activity. However, death has returned. The chronicles of Myers show that the northwestern region of the SNSM is in the midst of a conflict that, for now, seems irresolvable. Although the area of La Lengüeta belongs to the Kogui–Malayo–Arhuaco reservation, other actors overlap, generating the violence of which Park officers are victims. In recent years, however, there are new Arhuaco and Kogui settlements in La Lengüetad, preventing the area from falling prey to tourism or drug trafficking. Exploitation in La Lengüeta must be seen from a historical perspective (Rodríguez 2018). The area has been occupied in various historical phases that have left their imprint. National integration led to the consolidation of the Santa Marta–Riohacha road in the 1980s, which facilitated fuel smuggling and marijuana trade. In the 1990s and 2000s, the territory was disputed by cocaine producers and dealers; a paramilitary war broke out that ended with the demobilizations of the early 2000s, which brought a relative calm due to the stabilization of the PNNT's and the PNNSNSM's operations at the hands of large tour operators. At the moment, the Indigenous territory of the northwestern SNSM is under attack; to make things worse, the representativeness of OGT organizations, to date commanded by the Kogui, is fragmented. For some years now, the Arhuaco have asked to take over, so their more recent settlements in La Lengüeta have had no Kogui payments and rituals (Rodríguez 2018:196). Wiwa and Arhuaco authorities indicate that resettlement does not produce sustainable villages integrated to global economies, but spaces for building other worlds within this world. This agenda does not occur in a bubble, but in highly conflicted conditions. As La Lengüeta shows, the territory of the native nations of the SNSM is in a tension constitutive of the modern/colonial world, since the area is a space for the reproduction of capital. In the 16th century, the Spaniards were not interested in land, but in gold and,

later, in the natives. In the 18th century, due to the transformations of the global system, the land became a commodity, and territorial expropriation began; thus, Indigenous peoples' villages were forced to migrate to higher altitudes. In the southeast of the SNSM, the Kogui populations of Palmor migrated due to the combined pressure of the Catholic church and the police.

In September 2019, national and local media reported an unfortunate act of violence in the mythical Kogui population of Mamarongo. As reported by the Santa Marta journal *El Informador*, 20 people had been attacked and beaten (*El Informador* 2019). The reporter accompanied an army platoon that had come to help Mamarongo's wounded. The photos show the wounded climbing into an old Bell 212 helicopter. They recall the 20th century and the Vietnam War. While the paramedics team is responsible for helping the injured, the community observes, behind the ezuama, how the helicopter prepares to take flight. In addition, this local newspaper published the comments of the leader of Mamarongo, Atanasio Moscote (*El Informador* 2019), who said that the media had belittled the news and that the beating had been ordered by the highest authority of the OGT, José de los Santos Sauna. The conflict was due to the lack of recognition of GKM, whose governor is Atanasio Moscote and which was constituted for representing, exclusively, the Kogui communities of the District of Santa Marta and the Department of Magdalena—mostly to take advantage of territorial and economic compensations on the part of the state. The Secretary of the Interior of the Department of Magdalena, Norma Vera, said that conditions had been met for the Kogui communities of Magdalena to consolidate their representation. GKM not only wants to depart from OGT but demands that justice be done regarding the atrocities of September 2019. This tension has occurred in a frontier location. These spaces are paramount for the administration of resources and the political capital that accrues in the interaction with the state. That is why presidential inaugurations have been staged in the northern basins of the SNSM that are considered "purest," unlike the southern basins, where there are Kogui clans that openly profess Evangelism. Further, there is a difference between the northern and southern clans (a difference that has become a political dispute) with regards to the imprint of the Catholic church.

The Kogui clans are being reorganized according to the political-administrative divisions of the SNSM: some areas correspond to the Departments of Magdalena, Guajira and Cesar. The conflict is not between clans but between political organizations that manage relations with the state at the departmental and municipal levels. Apart from this conflict—little studied, perhaps because the image of an ancestral, apolitical ethnicity must be maintained—the Indigenous nations of the SNSM carry out projects on the fringe of modernity/coloniality and the culture of technoscience. Their regime of care intends to control the territory, not to form a state or to segregate but to stop the predations of tourism and drug trafficking. Those

who have helped me make this book—such as Francisco, David, Ariel, Rumualdo and Ramón—have never told me that they considered themselves exclusive or that there are no blood ties between them. Polarization occurs, then, in the political arena. While the northern clans have a higher political and social visibility, the southern clans, especially GKM, are seeking to improve the dialogue with regional governments. Now that the clans of Taganga finally have state recognition they are fighting for the reclamation of their territories—not an easy task, however, because those territories are areas of environmental conservation and luxury tourism.

Returning to the land of the ancestors

For ten years, I went up to Pueblito Chairama without knowing the local value of the place to the Kogui people; now, all we know is Teykú. I got to know most of its recesses and its ezuamas before they were closed to tourism. I saw how the natives slowly recovered the surrounding lands; I saw how they made payments, hiding from ICANH and PNN officers, seeking to reestablish Pueblito connections, to activate it, and to put it at the service of the community. I also saw how the farmers supported them, and how some officials simply understood that those peoples were repopulating a site that belonged to them in their own right.

Now that Teykú has been recovered and is becoming the center for consulting the SNSM nations anew, the voices of the Kogui are beginning to be heard incisively. While in Palomino, drinking an excellent cup of coffee with Franz Florez—a member of the Fundación Nativa, who has lived in the region for at least a couple of decades—I realize that people in the Kogui–Malayo–Arhuaco reservation recognize that the primary source of energy for the Kogui is not corn but a tree locally known as kanzhí (*Metteniusa edulis*). As Franz points out, without kanzhí there would be no human life in the SNSM. As far as I know, no archaeologist has been concerned with understanding kanzhí as an essential element of the foraging strategies of the Kogui. The image of the Kogui as farmers with hierarchical structures based on a corn surplus, as proposed by Reichel, is an unfounded invention. The natives are not content to recover territories or strengthening internal identities; they also have to re-create history. The myth of the Tairona culture implies that, as in other parts of the world, evolution and social hierarchy automatically began once corn was domesticated. To counter that story, the Indigenous nations of the SNSM are de-archaeologizing memory. Their sacred sites, their practices, their culture have been used by technoscientific archaeology to "verify" the universality of hierarchical organizations and social evolution; it is as if, by decree, material evidence reflects the inevitable human tendency for subjugation and the increasing control of energy. Socioeconomic and political evolution understood as a universal phenomenon was a theory, or rather an ideology, popularized in the United States through the creation of area studies departments. As Walter Mignolo (1996)

demonstrated, area studies were a colonial tool by which the United States enacted the Third World, not just as an object of research but of intervention. The Center for Latin America Studies of the University of Pittsburgh, for instance, carried out large processualist projects in Colombia to verify the universality of pre-Hispanic hierarchical structures (Drennan 2008); by funding projects and scholarships to Colombian students, the Center naturalized its evolutionary models by implementing a technoscientific version of archaeology, which ignored the possibilities of historical multivocality (Gnecco 1999). Returning to the land of the ancestors, consequently, is a defuturizing journey that aims to keep the ontology of naturalism at bay; at the same time, it is a historical detoxification aiming to demystify ideologies such as evolutionism and to contest narratives such as that of the mythical Tairona tribe.

When the forces of economic globalization commoditize the body, the territory, culture, the Kogui and the other nations of the SNSM seek to travel the reverse path. For them, returning to the land of the ancestors is not hiding in an essentialized Indigenous, as elaborated by the market; their fundamental claim is to reunite with the ezuamas for making the consultations to restore the balance lost by colonialism. For the nations of the SNSM, the history of modernity is not the advancement of democracy and industry, but dispossession, murder, persecution and disintegration. Reclaiming pre-Hispanic villages aims to reconfigure the clans' organization to achieve cohesion and permanence over time. The reorganization around ezuamas is confronted by the disintegrating power of capitalism and its ability to corrupt social movements. Beyond the temptation into which some Indigenous leaders have fallen, there is an alternative agenda, unsubdued by modernity/coloniality and its commodification of the past. For Indigenous peoples' histories, the past is not a matter of yesterday, but the trustworthy source of the present; the past is ahead because it determines the behavior of the peoples who dwell in non-modern ontologies (Gutiérrez 2015; Walsh 2014).

Nowadays, the central square of Teykú is closed, and the old trail to Cabo San Juan is banned to non-Indigenous people. Those tourists wishing to enter the PNNT through the portal of Calabazo must pass by Pueblito and take the trail to *jate* Wakawazhi, currently known as Boca del Saco. Tourists who tour the *jate* Wakawazhi area are happy because they can strip off their clothes and dive into the sparkling waters of the Caribbean, or they can simply lie on the golden sands. Although the modern/colonial world does not recognize the ezuamas of these beaches, it does recognize another cult, that of the naked body: Boca del Saco is the nudist beach of the PNNT. This situation is paradoxical: on the shores of the periphery that is the Colombian Caribbean, tourists, especially Europeans, find that the sacred area is useful for exercising contemporary rituals—such as undressing.

Jate Wakawazhi is an essential site because it is connected to Nuldanbagaka and Nuxldaldue, known as Playa Brava. Few people recognize the relationship between Wakawazhi and the couple Nuldanbagaka and Nuxldaldue, because

that social relationship allows the mountain and the sea to maintain their reciprocal relations, and fresh and salt waters to retain their respective places or their individual encounters without upsetting order. I remember Amado Villafaña's insistence on understanding that ezuamas are like the cathedrals of Christendom; sites such as Boca del Saco are for the natives the cathedrals of their cults, the central places where the belief in the world is renewed; a world that has been organized since the beginning of time by *jabas* and *jates*, the owners of the threads that connect things. Boca del Saco is not, consequently, a place to bathe naked with an instrumentalized conception of the body, but the site that sets water apart from the earth. Therefore, explains Juan Nieves, it is crucial that the PNNT can rest, because otherwise the balance of the world is disturbed, and it happens, as now, that some places are without water and others have too much. That is why it is so important that Nikuma, the Pueblito of Teykú, recovers its place as a dwelling, not only for the SNSM nations but also for animals and things because they also have their forms of social organization, their limits, their ezuamas. Nikuma is necessary so that the world's beings can find their functions anew, and balance can be restored. Since Nikuma is the place of agreements, Teykú must be kept as a sacred place for all entities to reach the agreements that were broken by colonialism.

As Kogui leaders accept it, when Nikuma, as a space of Teykú, regains its place within the sacred territory of the clans, it will receive the ezuamas of Taganga, especially Jalkbasheízi, where the payments for stinging animals are made. If Nikuma joins Jalkbasheízi, then those ezuamas will connect with La Lengüeta, especially with *jaba* Teyunashikaka, the mouth of the Buritaca River, where the payments for tumas take place and which connects with the place of stinging animals, which in turn connects with Pueblito. Further, Teykú is related to Ulueyllaka (known to tourists as La Piscina, one of the most visited beaches in the PNNT). Thus, the reclaiming of Pueblito should trigger the reclaiming of the ezuamas with which it is interconnected. Once these connections are restored, so will the balance.

In this mythology that expresses the sacred character of the territory, the clans are united beyond political boundaries. These areas are not heritage or tourism resources. Teykú is a place for healing the human and non-human clans hit by violence; it is a pilgrimage center that meets the principles of the universe and things again. The reclaiming of Teykú puts forward the discussion—with local and regional governments—about the management of sacred areas such as the Buritaca and Don Diego river basins; the integration of the Cabildo de Taganga into the most important organizations, such as OGT and GKM; and the strengthening of territorial integrity beyond regional political-administrative divisions. The territory is indivisible. But the state asks the clans to have their dialogues with local governments, so nowadays the southern clans have little relation with the northern clans. The idealization of the Kogui by certain writers has created the idea that the southern clans are less pure than those of the north due to the influence of Evangelism. The consolidation of the Kággaba agenda must resolve these internal tensions to strengthen the social movement.

The return to earth of the ancestors is a symptom of post-Anthropocene transitions. The reclaiming of Teykú did not occur as a re-foundation of one of the many villages abandoned in the SNSM—presented by explorers as great findings of contemporary exploration. Pueblito has been won through decades of fighting with the Colombian state since the great decolonization of the second half of 20th century began—when the religious orders were expelled. Since the 1960s, when the territory and regional geopolitics were reorganized, mostly due to the predominance of guerrillas such as the ELN, Indigenous movements have successfully halted the expansion of large estates; however, paramilitarism emerged shortly after as an illegal army of the land-owners that sought to prevent agrarian reforms (Rodríguez 2009). Indigenous nations somehow managed to stay in the margins. Peasant communities were significantly affected, including Afro-Colombians. In many areas to the south of the SNSM, the expansion of large estates caused demographic densification in small towns such as Fundación, Zona Banarera and Aracataca.

The novel *La Hojarasca* (García Márquez 2011) portrays this first colonization of the early 20th century when the first territorial plunder began. The book is the story of the arrival and departure of the banana company in Macondo—which, for practical purposes, is Aracataca. The relative calm that prevailed in Macondo is upset when the banana industry arrives in the last decade of the 19th century. Upon the departure of the company (which García Márquez dates as 1915) after having squeezed the region, the loneliness of the pauperized landscapes remains. *La Hojarasca* ends at that point. García Márquez, if he had stayed in Macondo, could have told how after the departure of the banana company the peasants were evicted from their lands so that those areas could be planted with African palm; they were then forced to settle near the new population centers of Fundación, Zona Bananera and Aracataca, contributing another layer of pauperized and proletarianized generations.

This panorama of desolation that marks the former province of Magdalena, with its once glorious capital Santa Marta, makes the Indigenous peoples' reclaiming of sites such as Teykú all the more important—the beginning of a new era. The SNSM has witnessed this before: re-foundations are a part of the mythology of its inhabitants. In *One Hundred Years of Solitude*, García Márquez tells how Aureliano Buendía, a retired colonel from the wars of the late 19th century, founded Macondo, and after murdering Guaira migrated south to establish a town. This is the story of Nicolás Márquez, the grandfather of García Márquez, a notable citizen of Aracataca. The mythical foundation of Macondo is similar to the mythical history of the Kogui, who build their villages following the teachings of great mamos such as Teykú. Unlike Macondo, which is the nostalgic expression of a bygone world, the re-foundation of Teykú is the expression of the world to come that springs from the past.

In 2025, the 500th anniversary of the founding of Santa Marta will be celebrated, and the city is preparing to commemorate the arrival of Western

civilization to the ezuamas' land. But before that happens, this book is my way of saying that this celebration is improper because Bastidas, the conqueror, rests on *jaba* Sé, the mother of spiritual origin. *Jaba* Sé is the mother of the *zhátukwa* that connects with Nañiba Alduamiku, the source of the tumas. Jaba Sé will hardly replace Bastidas, but she will know that we have seen her, that we have heard about her. This book bears evidence that in that far away time in the archaeology laboratory of the University of Magdalena, the tumas I returned to the mamos that had been taken from the Reichel-Dolmatoff collection of Pueblito Chairama, activated the ezuamas that now speak to us.

The ezuamas had always been there, in Taganga, on my arrival in 2008, when I lived in a small hostel full of Belgians, French, Canadians and Germans. Every morning, without knowing it, I went to Julaken, now occupied by the police station. The site is of great importance because it was the place that provided tumas for the *zhátukwa* in the ezuamas. Every morning I went for a run through the *nujue* of Mulkueke, Nujue chi Mulkueke, one of the spiritual fathers of the SNSM, together with Siukuki, Seyankua, Alduawiku, Sintana and *Jaba* Sé. Taganga is an essential place for the nations of the SNSM: it is home to one of the ordering fathers of the world's principles. Back then, I also went to *jaba* Kuintameizhi, before the tourists arrived, to contemplate the emerald green waters that bathe the white sands of Playa Grande. Later on, I realized that Kuintameizhi was the mother of green tumas.

Back then, I was living near Mamatukwa, near the Manzanares river that flows through the Quinta de San Pedro Alejandrino, where Simón Bolívar died. On some afternoons, I used to go to the cottage by the old stables, where Bolívar took his last breath. Legend has it that before he died, Bolívar received an Indigenous priest from the town of Mamatoco, about a kilometer away from where he lay dying. He repented of his sins and died on the banks of the ezuama of Mamatukwa, the site of organization and consensus. The mamos who make payments for the agreements, for the political stability of the community, do so in Mamatukwa, Taganga, Makotama and Jukumeizhi. Bolívar could have died anywhere, but he died in a place that evokes quietude, peace, even for a warrior. Ancestral mythology says that Taganga is home to Takshikukwe and Nukuataba, who were trained in Makotama to protect the territory. Mamatukwa is connected with Takshikukwe and Nukuataba, but unlike Mamatoco, a resting place, Taganga is a border site, a site of containment.

I have returned to Taganga, where I write these lines. I am writing the last words of this book, which took me more than a decade to write. It has been a trip that brought me to a place where I see resorts and police stations over the ezuamas. It gives me the creeps to see the tumas labeled on the dusty shelves of the university's archaeology deposit. As I was taught the first time, I am to make a payment, I want to make a payment for the book I am finishing, and I remember my last dream. I dreamed of Sisihuaca, a beach in Taganga where I used to go with my mother. It is not a coincidence that we placed her ashes

and those of my father in front of Ñiulalue, the house of *jaba* Zuldziwe, the mother of mothers. After spending a Sunday in the waters that bathe *jate* Maktulueshikaka, the dream came to me, where family relationships are strengthened. The ezuamas, upon inquiry, orient me to my clans and make me understand that I have to share the signs that I have read.

Conclusions

The Kogui have successfully reclaimed iconic territories, such as the central plaza of Teykú within the PNNT. They have also managed to get the Park to close protected areas more frequently. Although the politics of payments have strengthened their organizations, there has been a simultaneous upsurge in violence in the region, and increasing pressure for the commodification of the SNSM coastline to promote tourism. Local processes are thus confronted by global forces, renewing conflict. The future of the Kogui and the other nations of the SNSM will depend on the understanding of civil society about the importance of Indigenous territories from the point of view of their ontologies.

References

Alonso, P. (2014). From a given to a construct: heritage as a commons. *Cultural Studies*, vol. 28, no. 3, pp. 359–390. DOI: https://doi.org/10.1080/09502386.2013.789067

Appadurai, A. (2001). Deep democracy: urban governmentality and the horizon of politics. *Environment and Urbanization*, vol. 13, no. 2, pp. 23–43. DOI: https://doi.org/10.1177/095624780101300203

Augé, M. (1993). *Los no lugares: espacios del anonimato*. Barcelona, Spain. Gedisa.

Blu Radio. (2015, 1 December). Indígenas solicitan nuevos cierres anuales en el Parque Tayrona. Colombia. www.bluradio.com

Clifford, J. (1997). *Routes: travel and translation in the late twentieth century*. United States. Harvard University Press.

Dean, J. (2005). Communicative capitalism: circulation and the foreclosure of politics. *Cultural Politics*, vol. 1, no. 1, pp. 51–74. DOI: https://doi.org/10.2752/174321905778054845

Del Pozo, P. & Gonzáles, P. A. (2012). Industrial heritage and place identity in Spain: from monuments to landscapes. *Geographical Review*, vol. 102, no. 4. United States, pp. 446–464. DOI: https://doi.org/10.1111/j.1931-0846.2012.00169.x

Deracamandaca. (2012, 5 November). Kankuamos vs. Koguis, Arhuacos y Wiwas por hotel 7 estrellas en el Tayrona. Colombia. Available at www.deracamandaca.com

Drennan, R. (2008). Chiefdoms of southwestern Colombia. Silverman, H. & Isbell, W. *The handbook of South American archaeology* (pp. 381–403). New York. Springer.

El Heraldo. (2015a, 18 November). Indígenas piden que Parque Tayrona sea cerrado por siempre. Barranquilla, Colombia.

El Heraldo. (2015b, 20 November). Cerrar el Tayrona por siempre es imposible. Barranquilla, Colombia.

El Informador. (2019, 21 September). Líder Kogui denuncia al gobernador Sauna por torturar a indígenas. Santa Marta, Colombia.

Franco, L. & Alonso, P. (2016). El recurso del patrimonio o des-armar el patrimonio como recurso. *Revista Digital de Arqueología Profesional La Linde*, no. 6, pp. 178–191.

García Márquez, G. (2011). *La hojarasca*. Madrid. Vintage Español.

Gnecco, C. (1999). *Multivocalidad histórica hacia una cartografía postcolonial de la Arqueología*. Bogotá, Colombia. Universidad de los Andes.

Gnecco, C. (2011). De la arqueología del pasado a la arqueología del futuro: anotaciones sobre multiculturalismo y multivocalidad. *Jangwa Pana*, vol. 10, no. 1. Colombia, pp. 26–42. DOI: https://doi.org/10.21676/16574923.71

Gnecco, C. (2012). Arqueología multicultural. Notas intempestivas. *Complutum: Teoría Arqueológica*, vol. 23, no. 2, pp. 93–102. DOI: https://doi.org/10.5209/revCMPL.2012.v23.n2.40877

Gnecco, C. & Dias, A. (2015). On contract archaeology. *International Journal of Historical Archaeology*, vol. 19, no. 4, pp. 687–698. DOI: https://doi.org/10.1007/s10761-015-0305-6

Gutiérrez, A. (2015). Resurgimientos: sures como diseños y diseños otros. *Nómadas*, no. 43. Colombia, pp. 113–129. DOI: https://doi.org/10.30578/nomadas.n43a7

Haber, A. (2009). *Domesticidad e interacción en los Andes Meridionales*. Popayán, Colombia. Universidad del Cauca.

Haber, A. (2011). Nometodología Payanesa: notas de metodología indisciplinada (con comentarios de Henry Tantalean, Francisco Gil García y Dante Angelo). *Revista Chilena de Antropología*, no. 23. Chile, pp. 9–49. DOI: https://doi.org/10.5354/0719-1472.2011.15564

Latour, B. (2008). *Re-ensamblar lo social: una introducción a la teoría del actor-red*. Buenos Aires, Argentina. Ediciones Manantial.

Londoño, W. (2007). Enunciados prescritos y no prescritos en arqueología: una evaluación. *Boletín de Antropología Universidad de Antioquia*, vol. 21, no. 38. Colombia, pp. 312–336.

Londoño, W. (2012). Espíritus en prisión: una etnografía del Museo Nacional de Colombia. *Chungura (Arica)*, vol. 44, no. 4. Chile, pp. 733–745. DOI: https://dx.doi.org/10.4067/S0717-73562012000400013

Londoño, W. (2016). Arqueología por contrato y nuevos contratos arqueológicos. *Jangwa Pana*, vol. 15, no. 1. Colombia, pp. 117–128. DOI: https://doi.org/10.21676/16574923.1756

Mantilla, C. (2013). El sujeto negro y la arqueología en Colombia. Apuntes preliminares para una descolonización del pensamiento. *Arqueología para el siglo XXI: actas de las V Jornadas de Jóvenes en Investigación Arqueológica, Santiago de Compostela, mayo de 2012*. JAS Arqueología S.L.U.

McGuire, R. (2008). *Archaeology as political action*. Vol. 17. United States. University of California Press.

Mignolo, W. (1996). Posoccidentalismo: las epistemologías fronterizas y el dilema de los estudios (latinoamericanos) de área. *Revista Iberoamericana*, vol. 62, no. 176, pp. 679–696. DOI: https://doi.org/10.5195/reviberoamer.2002.5978

Muñoz, C. (2019, 27 May). *"Turismo es el nuevo petróleo de Colombia": Álvaro Uribe Vélez*. Bogotá, Colombia. Uniminuto Radio.

Myers, J. (2019a). *El camino de Tito: crónica de un viaje al asilo político*. Bogotá, Colombia.

Myers, J. (2019b). *El camino de Tito: crónica de un viaje al asilo político (II)*. Bogotá, Colombia.

Pacifista. (2019, 15 January). ¿Por qué están matando los guardabosques en los Parques Nacionales?. Colombia.

Rodríguez, D. (2018). Consensos, conflictos y ambigüedades en torno al territorio: exploración etnohistórica de la lengüeta, Sierra Nevada de Santa Marta. *Maguaré*, vol. 32, no. 1. Colombia, pp. 171–204. DOI: https://doi.org/10.15446/mag.v32n1.76168

Rodríguez, E. (2009). Discurso y legitimación del paramilitarismo en Colombia: tras las huellas del proyecto hegemónico. *Ciencia Política*, vol. 4, no. 8. Colombia, pp. 82–114.

Seguimiento.co (2019, 6 March). *Prohíben ingreso de turistas a sitios sagrados de los indígenas del Parque Tayrona*. Santa Marta, Colombia.

Smith, C. & Wobst, H. M. (eds.). (2004). *Indigenous archaeologies: decolonising theory and practice*. London. Routledge.

Swarts, J. (2007). Mobility and composition: the architecture of coherence in non-places. *Technical Communication Quarterly*, vol. 16, no. 3, pp. 279–309. DOI: https://doi.org/10.1080/10572250701291020

Van der Duim, R. (2005). Tourismscapes: an actor-network perspective on sustainable tourism development. (Dissertation). Wageningen University.

Vanguardia. (2015, 19 November). El Tayrona se renueva biológica y espiritualmente. Colombia.

Walsh, C. (2014). Pedagogías decoloniales caminando y preguntando: notas a Paulo Freire desde Abya Yala. *Entramados: Educación y Sociedad*, vol. 1, no. 1. Colombia, pp. 17–30.

Index